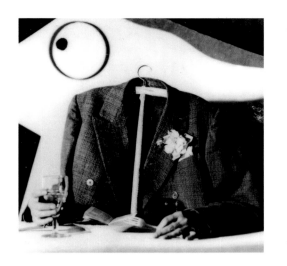

DUBLIN

Donated to

**Visual Art Degree
Sherkin Island**

2

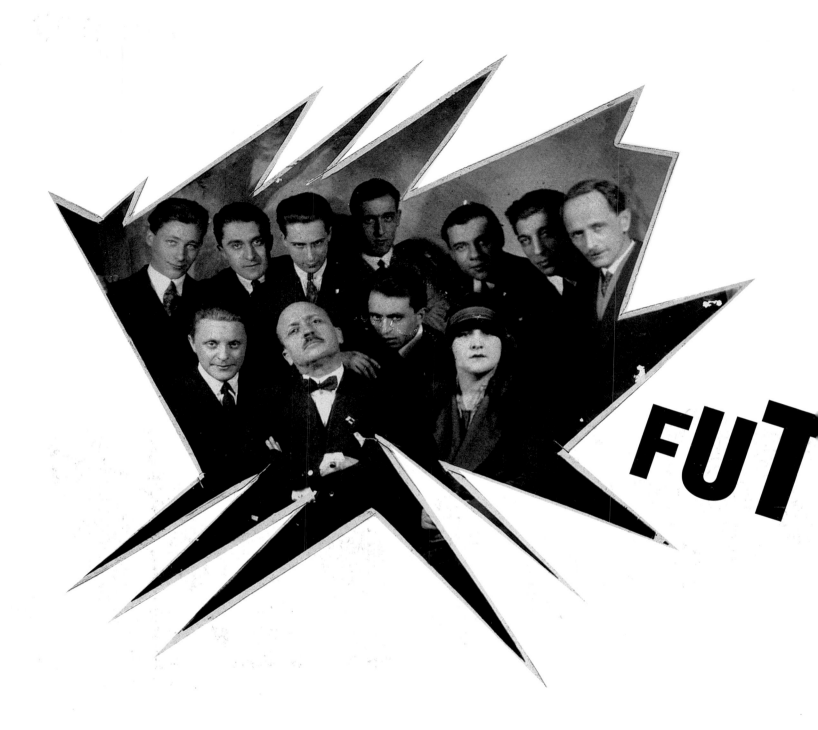

GIOVANNI LISTA

JRISM

& PHOTOGRAPHY

MERRELL

IN ASSOCIATION WITH

ESTORICK COLLECTION
OF MODERN ITALIAN ART

Cover images

Front cover

Tato ◆ *Central weights and measures* ◆
1932 ◆ detail; see p. 127

Front flap

Arturo Bragaglia ◆ *The Futurist Gerardo Dottori,*
pentagonal photographic construction ◆
c. 1920 ◆ see p. 52

Back cover

Studio Santacroce ◆ *Giannina Censi:*
Aerofuturist dance ◆ 1931 ◆ detail;
see pp. 130–31

Back flap

Gustavo Bonaventura ◆ *Photodynamic portrait*
of Anton Giulio Bragaglia ◆ 1912/13 ◆
see p. 29

Title page

Emanuele Lomiry ◆ *Marinetti and the Futurists*
Baroni, Azari, Rizzo, Ravelli, Casavola, Gerbino,
Catrizzi ◆ 1925 ◆ detail; see p. 64

This book has been produced to accompany the exhibition

FUTURISM AND PHOTOGRAPHY

held at the
Estorick Collection of Modern Italian Art
39a Canonbury Square
London N1

24 January–22 April 2001

Exhibition curator: Giovanni Lista
Exhibition organization: Alexandra Noble, Roberta Cremoncini

First published 2001 by Merrell Publishers Limited
Distributed in the USA and Canada by Rizzoli International Publications, Inc.
through St Martin's Press, 175 Fifth Avenue, New York, New York 10010

British Library Cataloguing-in-Publication Data:
Futurism & photography
1.Photography, Artistic 2.Futurism (Art)
I.Title II.Estorick Collection of Modern Italian Art
770.9′04

ISBN 1 85894 125 3

Produced by Merrell Publishers Limited
42 Southwark Street, London SE1 1UN
www.merrellpublishers.com

Designed and typeset in Franklin Gothic by studioGossett
Text translated from the Italian by Stella Craigie, Christopher Adams and Susan Wise
Edited by Julian Honer

Printed and bound in Italy

CONTENTS

6 ACKNOWLEDGEMENTS

7 PREFACE

9 FUTURISM AND PHOTOGRAPHY

13 THE IMAGE OF SELF

21 PHOTODYNAMISM

33 PHOTO-PERFORMANCE

49 THE TWENTIES

73 THE THIRTIES

91 NOTES

137 BIOGRAPHIES

151 WORKS IN THE EXHIBITION

156 BIBLIOGRAPHY

ACKNOWLEDGEMENTS

The Estorick Collection and Professor Giovanni Lista would like to thank the following organizations and individuals whose contribution has made this book and the exhibition *Futurism and Photography* possible.

Pierre Apraxine, Gilman Paper Company, New York

Laura Argento, Archivi Cineteca Nazionale, Rome

Lutz Becker

Marion Beckers, Das Verborgene Museum, Berlin-Charlottenburg

Dott.sa Gabriella Belli, Direttrice, MART, Trento and Rovereto

Prof.sa Francesca Bernardini, Archivio del Novecento, Università "La Sapienza", Rome

Dott.sa Laura Biancini, Biblioteca Nazionale Centrale, Rome

Antonella Vigliani Bragaglia

Angelo Calmarini

Mariangela Calubini, Fondazione 'Il Vittoriale degli Italiani', Gardone Riviera

Dott.sa Daniella Camilli, Archivi Alinari, Florence

Cont.sa Maria Fede Caproni Armani, Rome

Dott. Sergio Cereda

Maria Teresa Contini

Gianluca Corradi, Biblioteca Nazionale Centrale, Florence

Matteo D'Ambrosio

Colonnello Nicola Della Volpe, Stato Maggiore dell'Esercito, Rome

Angelina Di Vito, Ambasciata d'Italia, Asmara

Dott. Massimo Duranti

Franco Filippini

Dott. Stefano Fittipaldi, Archivio Parisio, Naples

Dott.sa Manuela La Cauza, Fondazione Primo Conti, Fiesole

Dr Hans-Ulrich Lehmann, Staatliche Kunstsammlungen, Dresden

Anne Lyden, Department of Photographs, The John Paul Getty Museum, Los Angeles

Dott.sa Monica Maffioli, Curator, Museo della Storia della Fotografia, Fratelli Alinari, Florence

Signora Franca Malabotta

Ferruccio Malandrini

Carlo Mansuino, Biblioteca Nazionale Centrale, Florence

Sig. Gianni Manzo

Laura Mattioli

Véronique Mattiussi, Bibliothèque, Musée Rodin, Paris

Museo Aeronautico Gianni Caproni, Trento

Marina Miraglia

Sig. Luca Pedrotti, Fotostudio Pedrotti, Bolzano

Dott. Paolo Perrone, Archivio Alberto Viviani, Milan

Massimo Prampolini

Dott.sa Maria Luisa Polichetti, Istituto Centrale per il Catalogo e La Documentazione, Rome

Maresciallo Gerardo Severino, Museo Storico della Guardia di Finanza, Rome

Dott.sa Luciana Spina, Biblioteca, Museo Nazionale del Cinema e della Fotografia, Turin

Dott. Leonardo Tiberi, Istituto L.U.C.E., Rome

Dott. Michele Vacchiano, Biblioteca Civica, Turin

Susan Wise

PREFACE

The Estorick Collection provides the perfect context for an exhibition of Futurism and photography. Since opening its doors to the public in January 1998, the collection, internationally known for its core of Futurist paintings and drawings, has proved an invaluable resource for the study of Italian Futurism in Britain. Alongside the collection, a programme of temporary exhibitions has explored the diversity of Futurist practice, as well as looking at twentieth-century Italian artists and their relationships with other modernist avant gardes.

The exhibition and book of Futurism and Photography is our most ambitious project to date, bringing together diverse forms of expression and experimentation by Italian photographers and artists from 1911 to 1939. The Futurists' relationship with photography was by no means straightforward; they used it to document their many activities, to promote their leading personalities, as an aid to painting and to express complex theoretical ideas. Anton Giulio Bragaglia's publication on photodynamism (*Fotodinamismo Futurista*, 1913) broke new ground in photographic history. The photodynamic technique created highly atmospheric, instantaneous, almost transparent images of motion in a single photographic frame. These photographs were visual proof of what the Futurists had proposed in their technical painting manifesto of 1910: "moving objects constantly multiply themselves; their form changes like rapid vibrations ...". A world of possibilities opened, only to be marred by Boccioni's critical stance against photodynamism. It was not until the 1920s that photography assumed a leading role within Futurism once more, with a range of techniques from photomontage and photocollage being employed. The Manifesto of Futurist Photography was published in 1930, written by F.T. Marinetti and Tato, the latter one of the major exponents of the new wave who both appropriated forms from the Surrealist and Dada movements and led with vital new directions of his own.

This area of Futurist research has been a well-kept secret from the English-speaking world and we are indebted to Professor Giovanni Lista for sharing his extensive knowledge of the subject through the exhibition itself and this related publication. Although Futurist photographs have now found their way into important archives throughout the world, works in the exhibition have come exclusively from Italian public and private collections, and our gratitude goes to those who have supported this project so enthusiastically.

Alexandra Noble
Director, Estorick Collection

FUTURISM & PHOTOGRAPHY

FUTURISM AND PHOTOGRAPHY

Studio Ottolenghi ◆ *Depero and Marinetti wearing Depero's Futurist waistcoats, with Marchesi, Fillia and Cangiullo in Turin* ◆ 1925 ◆ detail; see p. 47

FUTURISM'S POSITIVE ideology of urban modernism and technological progress heralded the involvement of art in a new sensibility to the visual dimension, which derived from the most recent scientific experiments. Art was called upon to become an instrument of knowledge at the service of the forces of progress, whose integration into society was actively promoted by the Futurists. Consequently, Futurist artists took on the task of stimulating this process of adaptation by translating into lyrical values, as novel as they were to be persuasive, the new iconographic culture that experimental sciences were developing. In this process the plastic arts of Futurism became involved in a secret dialogue with photography, but above all with scientific photography in which experiments attempted to harness the laws of movement and vital energy beyond the more banal phenomenal manifestations of reality.

In the early twentieth century there were two journals in Italy that provided a vehicle for the dissemination of the most innovative technical processes achieved in photography. The first of these was *Il Dilettante di fotografia*, founded in 1890 in Milan by Luigi Gioppi, followed in 1894 by *Il Progresso fotografico*, also based in Milan and founded by Rodolfo Namias, with a stronger professional and cultural commitment. Both journals published many articles on scientific photography, dealing with such issues as "the latent image revealed by Roentgen rays", the photography of sound, Mach's dynamography, microphotography, optical distortions and Marey's chronophotography. There were also articles on parascientific experiments, such as the "photography of thought" by Baraduc and Darget, ectoplasmic images and spiritualistic photography, in addition to highly imaginative research that aimed to violate any realistic conception of reality by resorting to processes including the "multiportrait", double exposure, and montage of several negatives to reveal the psychic content of the observed image. During these years, Marey carried out many of his chronophotographical experiments in a villa near Naples. A Neapolitan sculptor would make Marey's kinematic sculptures, while the Faculty of Physiology at the University of Turin directed by Angelo Mosso and Arnoldo Foà would disseminate his research. Chronophotography was as well known in Italy as in France. Even before Futurism was conceived, chronophotographical repetitions of a form to render the idea of movement were present in the painting of Boldini and in the caricatures of Cappiello. Moreover, the poetics of dynamism naturally led Boccioni, Carrà, Russolo, Balla and Severini to consider scientific photography as a possible matrix for the formal instruments of Futurist art.

By translating the infrasensorial and metaperceptive dimensions for the first time, by transfixing the transience or invisibility of the interaction between matter and energy, thereby revealing the unconscious dimension of the gaze, photography seemed to penetrate the very mystery of life. In effect, it created a new visual code, a system of signs for which Futurism intended to provide an aesthetic interpretation in line with the rhythms of the modern world and the cadences of endless cycles that cause the continual mutation of everything. Boccioni believed that, in this way, Futurist art would express "universal dynamism" by giving material form to its paradigmatic values of *kinesis* and *dynamis*, that is to say, kinetics and energy, which he defined as "relative movement" and "absolute movement". Scientific and experimental photography, then, was bound to become an iconographic model for Futurism. The photographic formalizing analyses of life as it happens inspired the new vocabulary of Futurist "pictorial dynamism".

However, the conceptual approach of the Futurist artist to photography as a language was totally different. Though the photographic image was one of the cultural products of the technological innovations hailed by Futurism, it appeared as the petrification of life, or as actually the very negation of the sensation of life that Futurist art intended to express with explosive and lyrical flourish in order to educate society in the values of modernism. In an obscure way, photography was accused of arbitrarily stopping time and destroying the energetic dimension of the act, thus consigning the vital moment to an immutable and immobile representation of something that no longer is. Realist photography, especially the photographical experiments by writers of the Verismo movement, such as Luigi Capuana and Giovanni Verga, proposed a passive recording of reality that was subject to anthropological and social determinism, and by so doing confirmed that photography was the antithesis of what Futurist art wanted to be. At a more complex level, the Futurist artist intuitively understood that photography was a medium that was ontologically hostile to any dynamic perception of reality as absolute 'becoming', as a live magnetic field, a dimension in which anything was possible, a virtual and infinite space for creative freedom. For the Futurists, the image as *rigor mortis*, and the mortification of the life-breath, is inherent in photography. This is a problem that appears as an undercurrent in all Futurist portraits, first leading to emblematic photography, to be finally resolved by a total reversal in the photo-performances of the movement's early years.

This explains why Futurism could not immediately accept photography as art. In Italy, the debate about the aesthetic promotion of photography arose between 1880 and 1900. A relatively

left to right

Scipio Sighele ◆ (left to right) *The French journalist Carrère, the politician and writer Enrico Enrico Corradini and the journalist Castellini at Bu-Meliana, in Libya* ◆ 1911 ◆ detail; see p. 15

Gustavo Bonaventura ◆ *Photodynamic portrait of Anton Giulio Bragaglia* ◆ 1912/13 ◆ detail; see p. 29

Fortunato Depero ◆ *Self-portrait: Depero plays hide and seek, Rome, 1916* ◆ 1916 ◆ detail; see p. 45

Giorgio Riccardo Carmelich ◆ *Photographic composition* ◆ c. 1928 ◆ detail; see p. 69

Bruno Munari ◆ *Nothing is absurd to those who fly* ◆ 1939 ◆ detail; see p. 114

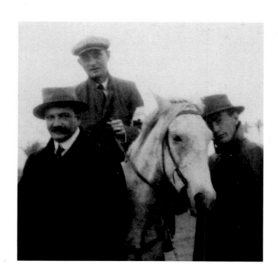

successful exhibition of artistic photography was held in Florence in 1895. The first National Photographic Congress took place in Turin in 1898 and a second congress was organized in Florence the following year, leading to a wide dissemination of pictorial photography. Pictorialism, with its correlations of technical virtuosity aiming to provide the image with a spiritual dimension, intended to create photography as art, but instead did nothing but realign it on the various *fin-de-siècle* styles of painting: social exoticism, intimism, Japonisme, Symbolism and decadent sentimentalism. Other trends in Italian photography, ranging from Giuseppe Primoli's social investigation to Wilhelm Von Gloeden's incredible "scenes and compositions of ancient times", enlivened the debate on photography as art, which, however – in a cultural environment heavily influenced by Gabriele D'Annunzio's literature – was still ruled by pictorialism. At the dawn of the new century, Guido Rey and Edoardo Di Sambuy were among the Italian photographers who had gained an international following, leading to contacts being established with Alfred Stieglitz. In 1904 the international journal *La Fotografia artistica* was founded in Turin by Annibale Cominetti, intended as the official mouthpiece of Italian pictorial photography. The debate on whether photography was art was to last until about 1910, though it regained momentum in 1911 on the occasion of the Third National Photographic Congress held in Rome, which was accompanied by a large International Photographic Exhibition. This two-fold event, rekindling the debate on photography as an art form, actually signified the dawning in 1911 of a new historical period, marked by the crisis in pictorialism and the advent of Futurist photodynamism – that is to say, the birth of Italian avant-garde photography.

Photodynamism was the most distinctive expression of Italian Futurism in photography. It reflected the aesthetic premisses of Futurism, opposing both art from the past and more recent formal experiments by other European avant-garde movements, such as Cubism. Similarly, photo-performance embodied the collusion between art and life that was at the very heart of the revolutionary manifesto of Futurism. However, any discussion of these two specific trends in Futurist photography also needs to include portrait photography, a genre that was widely practised by the Futurists during those years. Research in this field extended as far as the expressive medium of symbolic photography. The secret and contradictory links between Futurism and photography are evident here, casting light on all the factors that conditioned the Futurist artist's behaviour in front of the lens.

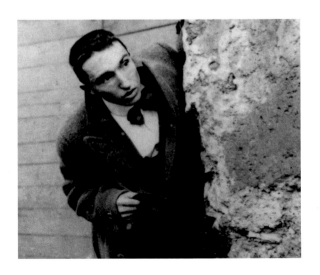

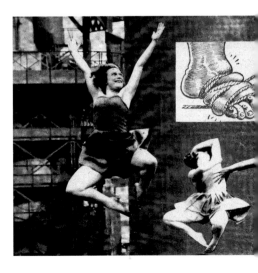

THE IMAGE OF SELF

Umberto Boccioni ◆ *I-We* ◆ 1905–07
◆ detail; see p. 18

THE FUTURISTS WIDELY used photography to disseminate their image, to send a message or just to make their presence felt in Italian cultural circles. By displaying their single and group portraits they showed that they understood that the birth of a cultural industry was nigh and that their militancy in revitalizing culture and art should also extend to the image. The last of the Symbolists sent their portraits by post to their correspondents, but this was with a view merely to conducting a more intimate exchange with their interlocutors. On the other hand, the Futurists wanted their portraits to appear in the press and be published in the most important newspapers of the time for reasons of propaganda, so they could send an official, carefully concocted and provocative message to the public. However, it was precisely this conscious desire to show themselves in an emblematic light and the symbolic use of their own images as a statement of their rejection of bourgeois conformism that immediately caused a serious rift to develop between the Futurists and photography. By manipulating reality, the photographic image would never be able to capture the fundamental essence of life. Its immediacy would always be accompanied by a sensation of distance and an idea of the past. Thus, to the Futurists, the camera projected the gaze of the Medusa, a death shot that turned all to stone.

So the conflictual relationship between the Futurists and photography centres on the figure of the artist as both subject and object of the image. Since the Futurists belonged to a generation that had discovered photography through the portrait taken in a photographer's studio, they had some difficulty in adapting to the language of the instantaneous exposure, though this seemed to be the most successful means of capturing that vital energy that all Futurist art aspired to. Photography in the studio provided plenty of opportunity for taste and culture to act as a filter, as the process was lengthy and complex. Similarly, in the deliberately bizarre or grotesque theatricality of the *tableau vivant* the model had to stay in pose and was also fully aware of the presence of the other person, namely the creator of the image. The capturing of reality always occurred by subterfuge and proxy, since the model willingly represented himself, at the same time identifying with the eye of the photographer, who was never an anonymous presence. The instantaneous exposure, on the other hand, by drastically reducing the distance that preserved the desired image of the sitter, upset the balance between perception and reality. This is

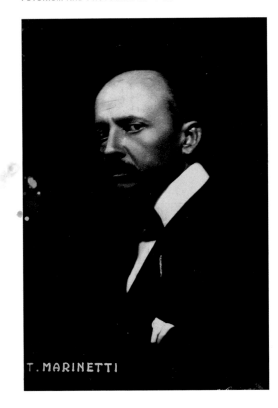

Studio Caminada ◆ *Portrait of F.T. Marinetti*
◆ 1909, printed postcard, 13 x 8.2 cm ◆
private collection

Mario Nunes Vais ◆ *Portrait of Carlo D. Carrà* ◆
1913, gelatin silver print from original glass plate,
24 x 18 cm ◆ Fondo Nunes Vais, Museo/Archivio di
Fotografia Storica, Rome

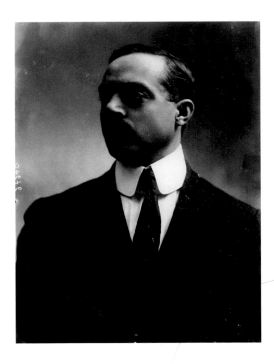

particularly true of the portraits of Marinetti, the oldest of the Futurists, which show how traumatic the experience of a snapshot could be for a man of his generation.

In the years preceding the foundation of the Futurist movement, Marinetti loved to have his photograph taken in bold, casual and youthful poses, producing images of himself that were coquettish, ironical and really alive, in the sense that they revealed the mobility of the sitter and his desire to appear as a young poet caught between passion and inspiration. This disenchanted vanity disappeared after 1909, the year when Marinetti felt it incumbent upon himself to assume the role of founder of the Futurist movement. From then on, as the sitter, he rarely seems to have a relaxed attitude in front of the camera, usually forcing himself to adopt the pose one might expect of the heroic avant-garde artist. Consequently, his poses are usually defensive, frowning, with arms folded, as he glares defiantly at the lens, revealing his revolutionary engagement with Futurism against the inquisitorial gaze of the camera-as-Father.

A man of action, Marinetti gave in to the rituals of the new photojournalism when, as correspondent for the French newspaper *L'Intransigeant,* he posed in a group with other war correspondents on the Libyan front. Marinetti, though, was used to the slow ritual of the studio photograph, which enabled him to decide in his own time how he wished to appear, so he experienced difficulties when the photographer intruded on his privacy and the situation was impromptu. When caught on camera coming out of the theatre or attending Futurists' events, he often seems stiff and rebellious as if the lens were actually his father's gaze. In his resistance to the penetrating gaze of the camera, Marinetti clearly felt the need to censure every image of himself that was too human in a *passéiste* sense, and therefore capable of contradicting the heroic and revolutionary myth of the avant garde. Thus, the founder of Futurism set great store by the emblematic value of the photographic image. If he could deprive it of every insight into the intimate and the private, if he could pay careful attention to gesture, pose and gaze in the photograph and could fashion being with respect to appearing, he would escape from the inevitable power of falsification that the lens always holds over reality, transforming a living being into a static and immutable 'pillar of salt'. His total lack of confidence in photography as a medium capable of translating the variety and essence of life "as it happens" was to undermine the entire relationship between Futurism and the photographic image.

Early evidence of Boccioni's interest in photography, which also concerns the issue of photography as a codified expression of reality, can be seen in a "self-multiportrait" of the artist made between 1905 and 1907, when he was living in Venice. The itinerant photographers of the time who worked at the fairs and amusement parks made portraits that were composed of "multiple photographs achieved by the use of mirrors placed at an angle behind the sitter". A decade later, other avant-garde artists would pose for this kind of photograph. Duchamp, Picabia and Witkiewicz, for example, all composed very similar self-multiportraits. Basically, this method of photography consisted of a multiplication of images of the subject, a technique used in famous paintings such as Lorenzo Lotto's *Triplo ritratto di orefice* (Triple portrait of a goldsmith) and Van Dyck's *Ritratto di Carlo I in tre posizioni* (Portrait of Charles I in three positions). However, Boccioni was apparently the first of the Futurist artists to explore his own identity in this way, through a stratagem that used the photographic medium by reversing its technical function. Technically speaking, photography is an instrument that captures reality unambiguously, translates the plurality of being into a single image and dispels the Ego through the image of the body, which is nothing but its shell. But in this case, by escaping the realist logic of reality, photography is forced to multiply the body in order to render the multiplicity of being. Boccioni's written annotations show exactly how he interpreted his multiportrait. As in paintings by Carus and Friedrich, the central figure with his back turned subjectively engages the observer, making him identify with the conscious gaze, while the other figures reflect the plurality of the social Ego, namely the diverse and changeable traits we exhibit in relational situations. By signing the photograph, Boccioni showed that he considered it a work of art, identifying with the theme of the

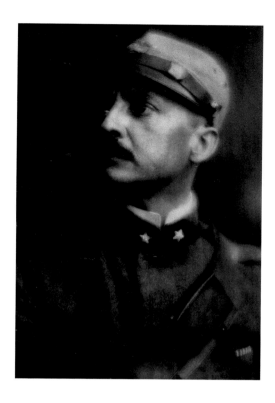

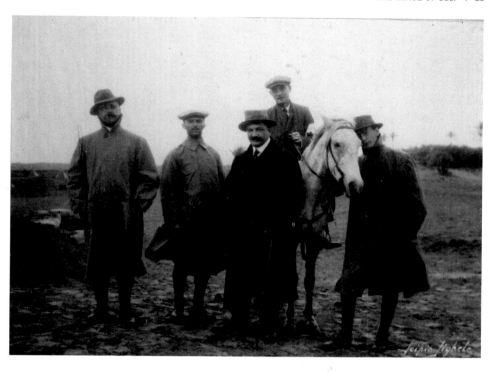

Mario Nunes Vais ◆ *Marinetti as a soldier* ◆ 1916,
17.2 x 11.7 cm ◆ Museo di Storia della Fotografia
Fratelli Alinari, Nunes Vais Archive, Florence

Scipio Sighele ◆ (left to right) *Marinetti, the
journalist Ezio Gray, the French journalist Carrère,
the politician and writer Enrico Enrico Corradini and
the journalist Castellini at Bu-Meliana, in Libya* ◆
1911, bromide print, 17 x 23 cm ◆ Malandrini
Collection, Florence

simultaneity and mythology of the Ego and the Doppelgänger, which runs through all Futurist work.

The Futurists posed in the studios of professional photographers who were popular with the bourgeoisie such as Badodi, Caminada and Sommariva in Milan, Nunes Vais in Florence and Ottolenghi in Turin, for official portraits as exponents of the movement. These portraits were also published in postcard format and were issued and distributed on many occasions. The use of photography to document events and specific moments in Futurist activity was also widespread. In addition to photographs in which the subjects were Futurists, namely those images in which Marinetti's followers supplied a self-presentation of themselves, there were also many other images taken on official occasions, such as inaugurations, private views of exhibitions, plays and entertainment directly linked to Futurism. The natural consequence of the Futurist doctrine of art as life and action was 'reportage' used by the Futurists as propaganda for the avant garde.

In their single portraits the Futurists only gradually managed to shake off the canons of bourgeois photography: the staring immobility of the passport photograph, the banal pictorialist use of out of focus, the *passéiste* quietism of the round or oval format, the neutral expressionless gaze of the subject taken in frontal, profile or three-quarter poses. The character traits and moods of the subjects, however, shine through in many cases: the portrait gallery of Futurists shows Buzzi's candid disarming smile, Papini's philosophical frown, Carli's air of post-D'Annunzian cynicism, Carrà's schoolmaster appearance, Soffici's thoughtful studied poses, Depero's amused air and Boccioni's pensive, determined, gritty stare. The brand new social figure of the avant-garde artist was finding it difficult to invent its own visual code out of the ruins of the Romantic stereotype of the man of letters, poet and painter, captured in a subjectivism that isolated him from the rest of the world.

The various temperaments were accompanied by different attitudes adopted by the artists when they were photographed in their studios among the tools of their trade, where the positioning of objects served to convey the symbolic power of the portrait. Posing in his studio next to one of his sculptures, Boccioni constructs an image in diptych. The shape of a door and the outlines of the canvases piled up against a wall create a geometrical structuring of the space and give a symbolic dimension to the way the sculpture looms over the artist. In Arturo

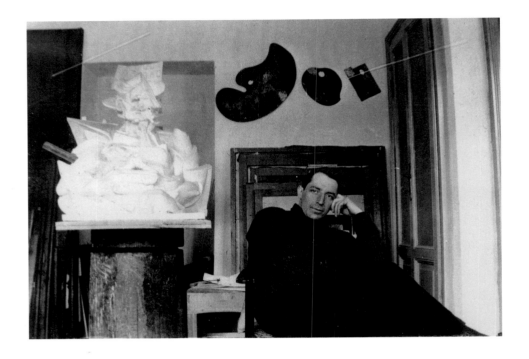

Anon. ◆ *Boccioni in his studio, in front of the sculpture 'Head+House+Light'* ◆ 1913, gelatin silver print, 6 x 8.5 cm ◆ Calmarini Collection, Milan

Bragaglia's portrait of the writer Giannetto Bisi, on the other hand, the subject chooses to visualize the metaphor of the cornerstone that gives rise to the dilemmas of creation between new and old, Futurism and *passéisme*. The image is dynamically formed on a diagonal axis representing the equilibrium of thought, while the hand with the raised index finger grazing the stone suggests the continuity of dialectics between reality and the inner world, between matter and the spirit. In its expressive vocation, it is only through the symbolic image that Futurism seemed able to engage in a peaceful relationship with photography.

Other sub-genres, in addition to studio photography, were portraits in uniform or group photographs, but it would be unwise to draw any ideological conclusions from Marinetti's proud virile pose in uniform in the photograph taken when on leave from the Front for a few days. Such portraits were a traditional feature of iconography at the time, and Picasso, Kirchner, Apollinaire, Cendrars and many other avant-garde artists also had photographs taken in uniform. However, Marinetti clearly wanted to express something more here than the existential episode of the First World War. His attitude seems to express his patriotism in an ingenuous and inspired manner, the same patriotic faith that had led him to found the Futurist movement, and today this photograph assumes the significance of a historical record of the sentiments of a generation educated in the ideals of the Italian Risorgimento. It does not seem likely, though, that there were other precedents for group photography sessions of avant-garde artists. A group portrait was taken by Nunes Vais in 1913 to mark the collaboration between the Florentine group *Lacerba* and the Milanese leadership of the Futurist movement. Standing in a line facing the front, positioned quite differently to the images of artists gathered at supper that were common in Romantic, Realist and Symbolist works, the Futurists started a tradition that was to be continued in the famous *photos de famille* of the Surrealists. The image, which possesses the extraordinary eloquence of a manifesto, equates to a peremptory assertion of the group's existence. Shoulder to shoulder like a group of soldiers, despite the *hauteur* and elegance of their bourgeois background, the Futurists seem to be guided by a common aspiration and possessed of the certainty of their convictions. The symbolic nature of the photograph leaves no doubt: the group militancy of the avant-garde was born with Futurism, in the form of an activist strategy through which art was determined to tackle life head-on in order to renew it.

Arturo Bragaglia ◆ *The writer Giannetto Bisi*
◆ 1919, gelatin silver print, 21.5 x 17 cm ◆
Calmarini Collection, Milan

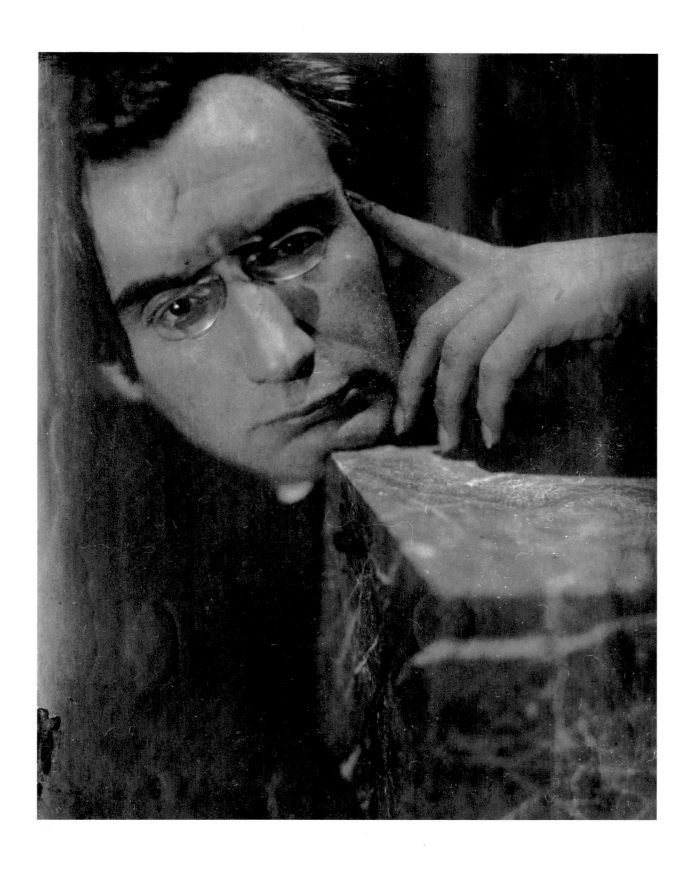

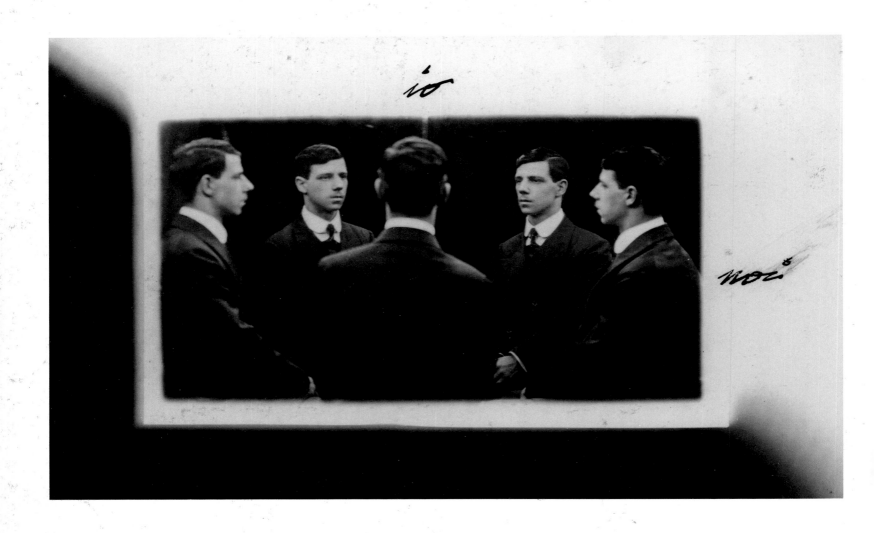

Umberto Boccioni ◆ *I-We* ◆
1905–07, gelatin silver
print, 9 x 13.5 cm ◆
Calmarini Collection, Milan

Mario Nunes Vais ◆ *The Futurist group: Palazzaeschi, Papini,
Marinetti, Carrà, Boccioni* ◆ 1913, gelatin silver print from
original glass plate, 24 x 18 cm ◆ Fondo Nunes Vais,
Museo/Archivio di Fotografia Storica, Rome

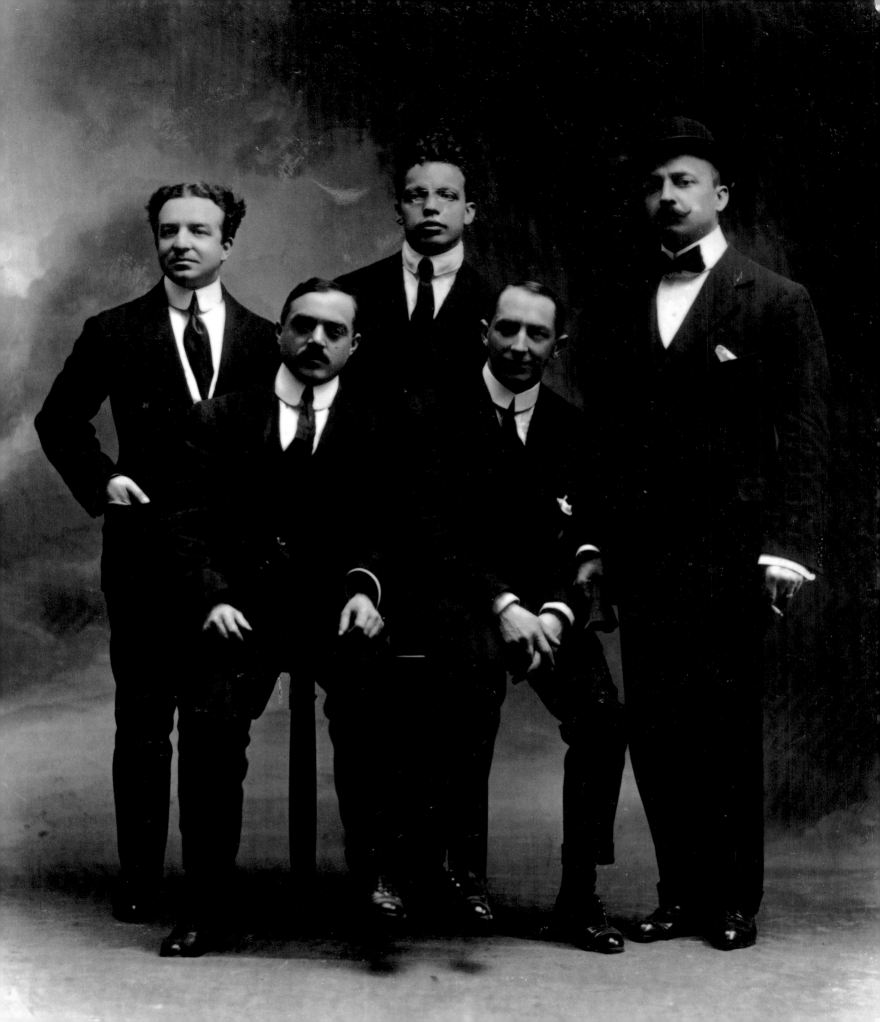

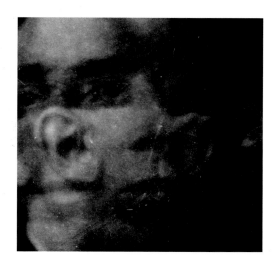

PHOTODYNAMISM

Anton Giulio and Arturo Bragaglia ◆

Polyphysiognomical portrait of Boccioni ◆ 1913

◆ detail; see p. 30

AN EXCEPTIONAL **SET** of circumstances led to the creation of photodynamism, a term used by Anton Giulio Bragaglia to define the photographs of movement that he made from 1911 with his brother Arturo and exhibited at conferences and personal shows of work in that year. Photodynamism – which followed on from Marinetti's "free-verse dynamism", Boccioni's "pictorial dynamism" and Pratella's "musical dynamism" – was the first Futurist expression of photography as art. Anton Giulio Bragaglia's great interest in photography and cinema was inspired by his visits to Cines, the first important Roman cinema studios. According to Anton Giulio, his younger brother Arturo "was my cameraman in Futurist photodynamic photography, cinema's rival offshoot, and was interested in the technical side of this art. The cinema has always figured large in both our lives as from 1909 our father was general manager of Cines. My brother Arturo acquired his skill in photography at the Cines plant, which produced film cameras and carried out processing and printing."[1] Lively and intelligent, Anton Giulio had an intellectual temperament while his brother was essentially a pragmatist. The creation of photodynamism was the brainchild of the two brothers, who were both amateur photographers with some experience of the cinema. Anton Giulio is credited with the aesthetic theories that inspired the creation of this novel expression of photography of movement, while Arturo was responsible for the actual production of the images of this new Futurist art form.

The circumstances that encouraged this new Futurist research date back to March 1911, when the fiftieth anniversary of Italian unity was celebrated with important exhibitions, festivals, congresses and cultural events in Rome, Turin, Florence and other Italian cities. The complex cultural terrain that gave rise to the experiments with photodynamism was reflected in these events, and they greatly interested the Bragaglia brothers. For the commemoration of the fiftieth anniversary of the proclamation of the Kingdom of Italy an International Exhibition of Fine Arts was organized in Rome with works by the French Impressionists and exhibits by Medardo Rosso and Rodin. An important sculpture in this exhibition was Rodin's *L'Homme qui marche*, which he wrote about in the context of the "representation of movement in art" in a chapter of his book *L'Art, entretiens réunis par Paul Gsell*, published in the same year. This chapter, which had previously been published in French and Italian periodicals[2] in 1910, became the subject of debate once more when Rodin visited Rome after the exhibition and the famous statue was erected in his

Anton Giulio Bragaglia ◆ *Self-Portrait* ◆ *c.* 1914, postcard, 15 x 10 cm ◆ Malandrini Collection, Florence

honour in the court of the Palazzo Farnese. Again in Rome, from 24 to 30 April, the Third Italian Photographic Congress was held with two linked displays – an International Photographic Exhibition, which validated the retrospective triumph of pictorial photography, and an International Competition of Scientific Photography, a forum for the discussion of Marey's chronophotography and experimental work. In the same month, April 1911, an International Philosophy Congress was held in Bologna attended by Bergson, who came to air his ideas on "philosophical intuition", a subject that sparked widespread debate among Italian intellectuals. In preparation for this event, the book *La Filosofia dell'intuizione* had been reprinted in early 1911, an anthology of texts written by Bergson, and selected and edited by Papini in 1909. Finally, on 29 May Boccioni gave a talk on Futurist painting at the Circolo Artistico Internazionale in Rome, during which he defined "pictorial dynamism" as "physical transcendentalism" for the first time. Boccioni claimed that dynamic sensation should be expressed by avoiding the formal representation of elements from the outside world, justifying his position with the words: "for the conditions of speed in which we live the continual rush of objects around us gives them an infinite fluidity so that they exist only as luminous entities".[3]

This talk by Boccioni certainly sparked off Anton Giulio Bragaglia's notion of photodynamism, which he called "transcendental photography of movement". While contesting Marey's chronophotography, he immersed himself in the study of the photography of movement, based on the trajectory of the movement of a body through space, rather than on the analysis of the body's kinetic phases as in Marey's images. Anton Giulio's research on photodynamism is recorded from 8 July 1911, the day he sent a photodynamic image entitled *Salutando* (Nodding) from his home town of Frosinone, showing the bust and head of a man leaning forward, as if nodding his head. Photodynamism was the first modern revolution in photography, and it began to be disseminated by means of postcards. This choice of form underlined the basic precept of Futurism, namely the rejection of museums and the conception of art as communication within society. These sepia photodynamic images contained what were to be the typical features of the brothers' work: the representation of a sudden gesture as opposed to the continuous linear movement that interested Marey, and the transience of form, which conveyed the impetus and immediacy of the kinetic episode. Marey photographed the complete cycle of a movement in order to capture the physiological mechanics of the process, while the Bragaglia brothers photographed only a gesture, which was often instinctive. Since this movement was brusque and voluntary, the photograph seemed intent on capturing the psychic drive behind the action.

Technically speaking, photodynamism was born as a process in which photographs are overexposed. However, the brothers immediately realized that movement as such cannot be photographed, because "it is impossible to impress the movement on to the plate".[4] To overcome this problem the first photodynamic images were obtained using three lamps to flood the subject in movement with bright light, thereby isolating the trajectory in space. This research was conducted following all the canons of experimental work. Reality is not captured in its extempore manifestation, namely when the act actually takes place, but used only as an object of study, or as a finding for laboratory tests. The way the Bragaglia brothers worked has much in common with scientific research – studio shots, black background, a model willing to undergo the experiment, the gesture reconstructed in front of the camera, the movement placed at right angles to the focal axis of the lens. The dematerialization of bodies produced by the movement and light, expounded in the *Manifesto tecnico della pittura futurista* (Technical manifesto of Futurist painting) is thus tested photographically, and it is here that Anton Giulio immediately competes with Boccioni, because, as he wrote later, he wanted to give "'movementist' painting and sculpture the solid foundations that are so necessary today".[5]

Some months later, between September and October 1911, Anton Giulio gave his first lectures on photodynamism, accompanied by an exhibition of photodynamic images. He then became the editor-in-chief of the fortnightly paper *L'Artista*, the bulletin of a Roman theatrical agency. He

Anton Giulio and Arturo Bragaglia ◆ *Typist* ◆
1913, postcard, 9 x 14 cm ◆ Malandrini Collection, Florence

Dattilografa.

Fotodinamica Futurista :: :: ::
di Anton Giulio e Arturo Bragaglia.

transformed this into a monthly paper and in December announced in it the publication of the text of his lecture on "photodynamism". However, the paper folded immediately afterwards, and the book was almost certainly never published. The Bragaglia brothers, who had every intention of making their research more widely known, still lacked the necessary financial resources. In early 1912, after making friends with the photographer Gustavo Bonaventura, Anton Giulio wrote a series of articles for the periodical *La Fotografia artistica*, published in Turin, in which he analysed the aesthetic categories of photographic art and was highly critical of "realism", an intrinisic property of the lens since the dawn of photography. He felt that the photographic image could be elevated to an art form only by refusing to be a mere photograph: "What I mean is that such images, by passing through our consciousness, become refined and elevated, following the specific needs of art: in fact, it is precisely because of their removal from reality that they belong to art".[6] Meanwhile, in July 1912, in a long article published in this journal, Giovanni Di Jorio announced that the Bragaglia brothers were continuing with their research on photodynamism and producing images that were "strange and bizarre", sometimes even "monstrous", which revealed "life seized in its rapid and fleeting manifestations".[7] The photodynamic images of this period, such as *La Mano in movimento* (Hand in motion) and *Cambiamento di posizione* (Changing position), contain luminous trails that capture the subject at the point of complete dissolution of form. These are images in which the dynamics of the gesture are represented in a dimension of absolute "vitalism", as if the lens had grasped the immanence of the gesture that transcends matter. From the end of the nineteenth century photography had been accused of stopping time and of "killing off" reality; it had reacted by attempting to idealize form to achieve a sort of spiritual vision of the world of sensations through a pictorial aesthetic. On the contrary, in the Bragaglias' photodynamism the lens succeeded for the first time in tearing off the mask of objective reality, namely the outer appearances of the world that can be represented in a banal fashion in their natural forms. It was then, and only then, that the great creative adventure of the avant garde could begin.

Contacts between the Bragaglia brothers and certain exponents of the Roman Futurist group, such as Folgore and Altomare, were not established until mid-1912. In December that year Anton Giulio met Marinetti, who decided to finance photodynamic research. In January 1913 several articles in the press announced that photodynamism would officially be launched very shortly, on

the occasion of an exhibition of Futurist painting in the capital. At the request of Anton Giulio, the journalists published extracts from the lecture that he had delivered at the first exhibitions of photodynamism. With the intention of publishing it, Anton Giulio revised the text of the lecture, adding to it some considerations on the pictorial experiments of Balla. However, Marinetti hesitated to publish the book. In fact Boccioni, who aspired to the role of ideologist and leader of the Futurist group, decided not to include the Bragaglias' photodynamic images in the collective exhibition of Futurist work that opened on 21 February in the foyer of the Teatro Costanzi in Rome. This was not a rejection as such, since Boccioni's intention was merely to keep a certain distance between photography and painting. On 9 March, at Marinetti's invitation, Anton Giulio played a part in the "Futurist Evening" held at the Teatro Costanzi, where he threw leaflets from the gallery.[8] This was followed by a visit to the Bragaglia brothers by Russolo, Pratella, Balla and Folgore, with discussions and poses for portraits and photodynamic images.

Soon afterwards, Boccioni sent his "polyphysiognomic portrait" taken by the Bragaglias to Giannetto Bisi for publication in the magazine *Emporium* in Bergamo, with photographs of his sculptures.[9] This photodynamic image, which was never published, probably at Boccioni's request, revealed the new technique used by the brothers in their photodynamism. As in the "polyphysiognomic portrait" of the poet Folgore, made at the same time, the artist's face appears in the foreground, multiplied by a rotating movement. The anatomical details are captured using a rhythmic scansion that is part of a fluid, sweeping continuity. The models' movement are staccato and unnatural. In fact, as Anton Giulio was to write, the photodynamic images from the second phase of research "are not only *moved*, they are *made to move*".[10] On another occasion, he was more categorical, stating that the photodynamic image had started out "from a kind of faulty, blurred photograph that then achieved movement through the paroxysm of disciplining the error, which we guided and fostered".[11] The technique used was formally to construct the image – no longer to capture it, but to *organize* the progression of the gesture through a succession of juxtaposed planes, which were to merge with one another seamlessly, so as to convey the movement itself and also what happened during the movement. In this way the image seizes the to-and-fro movement between decomposition and reunification of the form. By avoiding Marey's doubling, the photodynamic image seems caught between the disappearance of the form and its dematerialized multiplication. The Bragaglia brothers found that the solution provided by this new photographic technique avoided breaking up the form into different individual planes, so it was able to convey both the unity of the gesture and the idea of transition by means of fluidity to create a new dynamic form. In this method the photodynamic image transcends the mechanical determinism implicit in photography and becomes an artefact, an accomplished work of art, despite its contamination by technology.

Another photograph taken by the Bragaglias at this time is a "dynamic" photograph of Balla, who is turning round to look at his painting: *Dinamismo di un cane al guinzaglio* (Dynamism of a dog on a lead), which was published in the journal *Humanitas* the following April. The image is imbued with significance, since it makes a fairly overt reference to the experimental basis on which photodynamism was founded, namely that photography could be elevated to an art form insofar as it confirms and goes beyond a certain kind of analytical painting of movement. As Anton Giulio was to write later on, "the technical research into *movementism* now rendered pictorial studies useless, though Giacomo Balla was producing pictures of this type at the time, which were very interesting".[12] Although Boccioni had approved of the experience of photodynamism as an expression of Futurist art in photography, he must have been somewhat perplexed by an image of this kind. As a theoretician of "pictorial dynamism" seen as a comprehensive representation of the values of energy and movement, Boccioni already showed scepticism towards Balla's studies of movement, which looked as though they might become the representative canon of Futurist painting owing to their ease of interpretation. Photodynamism now seemed to reflect this trend, and in the same period the discovery of Cubism and the subsequent assimilation of its processes

of breaking down the objective components of reality would profoundly influence the theoretical and creative orientation of Futurist art. Within a few months Boccioni was already directly challenging Léger and Delaunay, postulating the evolution from "pictorial dynamism" to "plastic dynamism", and assuming a new theoretical position that would eventually lead to condemnation of the Bragaglias' photodynamism.

Meanwhile, enthusiasm combined with the progress made by research into photodynamism encouraged Anton Giulio to consider himself the official spokesman of the Futurist aesthetic, a move that was to antagonize Boccioni even further. On 24 March 1913 Anton Giulio opened a one-man show at the Galleria Romagna of thirty photodynamic images. On sending Pratella the portraits he had made shortly before, he announced, "Now my show is open. It's a great success. All the articles I'm writing and I'm being asked to write are making me very tired. I'm about to give a lecture in Rome, another in Naples (at the Teatro Fiorentino) and many others in the Abruzzo and in Sicily. All accompanied by displays of photodynamics."[13] Soon afterwards, he published the manifesto *La Fotografia del movimento* (The photography of movement) and gave a lecture at the Sala Pichetti, which Marinetti attended. He wrote more and more articles and theoretical essays, which he sent to newspapers, receiving the support of the editors of *La Fotografia artistica*, the most authoritative Italian journal of photography. Thus, a new Futurist group in Rome began to form round the Bragaglia brothers, including Balla, Dinamo Correnti, Altomare, Folgore and Gustavo Bonaventura. The group would gather at the Caffé Groppo in via del Tritone, and the meetings focused on discussions of dynamism and the new expressive media of art.

Late in June 1913 the publisher Nalato in Rome printed Anton Giulio's essay entitled *Fotodinamismo futurista* (Futurist photodynamism), which was illustrated with sixteen photodynamic images and in effect expounded the phenomenology of *kinesis*, applying kinetics to sudden or brusque actions, to linear movement, rhythmical gestures of working or of playing music. Following a psychological drive or automatic reflexes, the bodies photographed moved in broken lines or in arcs, rotating on themselves, intensifying or refuting the force of gravity, developing an extended or contracted movement. Clearly proud of his achievements, Anton Giulio proclaimed that his experimental research "shows that the photodynamic image is much more appropriate, for contemporary uses, than all the other representational media in use today".[14] In other words, Anton Giulio believed that modernism now needed a new medium for aesthetic research, which would be more effective and direct. If photodynamism was a means of recording an experience of reality, then it could replace traditional media, such as painting and sculpture, to express dynamism.

The publication of the book was met with harsh words from Boccioni, who published his rebuttal in August in *Lacerba*: "All the worse for those short-sighted people who thought we were infatuated with this episode; who thought we were merely chasing trajectories and mechanical gestures. We have always rejected with disgust and contempt even the remotest connection with photography, because it is outside art."[15] Despite this stance, Anton Giulio continued to disseminate photodynamism under the label of Futurism. With the help of Folgore and other Roman Futurists, he organized a tour of lectures and exhibitions in central Italy. He also published new photodynamic images printed at the Danesi e Capaccini Press of Rome that explored other sensations of movement, including *Le Rose* (The roses),[16] based on a gesture dictated by the sense of smell, *Ragazza che cuce* (Girl sewing), with a semicircular movement,[17] *L'Accenno al saluto* (The brief salutation), showing a movement towards the front, *L'Apache* (The apache), in which the subject leans forward to land a punch, and *La Macchina da cucire* (The sewing-machine), on the symbiosis of mechanical and human rhythm. *Il Poeta dice una lirica* (The poet declaiming a lyrical poem) and *L'Oratore* (The orator) focus on two different forms of elocutional gestures, and finally *Ritratto* (Portrait)[18] uses the technique known as a "layered montage" of two negatives to convey the persistence of content in the conscious mind. This image shows the complete figure of a man with his head superimposed in the foreground. Soon after, the Bragaglia

brothers produced their *Ritratto di Gino Gori* (Portrait of Gino Gori) using the same technique, thus providing another interpretation of photodynamism – a suspended and dilated vision of reality capable of expressing a movement perceived exclusively in terms of duration and memory. The subjective dynamism, which produces the impression of simultaneity between proximity and distance, between perception and recollection, between what is seen and what remains impressed in the mind, was effectively one of the great Bergson-inspired themes of "pictorial dynamism" theorized by Boccioni. However, Boccioni became increasingly irritated, and rallying all the Futurist painters, he "excommunicated" the Bragaglia brothers. At this point, the exclusion of the Bragaglia brothers from the Futurist movement was official, and was made known in a "Notice" published in the magazine *Lacerba* in October. Meanwhile, the second edition of the essay *Fotodinamismo futurista* had been published. This was defined by Anton Giulio Bragaglia as a "volume of research", and a copy was sent to Papini with a dedication.

The core of the essay, which was the first book on the theory and aesthetics of photography published by the early twentieth-century avant gardes, was drawn from the lecture given by Anton Giulio Bragaglia in 1911 in several venues. However, the insertion of articles, published subsequently in the press, and of polemical texts, which the author used to respond to criticisms made during the various exhibitions of photodynamic images, shows that the editing of the text continued until early in 1913. Bragaglia developed an exhaustive reasoning, enriched by fairly precise references, and showed that he was aware of all the theories that were connected with the representation of movement in art. By fixing on the plate the kinetic expression of a body in space in a single trajectory, photodynamism aimed to "recall reality in a non-realistic manner", using "the recollection of the dynamic sensation that the transcendental dimension of a gesture produces on our retina, our senses and our spirit".[19] The photodynamic image differs from Marey's chronophotography in that its sole intention is to render "the psychic impression" of a gesture by evoking the trajectory in synthesis. Naturally, at the beginning of his experiments, Marey himself produced images that were very similar to the "photodynamic" ones, but he immediately discarded them, as they were impractical from the scientific point of view. Bragaglia explained how the aesthetic purpose of photodynamism was different: "I do not conduct an analysis of the gesture, nor do I follow the equivalent of a hundred snapshots, but I affirm and try to move towards the synthesis of the gesture which, as it is pure movement, namely a trajectory, is completely different to the pose, completely different to the snapshot, not static at all, and certainly not a scientific analytical reconstruction."[20] Furthermore, only photodynamism could render the natural continuity of movement, meaning reality indivisible in its "becoming", about which Bergson had spoken. For Bragaglia, the *raison d'être* of the photodynamic image is precisely the reflections on the "becoming of form" that the French philosopher had set out in *L'évolution créatrice*, in which he criticized cinematography as a mere ploy of the intelligence and therefore incapable of conveying the deepest truth of movement.

Bragaglia went on to criticize the concept of movement expressed in form as set out by Rodin in the volume *L'Art, entretiens réunis par Paul Gsell*, published in 1911. Rodin joined in the famous polemic on the positions of a horse's legs while galloping, a controversy that dated back to the time of Géricault, persisted for the whole of the nineteenth century and came to a temporary conclusion with Muybridge's photographs. Rodin affirmed that art could express movement not by "freezing it" in a snapshot, as happens in photography, but by the synthesis of the two fundamental moments of its development. Bragaglia countered this by saying: "The synthesis of two moments in time is always *static synthesis* of two *static states*, even though these are part of the general motion with other moments".[21] To conjure up the dynamic sensation, what is appropriate is "not the synthesis conceived as stasis resulting from the union of two moments in time, but the trajectory – the real and principal part of the movement".[22] To Bragaglia, movement was not an entity that could be measured in its various phases, nor was the transition from one phase to another contained in the material identity of the forms. Consequently, each time art

wished to express dynamism, it merely dematerialized form, as transpires in certain works by Velásquez, Cremona, the Impressionists, or Medardo Rosso, who, in his sculpture *Bambino che mastica* (Child masticating), was able to express the breathing of a living being through the "fluidity of the lips and the chin".[23]

Bragaglia also quotes *The First Principles* by Herbert Spencer, to refute his mechanistic conception of movement, and *The Principles of Psychology* by William James, using his work on movement's physiological and psychological aspects. Bragaglia expands on the notion that the authentic perception of movement "is to be found in the phenomenon of vertigo better than elsewhere".[24] Thus, the object of the photodynamic image is this "visual vertigo", which translates the vital and subjective dimension of movement and causes the image to move "even further away from the photographical reproduction of things". Bragaglia then moves on to the theme of photography as art, where he rejects both Realism and Pictorialism. He insists on the independence of the language of art, claiming that the "artistic conception" must occur "by asserting itself independently of any formal comparison with reality itself".[25] The logical consequence for photography is the need to "denature" itself, to cast off its own technological determinism (which requires it to be a faithful and passive reproduction of reality) so as to produce "the same emotions as a work of art". In his description of photodynamic research, Bragaglia lists everything that photographic media "can express that is non-photographical"[26] and sets out a future programme for avant-garde photography. He envisages a "dynamic vision" that captures immobile objects as they appear while speeding towards them, photomontage using superimposed printing of several negatives in order to achieve the projection of the psychological or dreamlike content of the image, simultaneous rendering of the different aspects of an object, fragmentation of bodies and their surreal and arbitrary recomposition, expressive and grotesque deformations, the creation of a "dynamic style" for the subject and the illogical association of the visualized ideas and elements of reality. In this essay, the first aesthetic revolution in avant-garde photography achieved full theoretical consciousness. Many of the formal categories described by Bragaglia would be explored by both Futurist photography and other European avant-garde movements in the 1920s and 1930s.

Bragaglia's ideas were warmly received by professional photographers, including Edoardo Di Sambuy and Giovanni Di Jorio, while Rodolfo Namias and Giorgio Balabani poured scorn on them. The Futurists were also divided in their opinions. Papini defended photodynamism. In fact, as the translator of Bergson he fully understood the importance of the Bragaglia brothers' research. In November 1913, right after Boccioni's rejection, Papini wrote: "They said that photography would sound the death knell of painting. However, photography – improving all the time – safeguards painting which must increasingly contradict photography, in other words, be increasingly remote and different from the so-called reality that everyone perceives."[27] In effect, Futurist painting was forced to evolve towards abstraction. In particular, it was Balla's works of 1913 on the theme "speed of cars racing" that appeared to be a result of Bragaglia's observations on the modifications of perception, the destruction of matter and the fading and whitening of the images produced by the "photodynamic vision".

After their ejection from the Futurist group, the Bragaglia brothers continued their research undeterred. Boccioni's "excommunication" concerned motion theories, so the brothers decided to explore the image of the "state of mind", an idea that, in the area of the poetics of "pictorial dynamism", represented the other major direction of Futurist research. Deeply interested in spiritualism for some time, Anton Giulio had studied works on parascientific photography. Now he began to publish articles on "the photography of the invisible" and "phantoms of the living and the dead". His writing revealed his knowledge not only of the experiences with the famous medium Eusapia Paladino carried out by Enrico Morselli and Cesare Lombroso, members of the Society of Psychic Studies of Milan, but also of those conducted in Turin by Enrico Imoda with the equally famous Linda Gazzeri. Anton Giulio was extremely sceptical and carefully examined the

photographic techniques used in images reproducing *vital* radiation, phenomena regarding the "externalization of sensibility", the "stereosis of phantoms" and ectoplasmic manifestations. He questioned the authenticity of these images and his criticism was accurate and justified, even opposing the publications produced by the Comité d'études de la Photographie Transcendentale[28] formed by Charles Robert Richet, Emmanuel Vauchez, Gabriel Delanne and Albert de Rochas at the Sorbonne in Paris. Anton Giulio then ironically fabricated "trick photographs" of apparitions, also organizing séances and spiritualistic meetings, which he defined as "a joke". These séances were also attended by Giuseppina Pelonzi, Anton Giulio's companion, and two of his brothers, Alberto and Carlo Ludovico.[29]

From 1913 to 1914, in what was now the third phase of Futurist photodynamism, Anton Giulio's principal interlocutor was Gustavo Bonaventura, who turned to Futurism after becoming famous as a pictorial photographer. Bonaventura worked on Anton Giulio's "spiritualistic portraits" using superimposed images to evoke the ghostly presence in a version that was overtly dreamlike and hallucinatory. The psychic evocation of the *vital* manifestation, which produced the luminous fluid effects of the early photodynamic images, thus developed into a visionary representation in line with the intention of Futurist painting, which, in Boccioni's words, is "to materialize and give form to what up to now has been considered ethereal, inflexible, unmodifiable and invisible". Given the effect of reality, which informs the language of photography, the surreal content of the image takes on the force of a mythical formulation. The photographic lie becomes a projection that suggests a tangible truth. On this issue Bragaglia wrote: "In us there are a number of different psychic principles and different bodies that interpenetrate, and the visible body, considered from the psychic viewpoint, is merely the instrument of the invisible body".[30] By revealing the latent, mnemonic, magic and obsessive content of consciousness, the photodynamic image becomes the most fitting vehicle for a visionary view of reality in terms of "state of mind", which Boccioni – now engaged in a confrontation with Cubism – refused to pursue. The protosurrealist nature of Futurist research into the "state of mind", acknowledged years later by André Breton, found a particularly significant expression in these images.

Such was the success of this research that in December 1913 the third edition of the book *Fotodinamismo futurista* was published, containing the photodynamic image *Un Gesto del capo* (A gesture of the head), which was a portrait of Anton Giulio Bragaglia. In an interview given in January 1914 to the journalist Vincenzo Bonafede for the newspaper *L'Ora* of Palermo, Anton Giulio renewed the claim, choosing his words carefully and tactfully, that his experiments were independent and referred to Boccioni's rejection, suggesting that it was in fact condemnation of Balla's analytical painting that had caused the exclusion of photodynamism from the fold of Futurist art: "I have always been an individualist and I have conducted my research seriously and scientifically, as I have attempted to show in my book. To provide an in-depth exposé of the ideas that I propose, I have dealt with Futurist painting in my book and have discussed it objectively, and I have not hesitated to appraise the positive directions pursued by some and the false ones by others."[31] A few months later, the outbreak of the First World War caused the two brothers to suspend their research. Arturo was to continue with photodynamic images in the 1920s, returning to the fold of the Futurist movement, and Anton Giulio would never forget his experiences. Though his work was culturally avant garde, it was always in the name of "independent artists". In 1916 he made *Thaïs*, the first film with abstract sets in the history of the cinema, working with Prampolini, who had also been excluded from the Futurist movement and claimed the originality of his research and the label of "independent" within the avant garde.

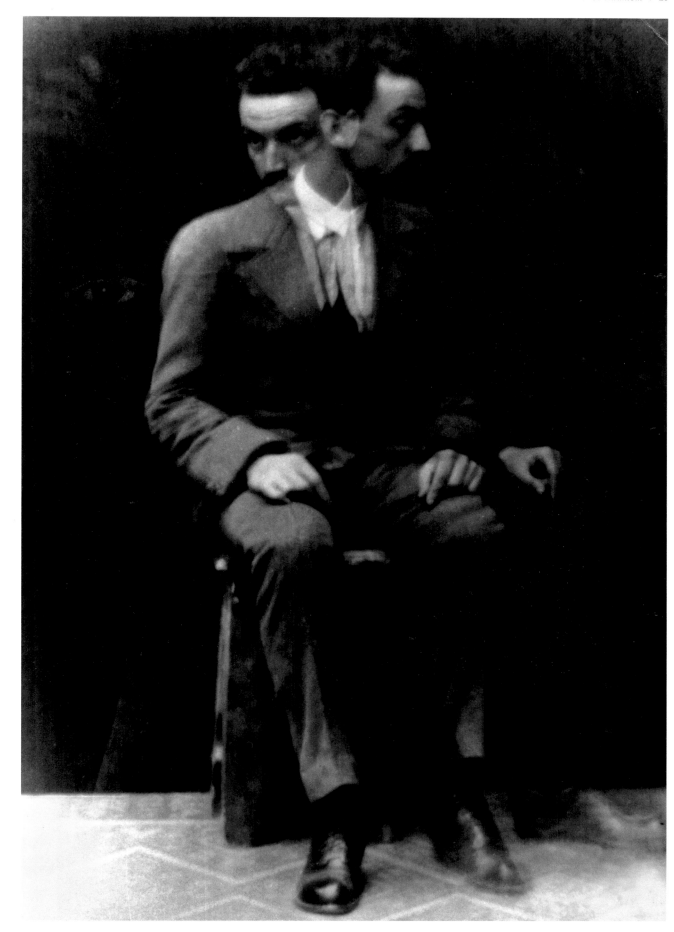

Gustavo Bonaventura ◆ *Photodynamic portrait of Anton Giulio Bragaglia* ◆ 1912/13, gelatin silver print, 22.8 x 16.5 cm ◆ Calmarini Collection, Milan

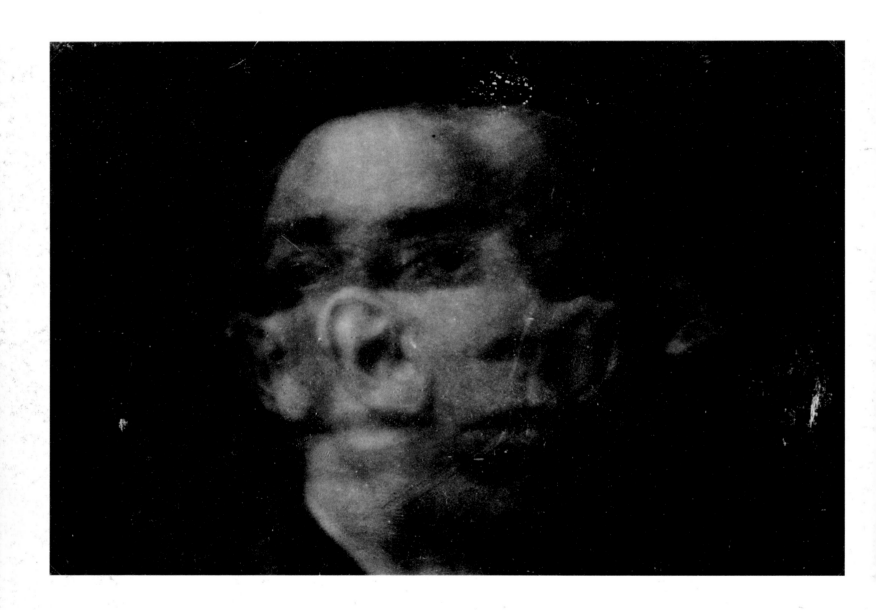

Anton Giulio and Arturo Bragaglia ◆ *Polyphysiognomical portrait of Boccioni* ◆ 1913, gelatin silver print, 12.3 x 17 cm ◆ Calmarini Collection, Milan

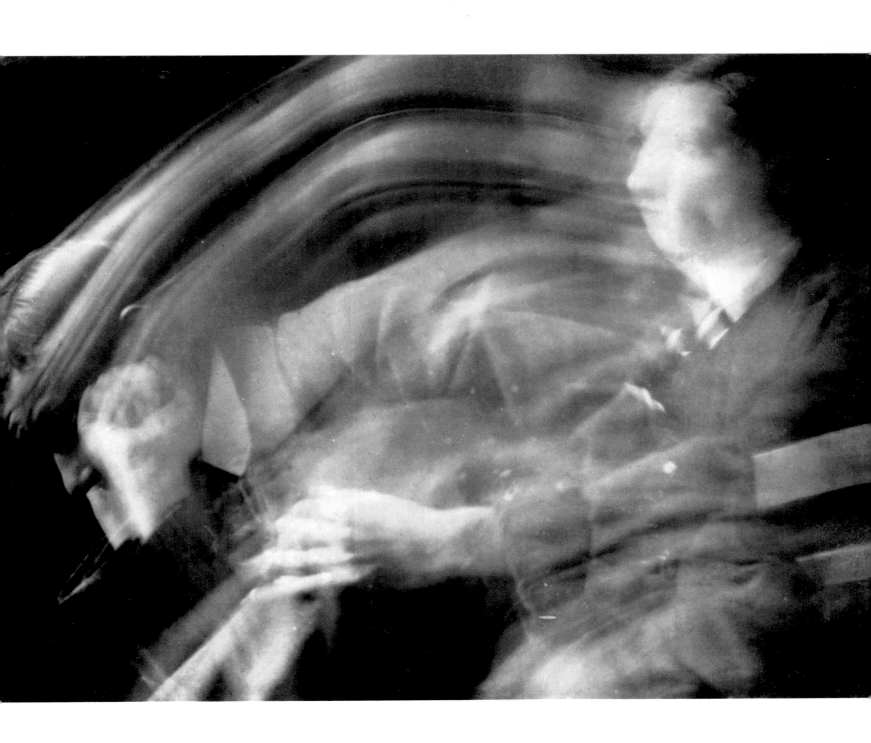

Anton Giulio Bragaglia ◆ *Change of position* ◆
1911, gelatin silver print, 12.8 x 17.9 cm ◆
Gilman Paper Company, New York

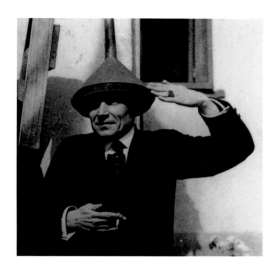

PHOTO-PERFORMANCE

AFTER BOCCIONI'S excommunication in October 1913, the development of a Futurist aesthetic for photography in line with the Bragaglia brothers' principles seemed out of the question, at least for the time being. Nonetheless, in the following years Futurist photodynamism was revived and practised by the Dadaist group in Zürich, which published a photodynamic image of the dancer Mary Wigman, and by the Bauhaus artists Oskar Schlemmer, Anton Stankowski and Erich Consemüller, who also produced photodynamic images on the dance theme. Within the Futurist movement, however, it was felt that there was incompatibility between the art of dynamism and the canonic vocation of the photographic image, namely, to bestow the absolute on the split second, to freeze the instant outside the stream of time. The experience of photodynamism through which Bragaglia had refuted the objective representation of reality, interpreting it as kinetics and vitalism based on the specific medium of photography, seemed destined to be banished for ever owing to the orthodoxy of the founders of the Futurist movement.

To Marinetti and Boccioni, photography is not only an inherently static and "necromorphic" language, incapable of expressing the complexity of being and the transience of a state of mind, but it is also a language that, by transforming reality into an immutable sign, provides a truth of the subject that is always alien and altered, meaning that it is objectively different to the event itself. As a technical medium, photography has a capacity for autonomy that eludes the conscious determination of the subject and even evades the ultimate aims of the photographer. By creating a structure for itself beyond all control, the photograph can represent a situation, highlight an affective feature and reveal a social peculiarity, none of which existed in the intentions of the subject or in the connotations of the photographer's act. Consequently, the Futurists felt extremely vulnerable in front of the camera as they wished to project an elective image of themselves, establish an ideal model for their identity, not simply portray reality for the sake of reality. Though they advocated a culture dominated by technology, they encountered problems with the use of the camera because of the way it directly affected their image. Emblematic photography, seen as the recomposition of a reality that was totally subjected to mental control, thus became the expressive *leitmotiv* of the early years of Futurism.

From the turn of the century, many artists had been photographed in flamboyant poses to stress their iconoclastic tendencies or simply their existential opposition to the canons of bourgeois life. Balla had some entertaining photographs taken in costume in the *tableau vivant*

Fortunato Depero ◆ *Depero and Clavel: Pantomime!*
◆ 1916 ◆ detail; see p. 44

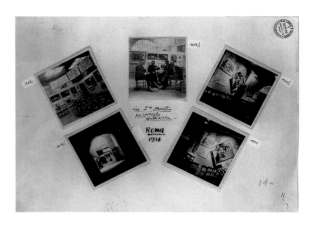

Fortunato Depero ◆ *The first solo Futurist exhibition:*
Rome 1916 ◆ 1916, five gelatin silver prints, 9 x 9 cm each
◆ MART, Archivio del '900, Rovereto

genre, which, by reconstructing the picture, make the photograph resemble the theatrical composition of a painting. In the context of Futurism, emblematic photography was mostly used as a ritual when new artists joined the movement. On such occasions, the founder and leader of the Futurists would pose with the new members, leaving for posterity an eloquent image of their choice and desire to be militants of the avant garde. One particular example shows all the young members in the Florentine group of the magazine *L'Italia futurista* with Marinetti. Lined up in profile, as on Roman medals, which allude to future glory, they look towards the left, off stage. This was a way of stressing their anticonformism, as the natural dynamic orientation is always towards the right. Another image shows them in a circle surrounding Marinetti while he makes a solemn gesture towards the ideal goal. The central position of the only woman in the group and the symmetrical balancing of light and dark clothing show great care in the composition of the image, though not without a subtle hint of irony.

Among the new generation of Futurists it was Depero, with Giacomo Bella, who extended the limits of emblematic photography, turning it into photo-performance. This evolution was in line with the new climate conditioning Futurist activities. In the history of modern and avant-garde art the English word "performance" had been used for the first time in 1914 by the journalist Paolo Scarfoglio to describe a "Futurist evening" held at the Galleria Sprovieri in Naples by Marinetti, Cangiullo and other Futurists. Depero's photographical research, conducted between 1915 and 1916, began with a self-portrait that was already a *mise-en-scène* of his identity as an artist. By breaking with the conventions of emblematic photography Depero revealed an awareness of himself, giving the image strong facial expressiveness and intensifying the effect with garish writing in gouache that enclosed it in the triangular shape of a pennant. Quite possibly, this is the first example ever produced of graphics on a photograph. The writing invades the image, and by underlining its materialness, also states that it is a work of art. Shortly afterwards, Depero produced a doubled self-portrait in which the repetition, sequential rather than differentiated,

Mario Nunes Vais ◆ *The editorial board of 'L'Italia futurista': Chiti, Neri Nannetti,*
Corra, Settimelli, Ginna, Maria Ginanni, Vieri Nannetti, Marinetti ◆ 1916, gelatin
silver print, 20 x 25 cm ◆ Fondazione Primo Conti: centro di documentazione e
ricerche sulle avanguardie storiche, Fiesole

Emidio Filippini ◆ *Pica, Depero, Marussig and Brenno del Giudice in Depero's*
studio decorated for the Futurist party on 10 January 1923 in Rovereto ◆ 1923,
gelatin silver print, 11 x 16 cm ◆ MART, Archivio del '900, Rovereto

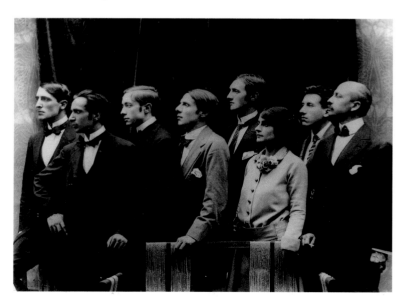

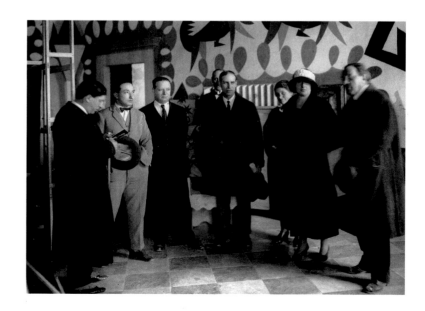

eliminates the recording of time and aims to produce a forced persistence of the image in the manner used by Severini in his painting *La Danseuse obsédante* or in Andy Warhol's *Elvis I and II*. Here, by repeating the photograph, Depero dematerializes the image and at the same time stresses its iconographic and semiotic values.

A sensational series of self-portraits, all close-ups, takes this expressive direction even further, the artist's very personality merging art and life. Depero uses excessive gesture and facial expression to project the idea of the exhibitionist, provocative theatricality of the behavioural models, the aesthetic ideals and subversive determination of Futurism. For instance, the images show the "cynical laugh" of the avant-garde artist, untouched by the rhetoric of academic culture or by the languor and dejection of D'Annunzio, the amazement that reveals his interest in the magic of "Futurist marvels" of modern life, the grimace that displays his explosive dynamism and his capacity to grapple with the impulses of a restless and disquieting energy. In reality, each image is an explicit eulogy of *dynamis* as life-giving breath. In the photograph in which he appears upside down in the act of landing a punch, Depero uses photography as an ideological instrument. In fact, to Marinetti the punch is the supreme argument in the cultural struggle of Futurism against the inert resistance of *passéisme*. Depero's gestures and facial expressions, projecting thus the Futurist artist's controversial state of mind and activist existential practice, produce a decidedly visual objectivization of the avant-garde creed. The violence and abruptness of the Futurist manifestos, which Marinetti considered an art form, now found their counterpart in iconographical terms. This was also a way for Depero to celebrate his acceptance into the Futurist movement, which Boccioni opposed. In March 1915 Depero stuck these self-portraits on to cards, added messages and hasty sketches in tempera or watercolour in red, black, yellow and blue and sent them to Carrà and Marinetti. He not only invented photo-performance, but also produced the first example of Futurist mail art. Three of these photographs, arrogantly signed "Depero is a genius" and sent to Carrà, form a triptych around the trio "art-life-action" that Marinetti posited as

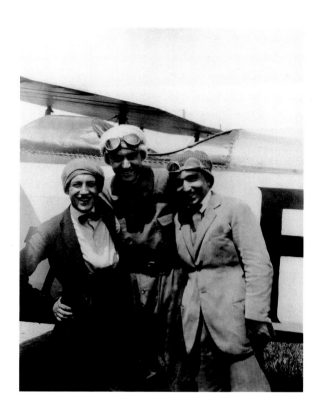

Anon. ◆ *Fortunato Depero, Fedele Azari and Franco Rampa Rossi beside Azari's aeroplane at Turin airport* ◆ 1922, gelatin silver print, 10.5 x 8 cm ◆ MART, Archivio del '900, Rovereto

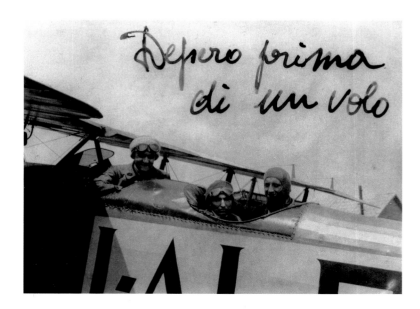

Anon. ◆ *Fortunato Depero, Fedele Azari and Franco Rampa Rossi: before a flight* ◆ 1922, gelatin silver print, 8 x 10.5 cm ◆ MART, Archivio del '900, Rovereto

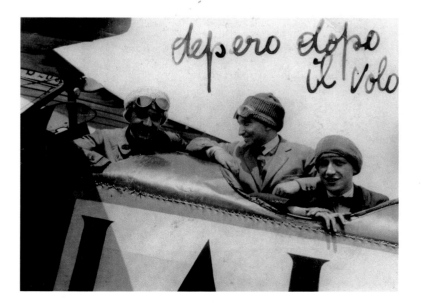

Anon. ◆ *Fortunato Depero, Fedele Azari and Franco Rampa Rossi: after the flight* ◆ 1922, gelatin silver print, 8 x 10.5 cm ◆ MART, Archivio del '900, Rovereto

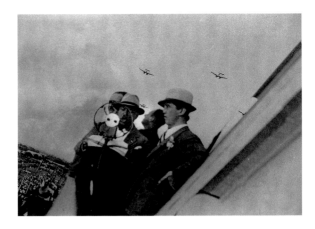

Umberto Perticarari ◆ *Mino Somenzi with Marinetti in Rome as the latter declaims live into the microphone his "poetical Futurist exaltation" of the second Atlantic crossing during the return of Italo Balbo's squadron of seaplanes* ◆ 1933, gelatin silver print, 15.5 x 21 cm ◆ MART, Archivio del '900, Rovereto

the very cornerstone of Futurism. By making images of himself that were not snapshots of everyday life but photo-performances, Depero laid the foundations for the historical avant-garde research that was carried on by famous photographers, for example the image by Duchamp with the tonsure in the form of a star or the one by Yves Klein in which he flies off a roof.

Depero's photographic research runs the whole gamut of representations of the figure of the artist, also resorting to famous archetypes. The new series opens with a scene showing the artist in the guise of a saint called upon to practise the ideals of avant-garde art. The image shows Depero seated at a table in a tavern, while he turns to the right with a dazed expression halfway between stupefaction and interrogation. This is a clear allusion to the position and gaze of St Matthew at the very moment when Christ points to him in Caravaggio's famous depiction of the saint. Again, the association of ideas is immediately obvious in the image where Depero climbs up a tree, recalling the allegory of "the portrait of the artist as a monkey", an iconographic tradition from Chardin to Picasso. After the artist as a saint and a monkey, Depero produced another metaphorical image: the artist as a young boy. In smart, neat clothes, he is photographed playing hide-and-seek, peering cautiously round a corner. Childish primitivism was an aesthetic theme that became popular in Italy following publication in 1887 of Corrado Ricci's famous book entitled *L'Arte dei bambini* (The art of children), and it can be found running through Depero's work in the Futurist avant garde. The playful childhood world is also conjured up by the following image: using an easel on his shoulder to represent the controls of a puppet on a string, Depero is frozen in the grotesque attitude of puppets and clowns, with the writer Gilbert Clavel at his side as a tin soldier. In these photo-performances Depero appears the most able of the Futurists triumphantly to experience the image, entirely embracing the Dionysian glory of the ephemeral. His emotive and explosive attitude towards the lens is precisely the opposite of the paralysing and static self-congratulatory pose that Marinetti adopts. By exorcizing the power of death of the lens, Depero's scenic and liberating solutions repel the gaze of the Medusa in as much as they are statements of

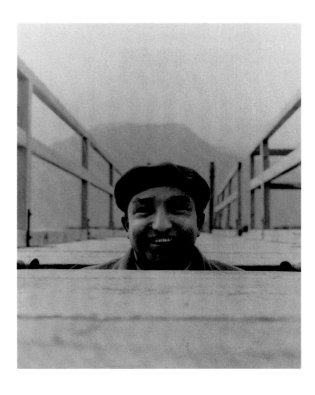

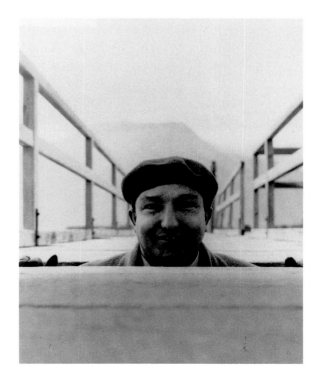

the "vitalistic dynamism" celebrated by Futurism. In effect, they represent another aspect of primal energy forces caught in the net of the visible, and already evident in the Bragaglia brothers' photodynamism.

During this period, the other great exponent of Futurist photo-performance was Balla. The first images show him establishing total complicity with the lens, posing in an "iridescent tie" or having his photograph taken in his studio dressed in multicoloured "Futurist raiment". Immediately afterwards, he gives a demonstration of his prodigious histrionics by conferring theatricality and playfulness on the image, often culminating in a critical distancing of the gaze by means of signs and gestures. On several occasions Balla is photographed wearing an ironically apologetic expression within an empty frame – an allusion, by means of cross-references between painting and photography, to all the possible contestations of the naturalist canon of the image. In other photographs he poses while painting, but the theme is no longer the typical snapshot of the artist at work in his studio. Balla reinvents the image, working outside the conventions. His photographs are grouped into veritable sequences, which show him in motion as he moves away from the canvas, peers closely at it, approaches to add a brushstroke and concentrates once more before continuing with the act. Such work is a pretext to represent art as action. On the other hand, some photographs in which Balla carried out purely allegorical actions alluding to Futurist activism border on the "conceptual". In one of these sequences he rushes forward, grasping an object, a piece of sculpture, which represents a giant fist. The action is imaginary, but its significance is multiple, eloquent and immediate. Balla has created a performance for the spectator who follows the photographic sequence. He uses the lens to show art as life, interprets the kinetic dimension of his Futurist paintings through his body and gesture, and at the same time provides an image of himself that is an ideological icon. This research naturally found its way into the film *Vita futurista* (Futurist life), made in 1916 by the Florentine group consisting of Ginna, Corra and Settimelli, with Balla's participation. This was the first film-performance in the history of cinema, a precursor by several decades of contemporary film-performances such as *Three Relationship Studies* by Vito Acconci and *Soziale Plastik* by Joseph Beuys.

Both the theatrical explorations of Balla and the deliberate, unconventional buffoonery of Depero brought to photography the absolute presence of the artist, who in a sole gesture occupies the scene of reality as he does the scene of art. At the same time, Marinetti still wanted to have control over his own image, to set a distance and to impose a model. By breaking with every iconographic rule in the book, photo-performance instead conveyed art as a game and life as the lightning flash of an instant that reveals the versatile genius of the artist. The genre of photo-performance also produced other expressions, which were just as ingenious and had overtones of the narcissistic, narrative, gestural, ironic and celebratory, in keeping with the temperament of the Futurists. Acknowledging his homosexuality, as an eccentrically dressed elegant and sophisticated dandy, Thayaht left an image of himself in which he sports "Futurist overalls" or other garments of his own creation, exhibiting himself in an act that seems to prefigure body art. Farfa had himself photographed wearing an incredible triumphal aluminium helmet given to him by Marinetti, assuming the pose of the Great Manitu of Futurist poetry. Tato produced a self-portrait with bizarre grimaces and grotesque costumes that allude to the most paradoxical metamorphoses of identity. The Futurist group from Verona posed for the parody "Serenade to Marinetti", which mocked his role as leader and role model of the Futurist movement. On other occasions they shot photographs suggesting work-in-progress or Utopia. Photography highlighted the behavioural act presenting itself as the paradigmatic iconography of the Futurist avant garde. This form of expression was used to such an extent that it actually reversed the group's propagandist intentions. Thus, as a medium of conceptual expression, photo-performance fluctuated between projections of the imagination and provocative acts intended to debunk every noble and romantic myth surrounding art.

below, left to right

Rosetta Amadori Depero ◆ *Fortunato Depero on a visit to Lake Garda* ◆ 1926, gelatin silver print, 8.5 x 6 cm ◆ MART, Archivio del '900, Rovereto

Rosetta Amadori Depero ◆ *Fortunato Depero on a visit to Lake Garda* ◆ 1926, gelatin silver print, 8.5 x 6 cm ◆ MART, Archivio del '900, Rovereto

Rosetta Amadori Depero ◆ *Fortunato Depero on a visit to Lake Garda* ◆ 1926, gelatin silver print, 7 x 6 cm ◆ MART, Archivio del '900, Rovereto

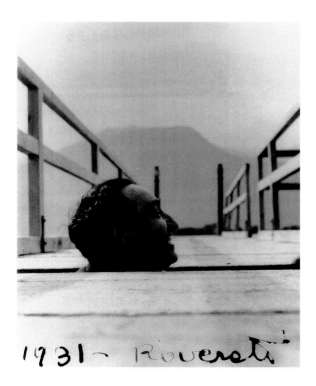

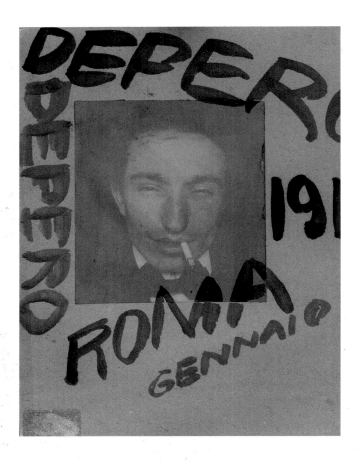

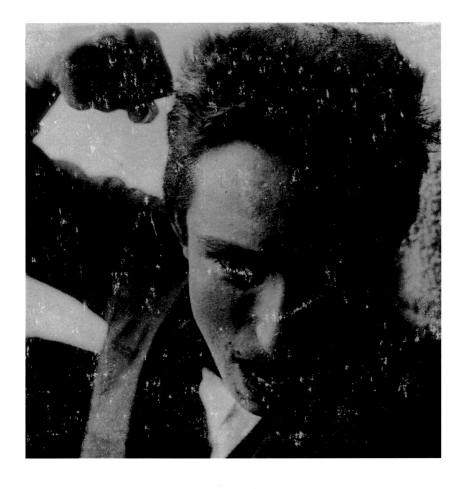

Fortunato Depero ◆ *Self-portrait* ◆ 1915, gelatin silver print, mounted on card with signature, 15 x 11 cm ◆ MART, Archivio del '900, Rovereto

Fortunato Depero ◆ *Self-portrait with clenched fist, 24 March 1915, Rome* ◆ 1915, gelatin silver print, 7.5 x 7 cm ◆ MART, Archivio del '900, Rovereto

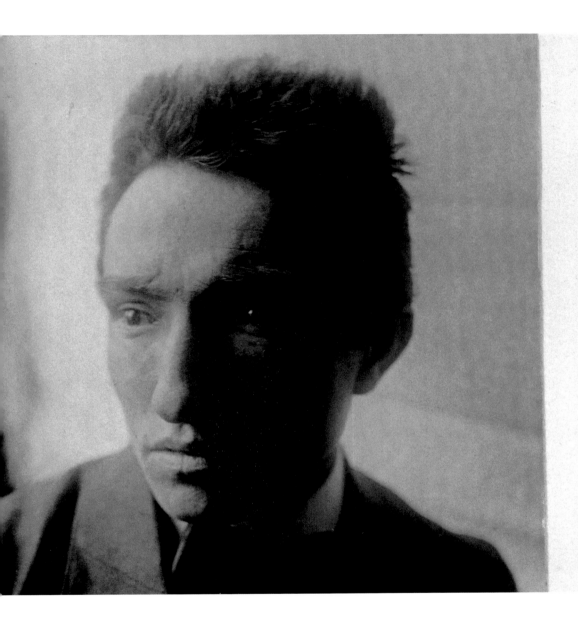
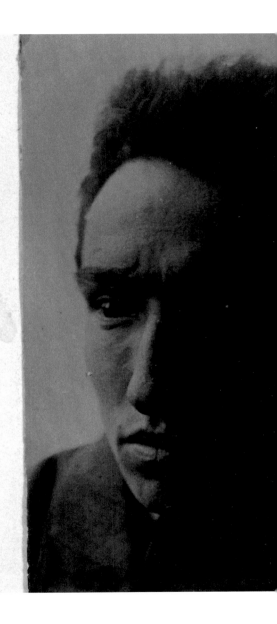

Fortunato Depero ◆ *Double self-portrait, 24 March 1915, Rome* ◆ 1915, gelatin silver print, 8 x 12.5 cm ◆ MART, Archivio del '900, Rovereto

Fortunato Depero ◆ *Self-portrait: cynical laugh,*
16 April 1915, Rome ◆ 1915, gelatin silver print, 8 x 8 cm
◆ MART, Archivio del '900, Rovereto

Fortunato Depero ◆ *Self-portrait with grimace,*
11 November 1915, Rome ◆ 1915, gelatin silver print, 9.5 x 9 cm
◆ MART, Archivio del '900, Rovereto

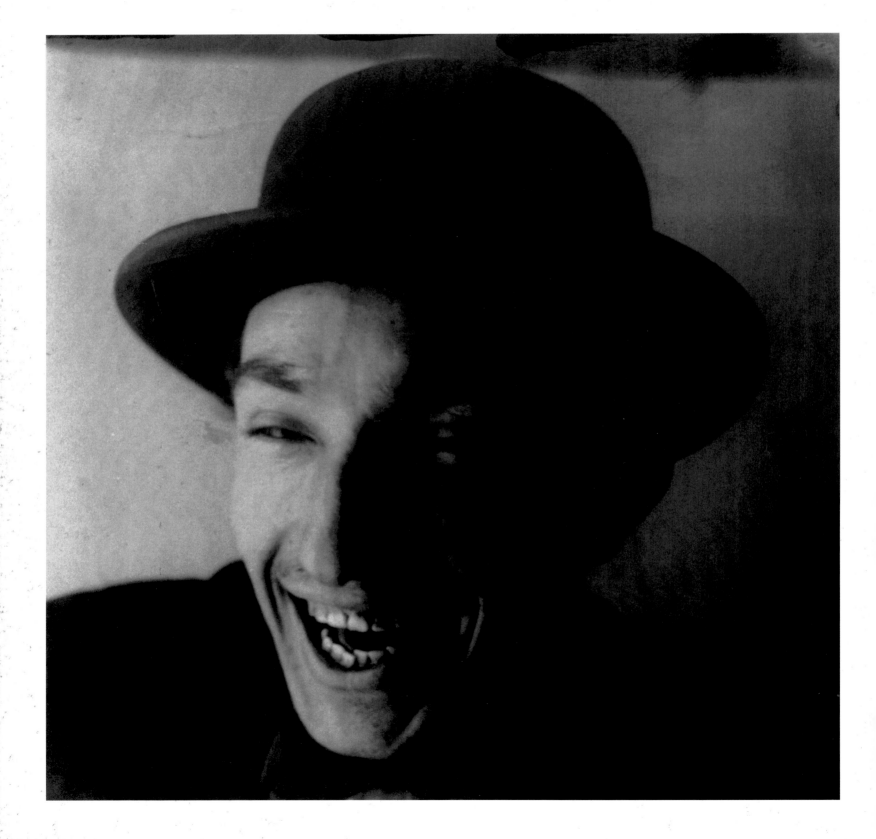

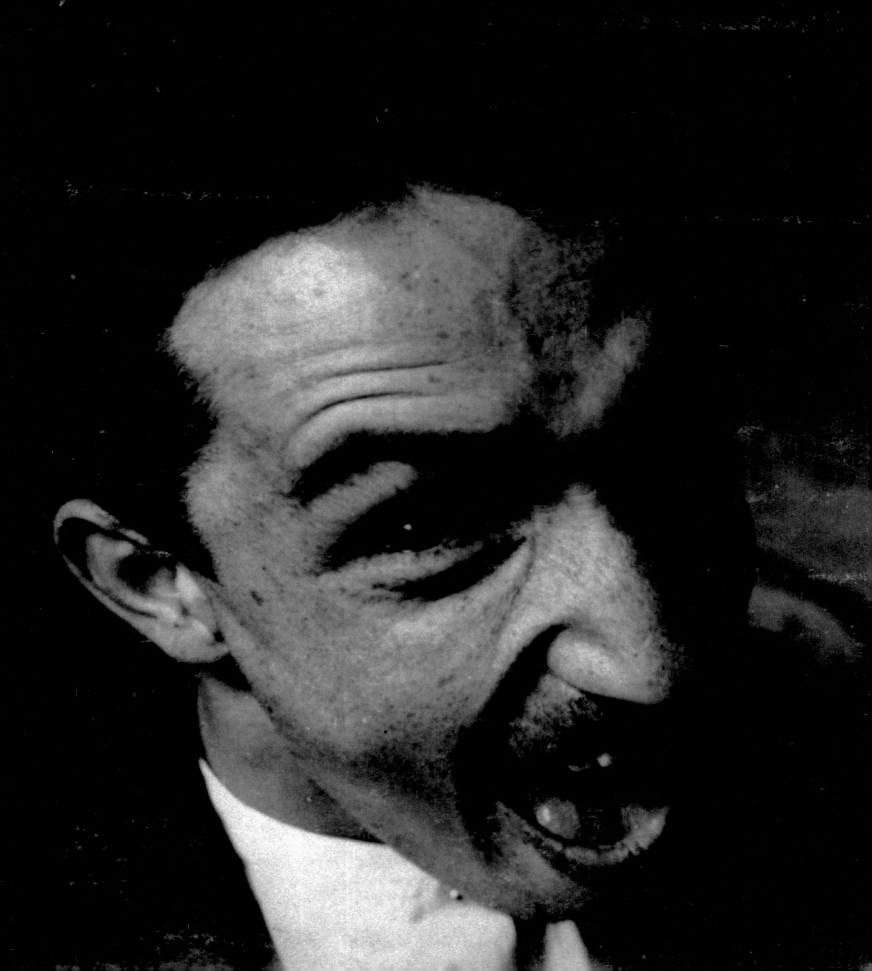

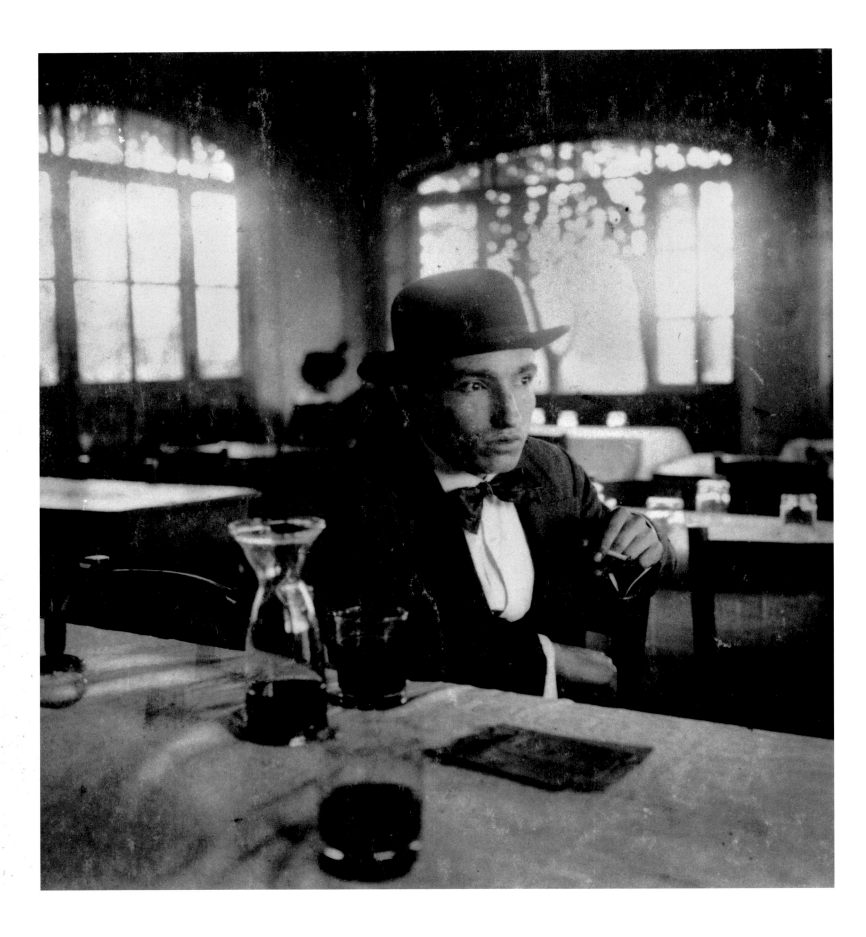

Fortunato Depero ◆ *Self-portrait in a bar* ◆ 1915, gelatin silver print, 9 x 9 cm ◆ MART, Archivio del '900, Rovereto

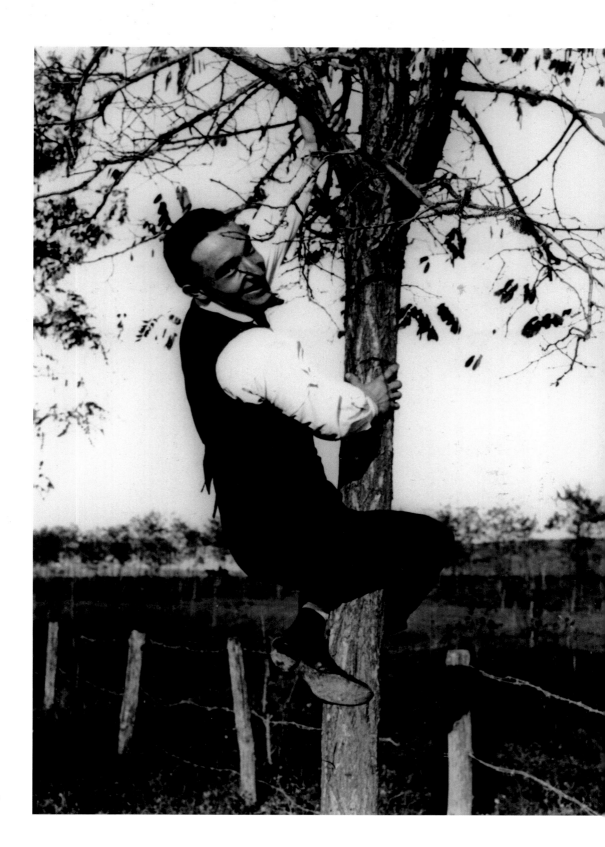

Fortunato Depero ◆ *Self-portrait in a tree at Acqua Acetosa, 6 November 1915, Rome* ◆ 1915, gelatin silver print, 6.5 x 4.9 cm ◆ MART, Archivio del '900, Rovereto

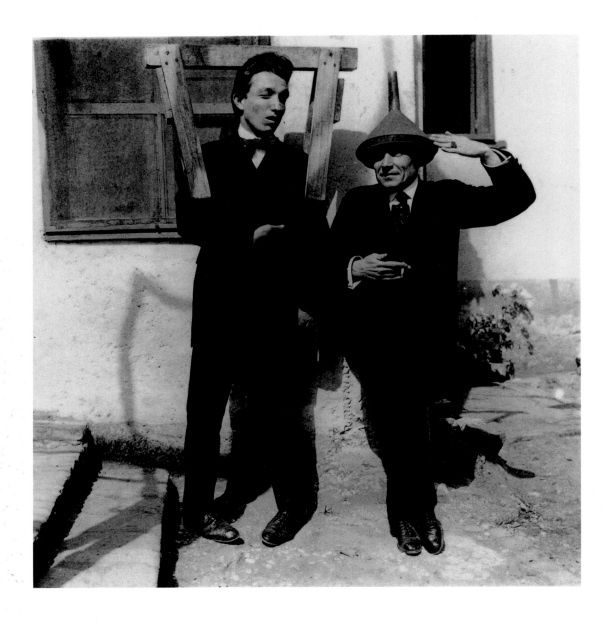

Fortunato Depero ◆ *Depero and Clavel: Pantomime!* ◆
1916, gelatin silver print, 8 x 8 cm ◆ MART, Archivio del
'900, Rovereto

Fortunato Depero ◆ *Self-portrait: Depero plays hide and
seek, Rome, 1916* ◆ 1916, gelatin silver print, 8.5 x 8 cm ◆
MART, Archivio del '900, Rovereto

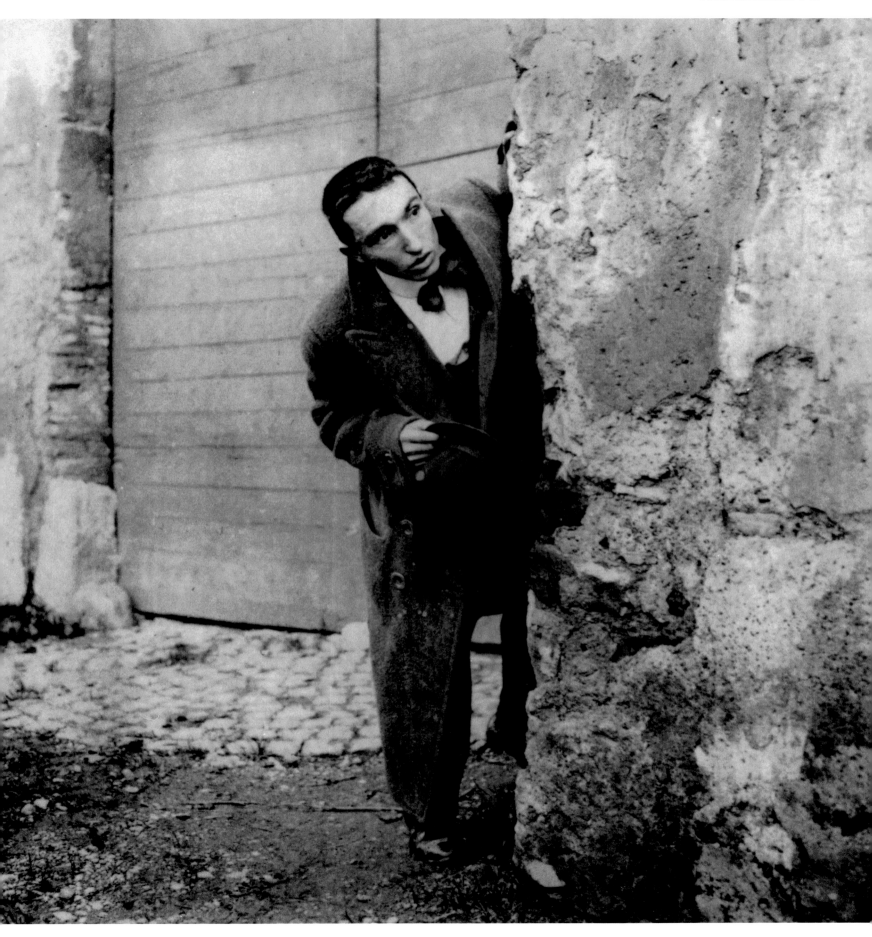

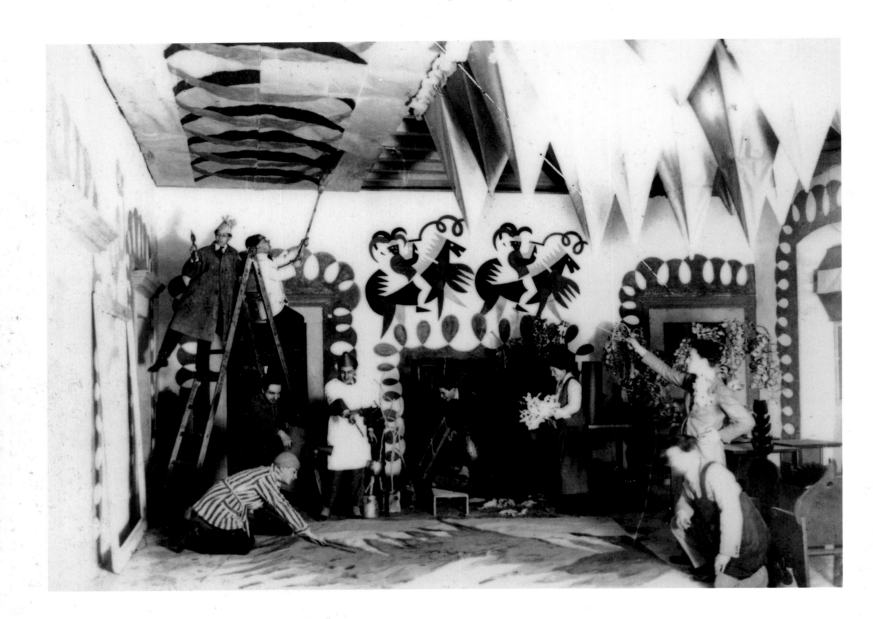

Emidio Filippini ◆ *Depero, Melli, Melotti, Pollini, Rosetta Depero and friends in the 'Salon of the Paper Horsemen', Futurist decoration by Depero for the ball of 1923 in Casa Kappel in Santa Maria, Rovereto* ◆ 1923, gelatin silver print, 11.5 x 16 cm ◆ MART, Archivio del '900, Rovereto

Studio Ottolenghi ◆ *Depero and Marinetti wearing Depero's Futurist waistcoats, with Marchesi, Fillia and Cangiullo in Turin* ◆ 1925, gelatin silver print, 22 x 17.5 cm ◆ MART, Archivio del '900, Rovereto

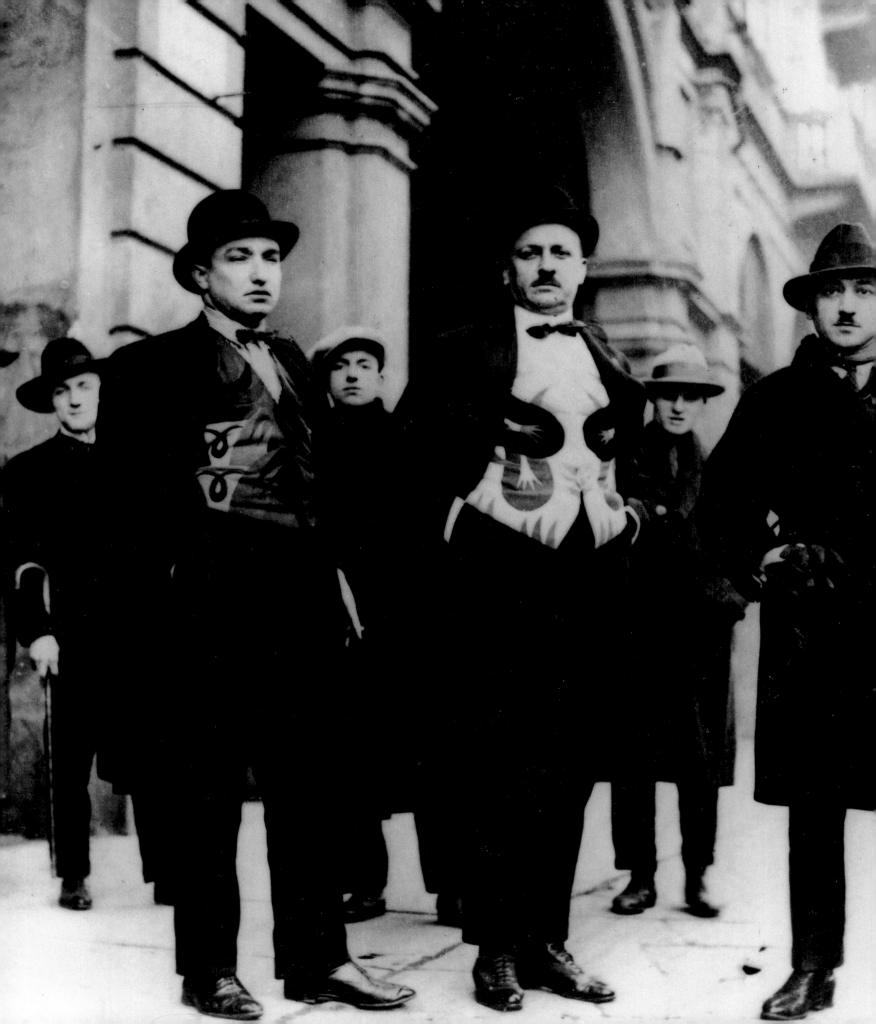

the 20's Twenties

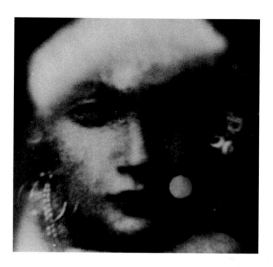

}

THE TWENTIES

Giorgio Riccardo Carmelich ◆

Photographic composition ◆
c. 1928 ◆ detail; see p. 68

THE POST-WAR PERIOD

led to a revival of Futurism and to a new environment for the avant garde. After the death of Boccioni the Futurist movement lost its infrastructure, and by abolishing hierarchical centralism and corporatist exclusivism, let itself be influenced by different aesthetic trends and became contaminated by foreign avant-garde movements. This keen interest in individual research was accompanied by the inward-looking institutional stance; experimental work appeared increasingly to follow traditional art forms, particularly painting and sculpture, works of art as objects meant for museums. This situation was not peculiar to Italian culture, since at this time there was a generalized tendency throughout Europe to a "return to order", abandoning the antagonism that had been rife between the avant-garde movements. In Italy, however, the rise of Fascism, which complicated the relations between culture and society, created hostile conditions for the avant garde, resulting in an absurd situation: the Futurist movement officially joined forces with a totalitarian régime. The collusion between Futurism and Fascism, mainly due to Marinetti, was a strategic error of historic significance. Marinetti believed that this was a way to save the Futurist movement as well as providing it with a hegemonic role in the cultural environment of the new Italy promised by Mussolini. In reality, this aspiration was soon doomed to failure. Futurism would never be the art of the régime; Fascism had every intention of imposing a cultural climate of its own, dominated by the revival of bourgeois values, which was completely opposed to the cultural tenets of the avant garde.

Historically speaking, though Fascism did borrow some revolutionary-sounding slogans from Futurism, there was never any ideological contribution from Futurism as such to Fascism. The common ground between them was limited to a historical development in progress within Italian culture in those years – the degeneration of the ideals belonging to the Risorgimento. The patriotism and nationalism of the Futurists was thus drawn into the political alignment that Marinetti obstinately supported to the bitter end, refusing to see all that in Futurism totally opposed the Fascist régime. It was only some of Marinetti's positions, in particular social Darwinism and the aesthetic apologia of war, that had anything in common with the political ideology that made up Fascism. However, the Futurists' political opinions did not form a monolithic or univocal body. Many only passively accepted, for opportunistic reasons, the compromise with

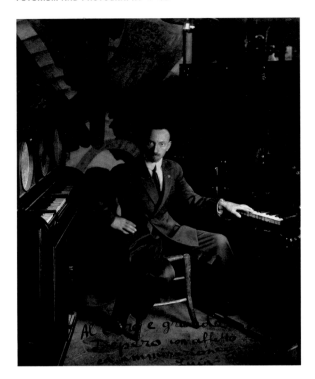

Anon. ◆ *Luigi Russolo seated in front of his painting 'Music' and between two models of his Rumorharmonium* ◆ 1928, gelatin silver print, 29 x 23 cm ◆ MART, Archivio del '900, Rovereto

Arturo Bragaglia ◆ *Inauguration with Marinetti and the Futurists at the Casa d'Arte Bragaglia, Rome* ◆ 1922, gelatin silver print, 12 x 17 cm ◆ MART, Archivio del '900, Rovereto

Fascism that Marinetti supported. Several others refused to have anything to do with it, forming an opposition group whose positions ranged from the overt antifascism of Russolo to the communism of Pannaggi and Paladini. In the mid-1920s this situation rapidly led to two distinct trends within the avant garde. The more active Futurists chose to go into exile and made direct contact with foreign groups, while in Italy Futurism became the culture of modernism. A number of other artists were also part of this culture or followed its tenets, though they were not officially Futurists in Marinetti's group. Of the Futurists who emigrated, Depero lived in New York from 1928 to 1930 and Russolo settled in Paris, where he continued with his noise research, building a new improved model of his 'Rumorharmonium'. Instead, the photographers Castagneri and Pedrotti, who carried out Futurist research after meeting Depero, sharing at the time his enthusiastic commitment to the avant garde, remained in Italy.

In photography, post-war Futurism at first timidly revived the forms of expression that typified the early years of the movement. In 1918 Anton Giulio and Arturo Bragaglia set up their Casa d'Arte in via Condotti in Rome with a photographic studio where they mounted a permanent display of "artistic photographic portraits". These were images where the style, as Anton Giulio wrote, aimed to "move away from *fotografismo* (realistic photography) without abandoning photography" and to achieve "psychological and environmental effects and tones using only photography".[32] Arturo enlisted the help of his younger brother, Carlo Ludovico, to make portraits of celebrities in society, actors of the theatre and cinema, Futurists and artists passing through Rome. He produced a photodynamic image with Archipenko, who had come to Rome in February 1921 for the exhibition La Section d'Or de Paris organized by Prampolini, and in 1925 exhibited other photodynamic images on the theme of dance at the Exhibition of Photography in Genoa, of which he was one of the organizers. In his portraits of Futurists, Arturo sometimes used transparencies or superimpositions of geometrical motifs and, to produce a greater dynamic effect, he studied a variety of different types of border, from the simple rectangular form to irregular contours. His portrait of Dottori is enclosed within a pentagonal shape that seems to allude to the star as a symbol of glory. In fact, this is a formal innovation, which tends to eliminate the contrast between background and figure following a minimalist scheme, which is very similar to the principle used in the shaped canvas, an invention now attributed to Frank Stella or Ellsworth

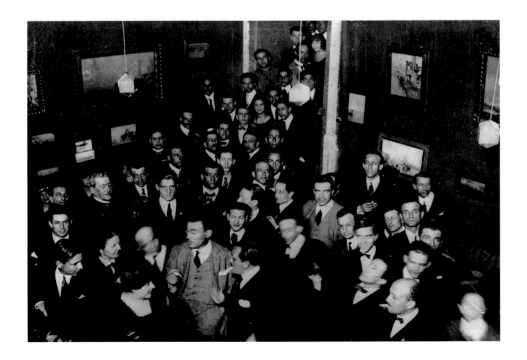

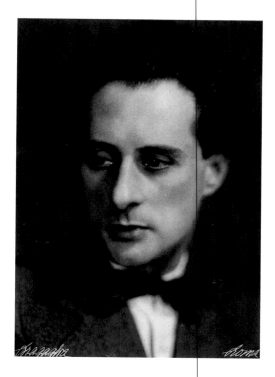

Arturo Bragaglia ◆ *Portrait of Alberto Viviani* ◆ 1929, sepia-toned gelatin silver print, 16.6 x 11.7 cm ◆ Archivio storico del futurismo e primo '900 europeo Alberto Viviani, Arezzo, Florence, Milan

Arturo Bragaglia ◆ *Portrait of Anton Giulio Bragaglia* ◆ c. 1924, gelatin silver print, 13 x 9 cm ◆ MART, Archivio del '900, Rovereto

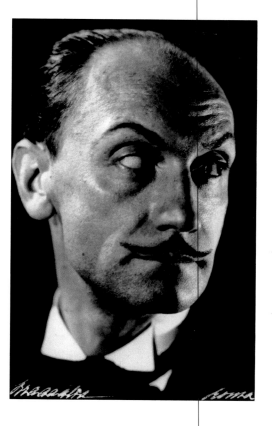

Kelly, but which has always existed in Italian folk votive art. The shaping of the photograph to give it greater expressive vigour was also practised by Tato and Depero.

At the same time, experiments with photo-performance and emblematic photography were continued by Marinetti, Balla, Depero, Carmelich, Prampolini and Cernigoy, to accompany and comment on many of the activities of the Futurist movement, even the less publicised events. These included scenic "happenings" organized by Depero, where the Futurist environment was completely saturated with forms and colours. In such cases, photo-performance complemented the poetic quality of art as a happening and a happening as art, while the daring exploit of a journey by plane enabled the Futurist identification of art with life to be translated into a photographic triptych. The image of the Symbolist "state of mind" always implied the suspension of the act and the immobility of bodies to concentrate the exploration of the inner world, whereas for Futurist modernism, the state of mind stemmed from action. The words "before" and "after the flight", which Depero wrote on the photographs, gave them the significance of a vestige of the event experienced. On other occasions, it was the context itself of Italian politics in those years that gave birth to the sensationalist aspect of Futurist action. In 1925, during an extravagant exhibition of "Futurist waistcoats" in front of the Porta Nuova railway station in Turin, Marinetti and Depero were the impassive protagonists of an urban performance in which the artist directed himself in the role of a trouble-maker clown. Depero returned to the themes of his early photo-performances, converting them into a new metaphorical image – the artist as visionary. He had himself photographed among the lights of a variety stage set with brush in hand, eyes wide open in astonishment, totally overwhelmed by his visual hallucinations. He also posed for Futurist portraits, in which he explored the sensation of mystery and magic produced by a scene rendered as a light-and-shadow show. In several other more improvised photographs he appears on a journey or on a visit to other Futurists. The image became a pretext for theatricality when Depero captured the singularity of a fence, which he used to satirize both the spatial organization of monocular perspective and the religious iconography of the decapitation of St John the Baptist. However, the image is emblematic when Depero flaunts his works of applied art in the company of the Sicilian Futurist poet Guglielmo Jannelli, thereby hinting at the activities and creations of the Futurist movement as an alternative culture within the orthodoxy promoted by Fascist power.

In this type of documentary reportage, which typifies the extensive range of research into the image and consequently the orientation of the Futurists towards the modern industrial culture of the mass media, the frontal pose is most common, signifying an attitude of defiance or self-assurance. Depero counters the sometimes intimist aspect of the group photograph by modifying the frame with scissor-cuts to create geometrical slashes radiating outwards, the aim of which was to stress the material quality of the work but also the vital immediacy of the image. Tato and Maraini, on the other hand, were the first to conceive the formal elements of a dynamic language that was later taken up by other Futurists – for example a composition with an off-centre corner, an image positioned on the bias or diagonal, the accentuation of asymmetry, the object or figure in the foreground on the axis of the vanishing point. Depero used similar techniques in all his photographic research, turning it into a critical exercise, a theme for reflection, making the ideas that produced the creative act visually explicit. He had several photographs taken of himself during work on the sculpture *Gloria plastica a Marinetti* (Artful glory to Marinetti), then cut out the photographs so that they drew attention to the pyramidal structure of the work. The construction of the Padiglione del Libro (Book Pavilion), which initiated a principle of Futurist architecture by the use of the plastic and decorative "lettering" theme invented by Le Corbusier, gave Depero the opportunity to take a large number of photographs of the interior and exterior of the building. By using low shots, close-ups and changes of the camera angle the images are studied one after the other to document the structure of the pavilion in terms of "typographical architecture", to convey the totemic outline of the built form and the way it shoots up into space, and to express the power of the plastic lettering in relief and the monumental scale of the volumes.

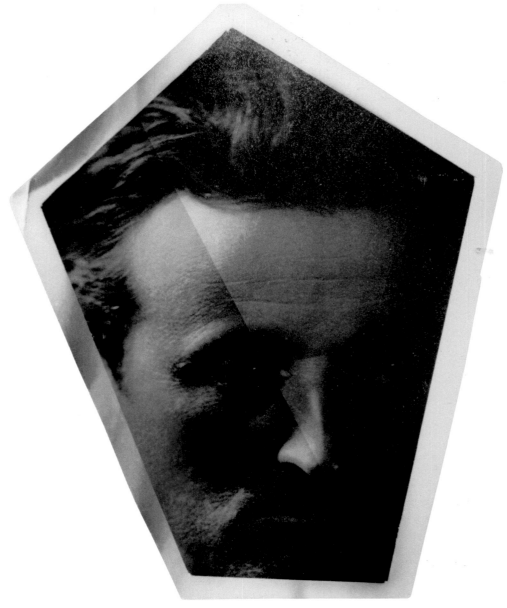

Arturo Bragaglia ◆ *Prampolini and Archipenko* ◆ 1921, gelatin silver print, 26.5 x 19.5 cm ◆ private collection, Rome

Arturo Bragaglia ◆ *The Futurist Gerardo Dottori*, pentagonal photographic construction ◆ *c.* 1920, gelatin silver print, 19 x 15 cm ◆ Archivio G. Dottori, M. Duranti, Perugia

The prevailing feature of the 1920s, born with the post-war industrial reconstruction, was the new poetics of "mechanical art". After founding a paradoxical "society for the protection of machines", Azari applied the spirit of this idea to photography, depicting enormous industrial machines with a fetishist gaze. Isolated in the deserted space of the factory and photographed like sculptures, the machines assume a hieratical and solemn dignity, appearing as true works of art. Azari used the same technique to photograph aeroplanes in flight or lined up in deserted hangars. Alberto Monacchini, Giulio Parisio, Enrico Pedrotti and Emidio Filippini used a similar technique in their photographs of machines and industrial plants. After the mid-1920s, the poetics of mechanical art drew inspiration from different sources, which transformed its language and its formal models. The myth of industrial progress extended to a social vision of modernism, through scenes of workers on the shop floor. The great building projects carried out by the régime for the country's industrial development were the object of photojournalism and photographic campaigns

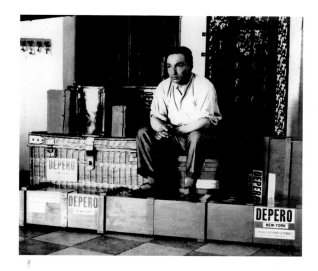

Anon. ◆ *Depero waiting to embark for New York* ◆ 1928, gelatin silver print, 18 x 21 cm ◆ MART, Archivio del '900, Rovereto

Fortunato Depero ◆ *Returning from New York: the decks of the motor-ship 'Roma', October 1930* ◆ 1930, gelatin silver print, 16.5 x 23 cm ◆ MART, Archivio del '900, Rovereto

Rosetta Amadori Depero ◆ *On the Atlantic: Depero on board the motor-ship 'Roma'* ◆ 1930, gelatin silver print, 17 x 41 cm ◆ MART, Archivio del '900, Rovereto

in which the Futurists demonstrated their enthusiastic support for the notion of a new Italy. A historical photographic tradition in the country, which had started in the mid-nineteenth century with the Alinari brothers, and Sommer and Brogi, had turned Italy into the land of "museum cities", with its monuments and splendours of an inimitable past. Italy could be considered nothing short of "an open-air museum", to quote the famous phrase coined by Quatremère de Quincy. In their industrial photography, the Futurists militated against the pictures taken for tourists in which Italy was "mummified" by its works of art, and refuted the idea of a country caught in a time warp. Instead, they used photography as a means of propaganda, to promote a forward-looking Italy. Filippini used this technique in his photography of the production stages at the Manifattura Tabacchi near Trento, and showed groups of workers and powerful machines in the hydroelectric plant at Ponale, Riva del Garda. Parisio made several visits to Southern Italy and the African colonies to photograph the advent of industrial modernism and the transformations in progress in the working world. However, for Fillia, Diulgheroff and Depero the genre of "mechanical art" was limited to simple stylistic effects, sometimes influenced by other European groups involved in mechanical aesthetics, based on the theories of such artists as Van Doesburg, Léger and Mallet-Stevens. The photographs made in October 1930 by Depero on the bridge of the ship *Roma*, on his return from New York to Italy, are examples of the celebration of mechanical forms in the "paquebot" style.

By frequently converging with research by foreign avant-garde movements, Futurism was in fact continuing to develop ideas that had been an integral part of its own founding poetics. The mechanical aesthetic proposed in the post-war period by such magazines as *L'Esprit Nouveau* in France or *De Stijl* in Holland was, in fact, inspired by the first Futurist manifestos devised by Marinetti. In other cases, the integration of formal solutions and expressive themes explored by the foreign avant gardes led Futurism to capitalize on the opportunity to claim it was a global avant-garde culture opposing the classicist revival promoted by Fascism. During the dictatorship set up by the Fascist régime, Futurism thus provided the only Italian opening towards European culture. In photography this integration of expressive orientations typical of other foreign avant-garde groups such as Purism, Dadaism, Constructivism, Surrealism and the Bauhaus concerned three specific areas of research: abstraction, photographic collage and montage, though in all three there was already a specifically Futurist creative tradition.

As a militant revolutionary movement founded on the trio "art–life–action", Italian Futurism was stirred by a concern for ethics, which prevented the movement from developing a complete theory of abstract art. Marinetti had spoken of this when he claimed for art the role of a social

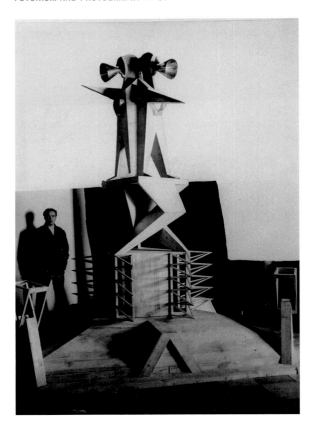

instrument that banned the language of abstraction viewed as a purely formal exercise. Both Boccioni and Balla had experimented with art that was virtually abstract but whose abstraction was merely a means of conveying *kinesis* and *dynamis* – still the two fundamental expressive tenets of Futurist art. Prampolini, as an exponent of the second generation of Futurists, disagreed with Kandinsky, stating that abstract art could not derive from an alchemy of the interior world but could only be the extreme consequence of a dynamic sensation, both physical and psychic, which meant being in the world in its becoming. In photography, a form of abstraction in line with Futurist work was provided by the ethereal images produced by the Bragaglia brothers' photodynamism. The way in which the Futurist tradition received new impetus in the mid-1920s from the contribution of other expressive ideas can be seen in Pedrotti's photographs, for example, showing the tracks left by skis and sleds in the snow. The desire to produce an abstract representation capable of transcending material elements is evident in both the composition and the tones of the image. The "rarefied" photograph, namely one showing the most subtle gradations of grey verging on white, using the technique called "high key", here acquires a calligraphic nuance that expresses the typically Futurist formal themes of energy paths and lines of continuous movement. In other instances, the photographs of mechanical art overcome the fetishism of the industrial machine to become pure rhythms of light and forms in the style of the most famous photographs by the German Bauhaus artists. The formal experiences gained in Europe thus penetrated Italy, breathing new life into photographic research by the Futurists.

Futurist experiments also included specific research in the area of photocollage and photomontage – two close techniques, though with clear differences. Born of mass journalism, photocollage made it possible to insert a fragment of a photograph into a drawing, co-ordinating

Emidio Filippini ◆ *Depero during the creation of 'Artful glory to Marinetti'* ◆ 1923, gelatin silver print, 42 x 30 cm ◆ MART, Archivio del '900, Rovereto

Anon. ◆ *Fortunato Depero, Guglielmo Jannelli and friends with Depero's tapestries at Castroreale Bagni* ◆ 1924, gelatin silver print, 8.5 x 13 cm ◆ MART, Archivio del '900, Rovereto

Studio Bassani ◆ *Final installation of 'Artful glory to Marinetti' in the Depero room at the Esposizione Internazionale, Monza* ◆ 1923, gelatin silver print, 18 x 24 cm ◆ MART, Archivio del '900, Rovereto

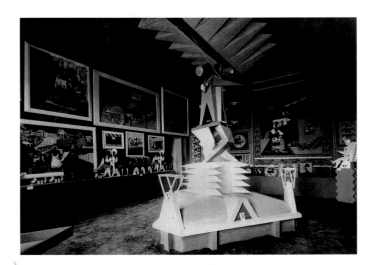

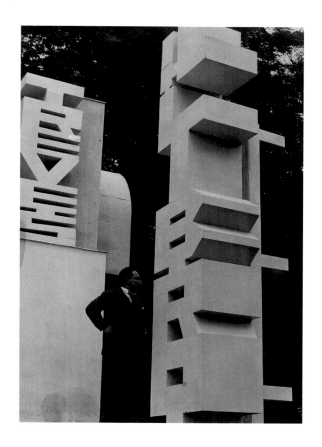

Anon. ◆ *Depero in front of the Book Pavilion* ◆ 1927, gelatin silver print, 23 x 17 cm ◆ MART, Archivio del '900, Rovereto

two different codes by means of cross-references and dialectics: the "fragment of reality" – which every photograph appears to be – and the mark of the artist's manual craft and imagination. The first photocollages of the Futurists were produced in 1914 in the plates for a book of "words-in-freedom" by Marinetti, which was never published, and in the paintings *Dinamismo di una testa di donna* (Dynamism of a female head) by Boccioni and *Dinamismo di una serata futurista* (Dynamism of a Futurist evening) by Marinetti and Cangiullo, to which can be added the illustration *Ufficiale francese che osserva le mosse del nemico* (French officer observing the enemy's movements) published by Carrà the following year. Gerardo Dottori and Gino Soggetti also used the technique of photocollage to some extent, and in the post-war period it was revived by Enrico Prampolini, Vinicio Paladini and Ivo Pannaggi, who applied this technique to posters as well as to book and magazine covers. Later on Nicolay Diulgheroff, Elia Vottero, Bruno Aschieri and Augusto Cernigoy made use of it as a political tool both for didactic and propagandistic purposes in accordance with the Futurist creed, which celebrated the technological era. Cernigoy juxtaposed fragments of photographs and cut-outs of coloured paper in his sketches of Constructivist-style sets. Pannaggi invented an original use of photocollage in his "mail collage".[33] This new form of Futurist mail art consisted of a photographic composition made on an envelope or a parcel sent by mail, which was sure to be anonymously completed by the postal-service staff, from the clerk at the post office counter, who would take the parcel and stamp it, to the postman, who would deliver it. Every stage would be materially recorded by postage stamps, rubber stamps, labels and various marks, and in so doing the post office staff would involuntarily contribute to the completion of a work of art, which would take on its final appearance only on delivery. The aesthetic promotion of the act of communication was typical of the experiments carried out by Futurists, but the provocation and

Anon. ◆ *Interior view with display cases of Depero's Book Pavilion* ◆ 1927, gelatin silver print, 23 x 16.5 cm ◆ MART, Archivio del '900, Rovereto

Anon. ◆ *Depero's Futurist typographical architecture: "The Book Pavilion of the Bestetti, Treves and Tuminelli publishing houses" at the III Mostra Internazionale delle Arti Decorative, Monza* ◆ 1927, gelatin silver print, 23 x 28.5 cm ◆ MART, Archivio del '900, Rovereto

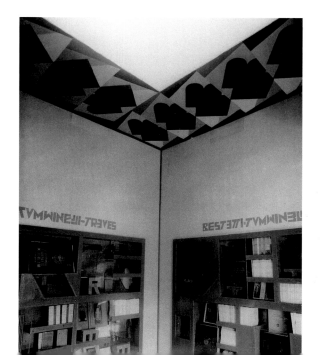

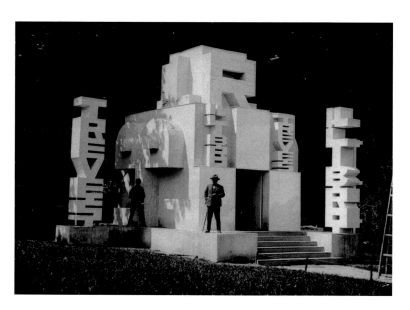

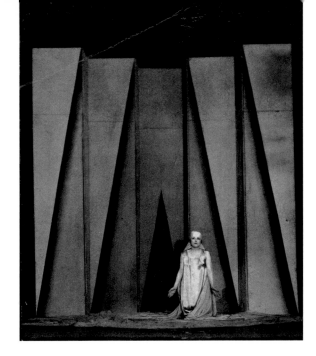

Iwata Nakayama ◆ *Maria Ricotti in a mimed interpretation of 'Poème érotique' set to the music of Edvard Grieg* ◆ 1927, gelatin silver print, 24 x 19 cm ◆ private collection, Rome

above and below

Iwata Nakayama ◆ *Photographs of scenery for 'Mercante di cuori'* ◆ 1927, gelatin silver print, 23.5 x 29.5 cm (above), 24 x 30 cm (below) ◆ private collection, Rome

integration of the fortuitous outcome into the artwork adds overtones of Dadaism to Pannaggi's "mail collage", effectively placing it in a tradition of expressive art ranging from Schwitters to *Nouveau Réalisme*.

Balla, meanwhile, reversed the principle of photocollage, also in a Futurist mail art perspective, by sending photographic postcards he had altered. In this instance, it was not the photographic fragment that was added to the artist's own work, but the opposite. By applying splashes of colour, drawings or words to the photograph, Balla modified the stereotypical image, changing its meaning and altering its aesthetic dimension. In effect, he raised the postcard to the level of work capable of influencing collective taste. Balla's interventions in some instances prefigured Cocteau's *photos écrites*, and would later be used in 'narrative art'. At other times his work followed a gestural style that intensified the dynamism of the image, though always in a playful and ironic fashion, without ever reaching the corrosive violence and grotesque expression demonstrated by Arnulf Rainer, who radicalized this type of experimental work in the latter half of the century and was the main heir to Futurist photo-performance.

Photomontage had been introduced into Futurist photography by the Bragaglia brothers and as a choice of expression had been endorsed on a theoretical plane by Anton Giulio Bragaglia, who had published two typical examples of this process, in 1913 and 1914. However, these images were obtained using a "layered montage effect" – a superimposition of two or more different negatives, resulting in effects similar to the fade-over that links two film sequences together. This early form of photomontage, called "photo-composition" at the time, was used alongside a more recent development in photomontage in the 1920s. In this technique different photographic images were cut out and stuck on to a flat surface, then assembled to form a highly organized, non-realistic language. So, in Italy, perhaps more so than in any other country, there were two fundamentally different schools of thought about how photomontage should be interpreted. On the one hand, it was considered research carried out in the darkroom, aiming to achieve the magic of transfiguring perceptions so as to protest against the commonplace appearance of objective reality by implosion. On the other hand, it was considered a practice that has a revolutionary, materialist calling, since cutting and contrasting fragments of the visible means breaking apart at once the elements that form reality and the organic unity of the work. The first tendency, which was a process that derived from a specific tradition in Futurism, includes experimentation by Tato, Luigi Pirrone and Mario Castagneri. The latter exhibited a series of photomontages in Milan in 1927 in which faces, nudes and figures are altered by differentiated stratification and repetition, while striking blue monochromes give the image an intense dreamlike sensation. The second trend relates principally to the work of Pannaggi and Paladini, which borrowed the formal models of the Dadaists and Constructivists from Germany or Eastern Europe. Pannaggi was heavily influenced by Rodchenko, creating photomontages with a syncopated rhythm, pervaded with irony and inspired by the themes of mechanical art. Paladini, on the other hand, was attracted to the cartographic compositions of Hanna Höch and the "photoplastic" work of Moholy-Nagy, producing photomontages that were more narrative, which he termed "Proustian", having a symbolic content and a highly structured form. Both artists were the driving force behind the rapid dissemination of photomontage in Italy in cultural circles directly linked to, or close to, avant-garde work, through illustrations in the press, posters, book and magazine covers. Photomontages were also made by Diulgheroff, Depero and Fillia, the last of whom exhibited a self-portrait in Constructivist style in Turin in 1928.

The penetration into Futurism of formal concepts that had originated elsewhere obviously needs to be considered in the more general context of the protean development of the post-war foreign avant-garde groups, who had continuous and frequent contacts at an international level. After an extended stay in Prague, Prampolini settled in Paris, where he joined in the activities of the Cercle et Carré group, made friends with Florence Henri, with whom he shared a studio, and associated with André Kertész, who made many portraits of him, both alone and in groups with

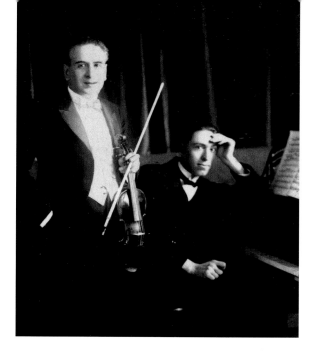

Scharankoff ◆ *Portrait of Silvio Mix at the piano* ◆ *c.* 1925, gelatin silver print, 17 x 11.5 cm ◆ private collection, Rome

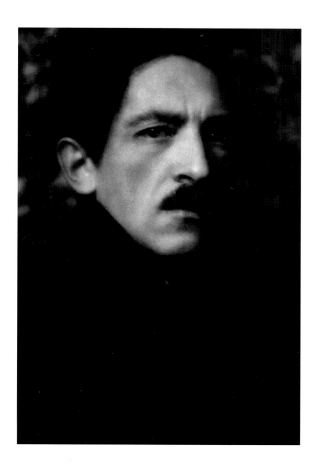

Mario Castagneri ◆ *Portrait of Emilio Settimelli*, dedicated to Vincenzo Ruggero ◆ 1925, bromide print, 13.5 x 8.4 cm ◆ Malandrini Collection, Florence

other avant-garde artists. In 1927, together with Silvio Mix and Franco Casavola, Prampolini produced a show at the Futurist Teatro della Pantomima in Paris, delegating the photography to Iwata Nakayama, who produced a series of images in a modern style that had become typical of many avant-garde groups: geometrical lines, sudden foreshortening, abrupt changes in rhythm and volumetric forms. After retouching these photographs to remodel their reliefs and forms so that they would suggest another interpretation, Prampolini started his own experimentation. With exaggerated close-ups, he made self-portraits in a style that imposed compactness of form, and completed his images with abstract graphics. The subtle balance between the immediacy of the fragment and the psychological complexity of the image reveals the influence of the Bauhaus artists. However, such experiments enabled Prampolini to be part of the European avant garde without having to give up Futurism. A similar tendency can be noted in the other strands of the avant garde. Kertész made a portrait of Prampolini, Michel Seuphor and Paul Dermée in which all three were wearing headphones connected to a radio. The photograph is an emblematic *Omaggio a Marconi* (Tribute to Marconi), in which the Futurist theme dovetails with the celebration of modernism *per se.* Florence Henri drew upon Futurism when, among other things, she produced a series of portraits of Arturo Ciacelli. Even the research by some of the Bauhaus artists, such as Karl Straub, Hans Finsler, Lotte Beese and Moholy-Nagy, were inspired by the photographic experiments of the Italian Futurists for their studies of movement, doubling and dynamic superimpositions.

The avant garde had by now become a shared culture, uniting artists across national boundaries. Pannaggi often went to Germany and visited the Dadaist community there. He stayed in Berlin from 1927 to 1929, living in the house of Leni Herfeld, the sister of John Heartfield. He also associated with Schwitters and met the philosopher Walter Benjamin. Pannaggi's work was highly esteemed by Benjamin, who introduced him to the editing staff of the daily *Welt-Spiegel* so that his photomontage *Berliner-Börse,* an emphatically political work, could be published. Paladini also had left-wing tendencies and travelled to Paris and Moscow. He corresponded with Michel Seuphor, with the magazine *Het Hoverzicht* of Antwerp, and also with Karel Teige and the artists of the *Red* magazine group in Prague. In 1926 he decided to found a movement called Imaginism in Rome, which was to be a satellite Futurist group, and devised a new aesthetic. The main thrust of this new trend was the technique of manipulating materials, which played an important role in photomontage. He then undertook a new series of photomontages on dreams interpreted as subjective reality, on urban culture and on sport, as themes of modernism. His technique consists of quoting from Muybridge's photographic cut-out sequences and photojournalistic fragments of the American press, combining them in images endowed with the strong gestural component that would later inform the aesthetic of Mec Art. The Futurists of the Trieste group, such as Cernigoy and Giorgio R. Carmelich, also carried out experimental research similar to that of the central European avant gardes, being geographically closer to Berlin and Prague than to Milan or Rome. Cernigoy used a mirror to create anamorphoses and optical distortion, while Carmelich – an artist with a forceful personality – explored the theme of the artist's self-portrait in a style that had grotesque, Expressionist and neo-Dadaist features. He photographed himself in costume or wearing a mask, assuming surreal and enigmatic poses. His staging of the multiple and problematic identity of the artist included a dialogue with a Classical statue – an image that appears as the archetypal contrast between the seriousness and the playfulness of art. Another image explores the splitting of the Ego and a series of allegorical objects, such as flasks, scissors and measuring instruments placed around an open book so as to show reading as an imaginary activity. In his work on the themes of effigy and the image as mere appearance, Carmelich was innovative mainly when photographing long, thin, stylized paper puppets or arbitrary compositions of everyday objects transformed by the play of shadows into anthropomorphic presences and disquieting psychological landscapes. In the following decade, Tato was to become the most zealous ideologist of these new forms of expression in Futurist photography.

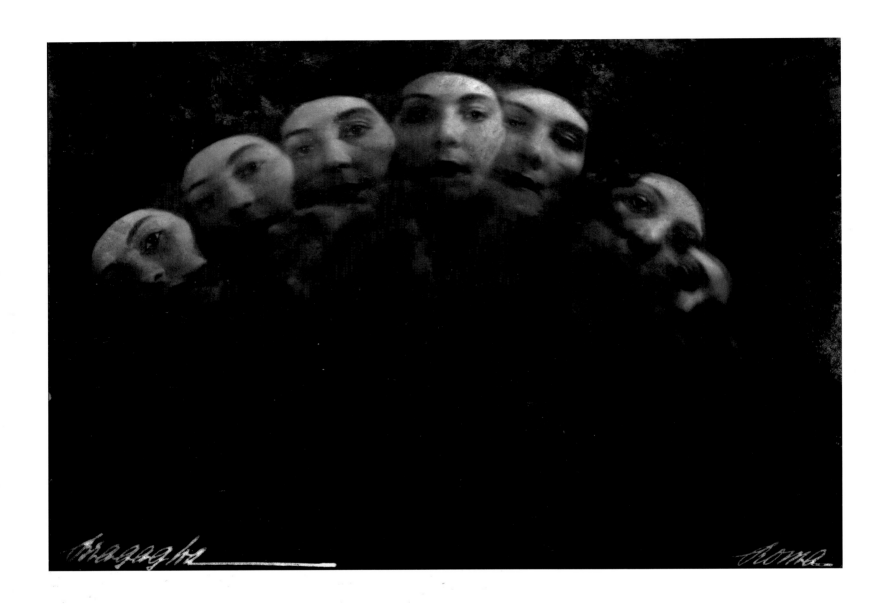

Arturo Bragaglia ◆ *Photodynamic portrait of a woman* ◆
c. 1924, gelatin silver print, 11.5 x 16.2 cm ◆ The J. Paul
Getty Museum, Los Angeles

Arturo Bragaglia ◆ *Child* ◆ *c.* 1920, sepia-toned gelatin silver print, 16 x 12 cm ◆ Malandrini Collection Florence

Mario Castagneri ◆ *Female nudes* ◆ 1927, gelatin silver print, 29.5 x 23.5 cm ◆ Museo di Storia della Fotografia Fratelli Alinari – Castagneri Archive, Florence

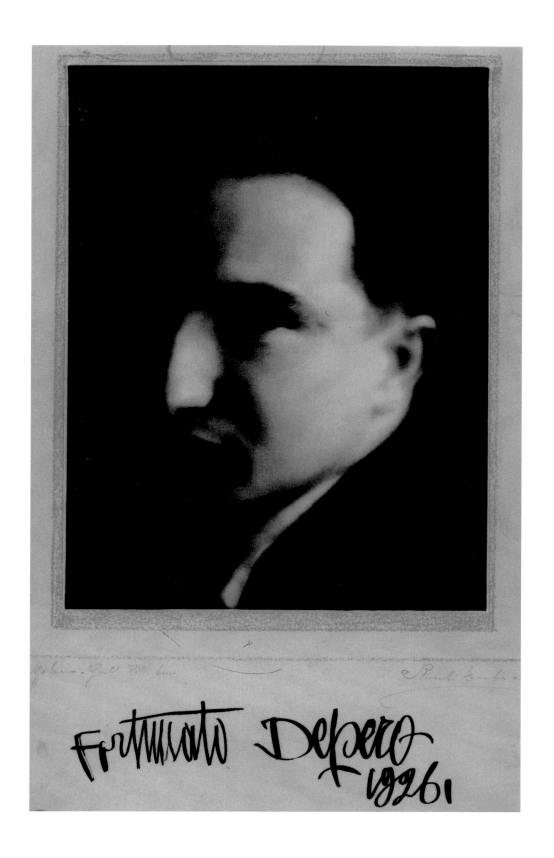

Studio Stucchi Recchia ◆ *Fortunato Depero in Milan* ◆ 1926, gelatin sliver print, 23 x 17 cm ◆ MART, Archivio del '900, Rovereto

André Kertész ◆ *Portrait of Enrico Prampolini* ◆
1927, gelatin silver print, 8 x 12 cm ◆ private
collection, Rome

André. Kertész ◆ *Portrait of Mondrian, Prampolini,
Seuphor* ◆ 1926, gelatin silver print,
8.3 x 12.5 cm ◆ private collection, Rome

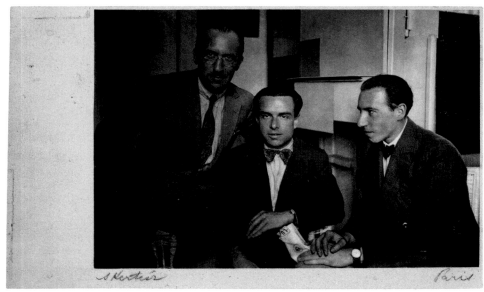

André Kertész ◆ *Rue de la Grande Chaumière* ◆
1928, gelatin silver print, 8.3 x 12.5 cm ◆
private collection, Rome

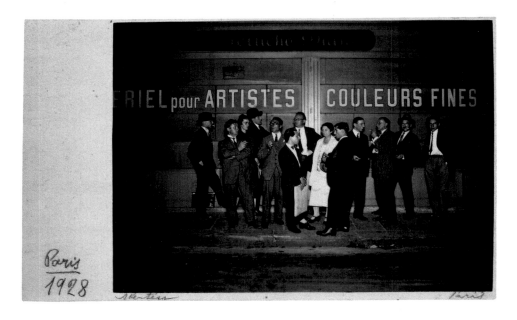

Studio Caminada ◆ *Portrait of Fedele Azari* ◆ 1920,
gelatin silver print, 23.5 x 17 cm ◆ MART, Archivio
del '900, Rovereto

Emidio Filippini ◆ *Fortunato Depero* ◆ 1923,
gelatin silver print, 23 x 17.5 cm ◆ MART,
Archivio del '900, Rovereto

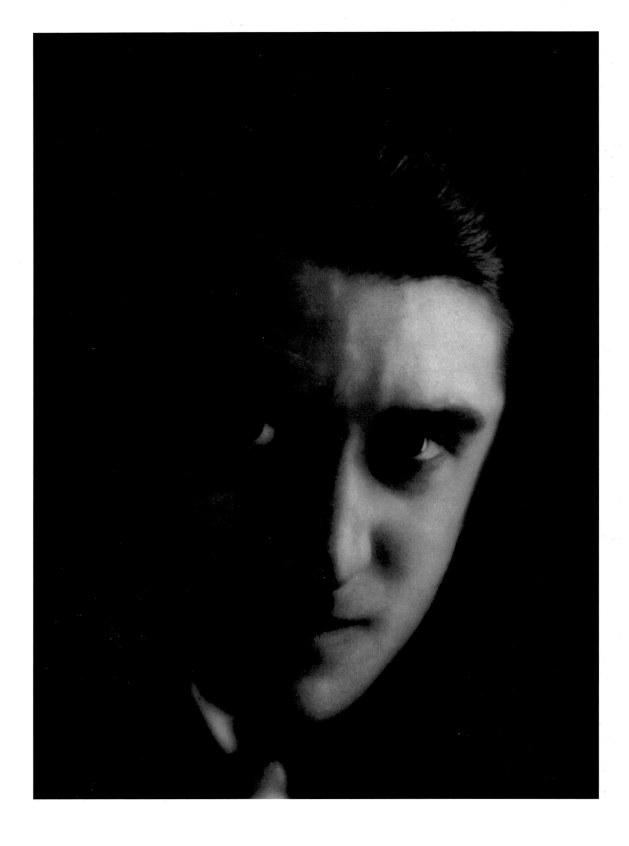

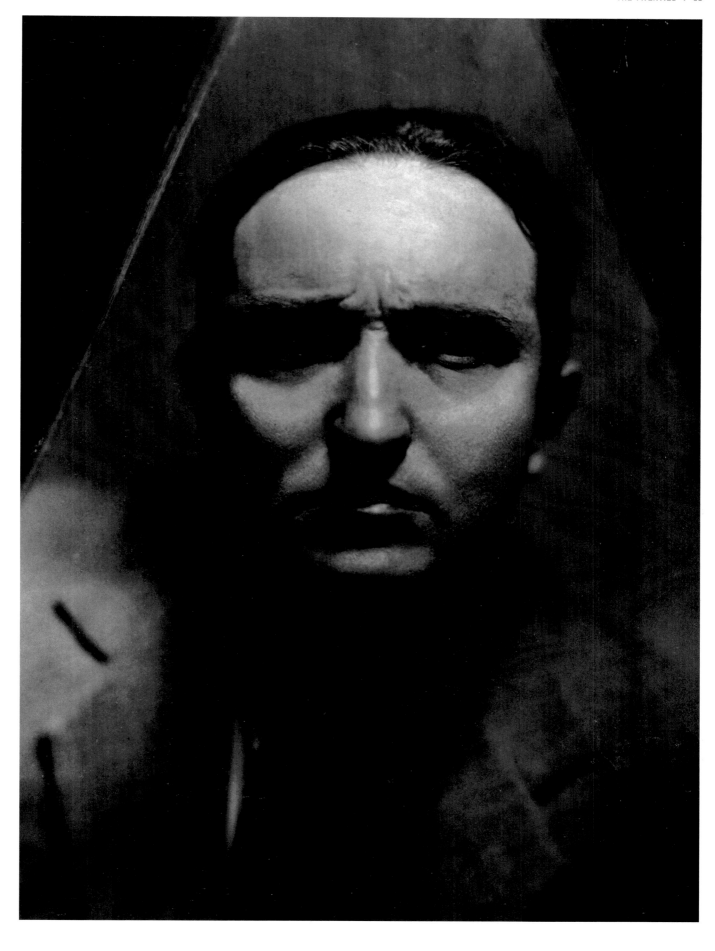

Emanuele Lomiry ◆ *Marinetti and the Futurists Baroni, Azari,*
Rizzo, Ravelli, Casavola, Gerbino, Catrizzi ◆ 1925, gelatin
silver print, 31 x 20 cm ◆ private collection, Milan

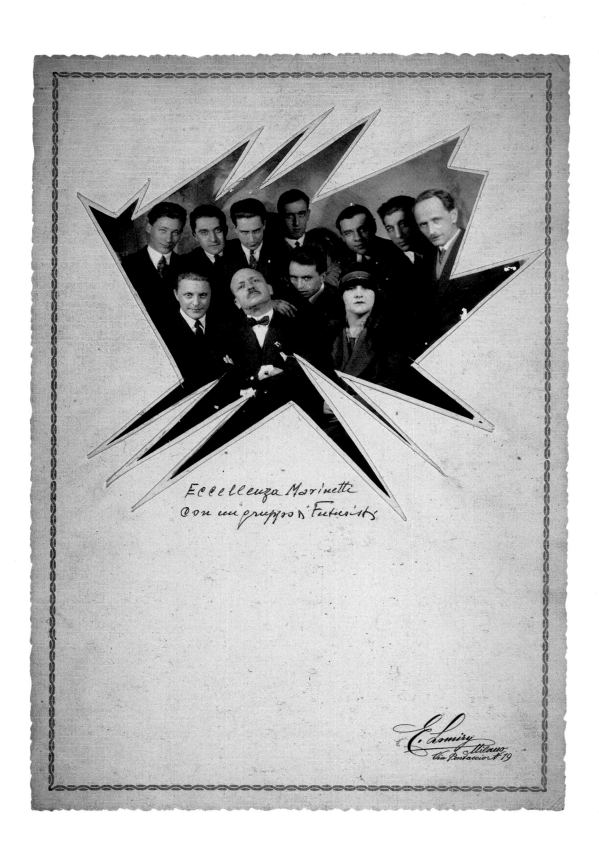

Enrico Prampolini ◆ *Self-portrait* ◆ 1927,
gelatin silver print, 22.5 x 18 cm ◆
private collection, Rome

Enrico Pedrotti ◆ *Skier*
◆ 1927, gelatin silver print,
38 x 26 cm ◆ Foto Studio
Pedrotti, Bolzano

Enrico Pedrotti ◆ *Tracks*
◆ 1929, gelatin silver print,
29 x 26 cm ◆ Foto Studio
Pedrotti, Bolzano

Giorgio Riccardo Carmelich ◆ *Photographic composition* ◆
c. 1928, gelatin silver print, 11 x 8.5 cm ◆ private
collection, Trieste

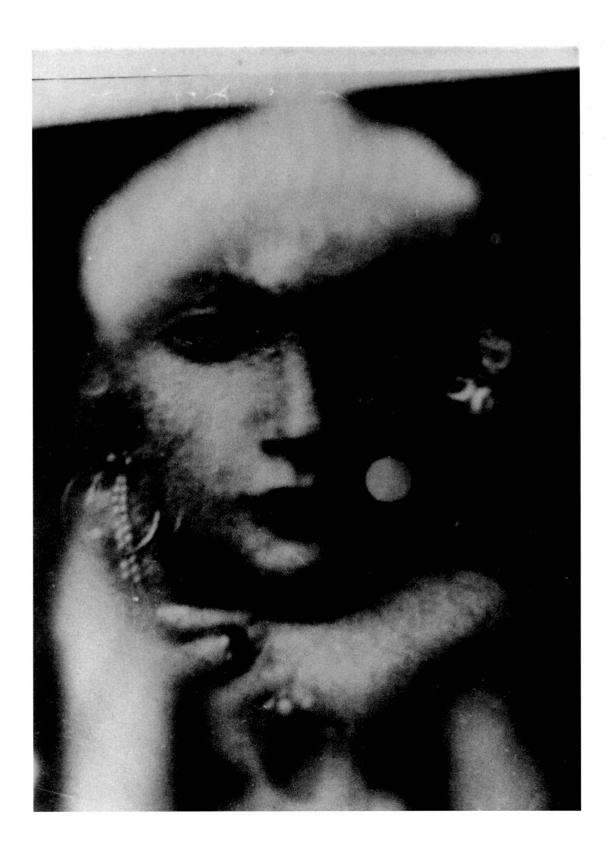

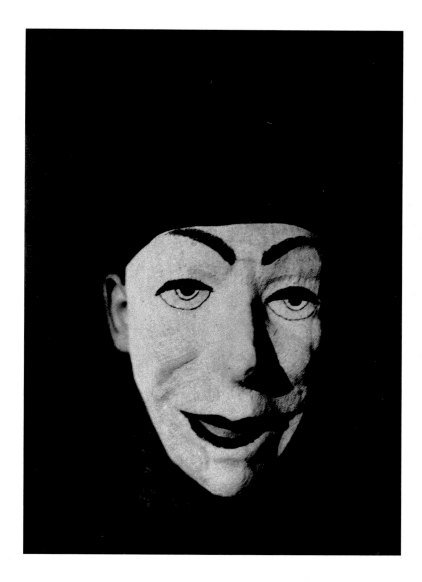

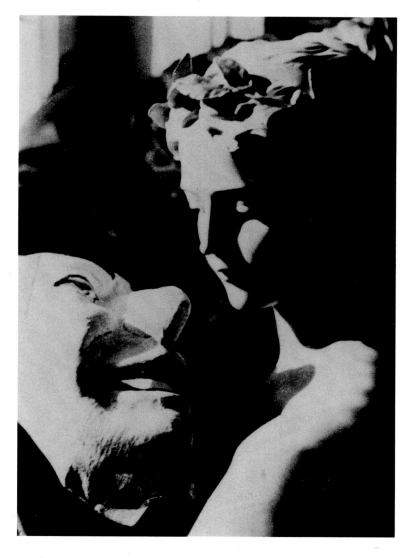

Giorgio Riccardo Carmelich ◆ *Photographic composition*
◆ *c.* 1928, gelatin silver print, 11 x 8.5 cm ◆ private collection,
Trieste

Giorgio Riccardo Carmelich ◆ *Photographic composition*
◆ *c.* 1928, gelatin silver print, 11 x 8.5 cm ◆ private collection,
Trieste

Studio Abeni ◆ *Depero in a dressing-room* ◆
1927, gelatin silver print, 22 x 17 cm ◆
MART, Archivio del '900, Rovereto

Studio Abeni ◆ *Depero, painter and poet* ◆
1927, gelatin silver print, 22 x 17 cm ◆
MART, Archivio del '900, Rovereto

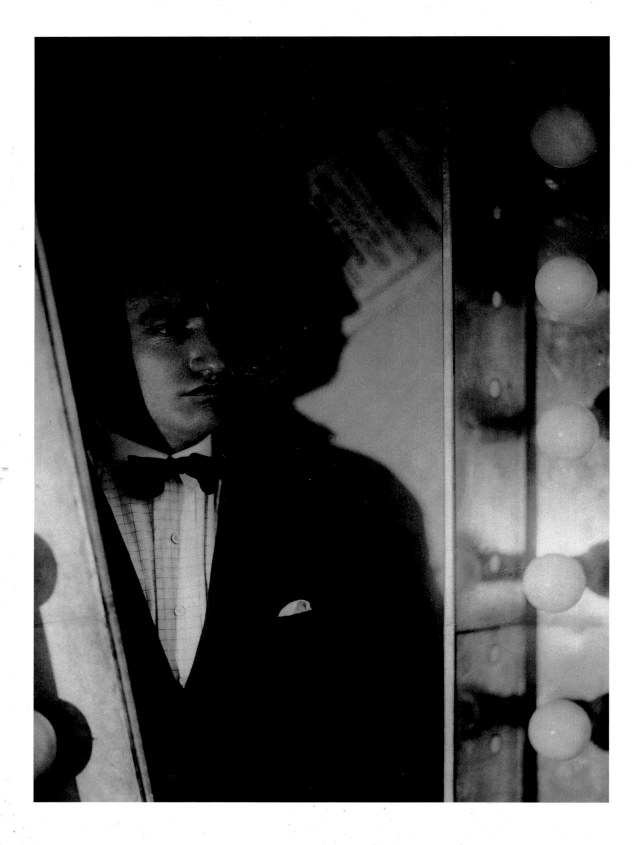

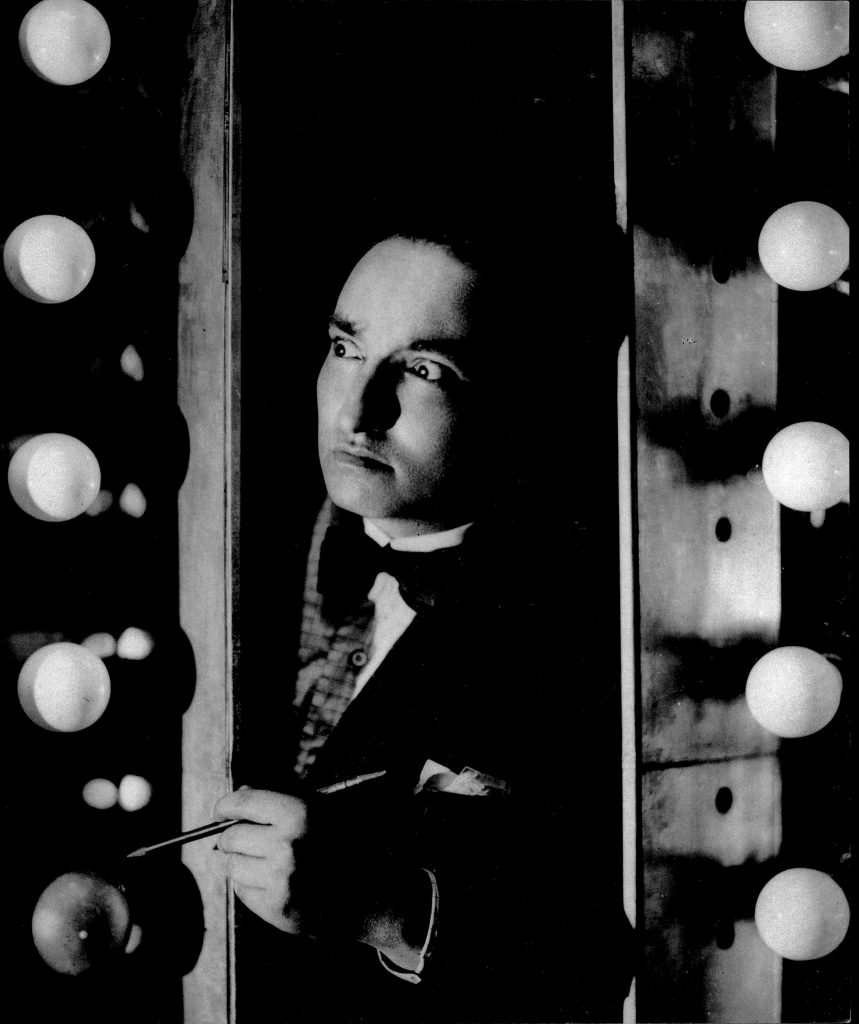

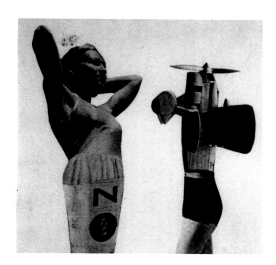

THE THIRTIES

Bruno Munari ◆ *And thus we would set about seeking an aeroplane woman* ◆ 1939 ◆ detail; see p. 116

THE POST-WAR YEARS

were marked by the poetics of mechanical art and the spread of the formal models and choices of expression that were typical of the foreign avant-garde movements. In the following decade, the theme of aeroplanes became popular and there was a vibrant revival of more specific Futurist research. This return to forms of expression that belonged to the Futurists' own national culture co-existed harmoniously with the trend that had held sway in the 1920s. While Futurism continued to show interest in European culture, an attempt was made to produce a national avant-garde culture. Marinetti did not want Futurism to play a secondary role to international modernism, and his actions were of great historical significance in these years of repression, when modern art was accused of being "degenerate art". Futurism also needed to promote a culture of modernism that was typically Italian, and to continue to provide an active and original contribution to the creation of new art forms. Consequently, Marinetti constantly sought to relaunch the early ideas of Futurism in order to assert an Italian avant-garde tradition.

In line with the latest trends in modern European culture, the Futurists continued to produce photocollages and photomontages, using a style that they adapted to specific circumstances, depending on the environment they were working in and their own sensibilities. Depero used a combination of techniques for the retrospective illustration of his long stay in New York. In *Traversando lo Hudson sul ferry-boat* (Crossing the Hudson on a ferry), he reinterpreted the Futurist tenet "words-in-freedom" accompanied by the geometrical compositions of Constructivism. In so doing, he created a calligram that runs along the centripetal axes of a rotating composition containing a collection of images of the voyage. The theme is the sensation of the immensity of space and the centrality of the Ego, which is symbolized by the ferry on the water. In *Alla scoperta di New York* (Discovering New York), Depero gives an account of his experience of the metropolis in the form of photojournalism, taking up an entire page in an illustrated newspaper with photographic cameos in a composition of diagonals and verticals interwoven with the text. In their photocollages, Adele Gloria, Wanda Wulz and Renato Fazioli also used non-photographic materials. Bruno Munari combined photography with an iconographical element popular with Max Ernst – engravings and old prints – using this technique for humorous photomontages in the novel *L'Aeroplano innamorato* (The plane in love) by Luigi Bonelli. These

Fosco Maraini ◆ *Fillia in front of his paintings and between the sculptures of Luigi Pepe Diaz and Mino Rosso, in the Futurist room at the XVII Venice Biennale* ◆ 1930, gelatin silver print, 18 x 29 cm ◆ MART, Archivio del '900, Rovereto

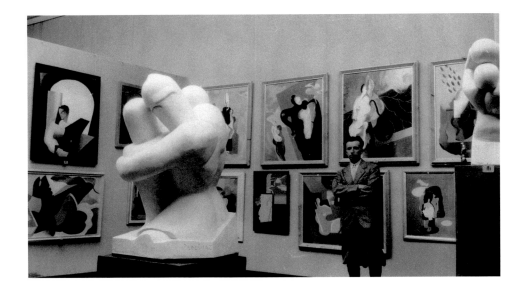

Tato ◆ *Marinetti and Mino Somenzi among the members of the Savona-Albisola Futurist group, at the inauguration of the Prima Mostra Italiana d'Arte Futurista, Rome* ◆ 1933, gelatin silver print, 12.5 x 17.5 cm ◆ MART, Archivio del '900, Rovereto

Tato ◆ *A room of the Prima Mostra Italiana d'Arte Futurista, Rome* ◆ 1933, gelatin silver print, 17.5 x 12.5 cm ◆ MART, Archivio del '900, Rovereto

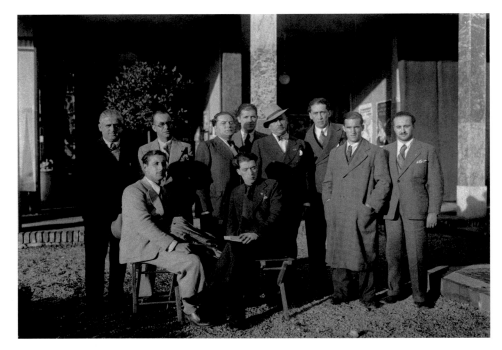

images link the new with the old, echoing themes typical of folk culture ranging from mythological metamorphoses to nineteenth-century literature, including natural landscapes with enigmatic townspeople, women-aeroplanes in a fashion show and women-machines dancing. Cesare Cerati produced narrative compositions, building up cut-outs of photographs based on a logic of causality and analogy. Vinicio Paladini's research was more complex, and drew its inspiration from German Expressionism, though he mostly used vast painted backgrounds containing geometrical forms. He used fragments of photographs and coloured paper and, like Ernst Preusser, figures from famous paintings so as to make contrasts that would suspend the image in a time warp, thus moving away from the urgency of the militant document that was typical of photomontage at that time. He also produced images of Olympic sports in an extremely iconic style, as mental representations, shunning the theme of the glorification of athletic physique, which was politically in vogue. He placed fragments of Classical statues in a linear grid, contrasting the values of geometry with the volumes of organic form.

Tato ◆ *A room of the Prima Mostra Italiana d'Arte Futurista, Rome* ◆ 1933, gelatin silver print, 17.5 x 12.5 cm ◆ MART, Archivio del '900, Rovereto

The techniques of photocollage and photomontage were also used in mass propaganda. Munari worked for the *Almanacco Bompiani*, providing advertisements in the style of Mieczyslaw Berman, which hailed the great "economic battles" launched by the Fascist government to increase agricultural and industrial production. Tato's compositions for the covers of the magazine *La Stirpe* celebrated Mussolini as the supreme head of Italy. Pedrotti designed the posters for the G.I.L. (Gioventù Italiana del Littorio, an Italian youth movement), the school that was supposed to produce the nation's future élite. The aim of the Futurists was to oppose the cultural conformism of the régime through a policy of images that aimed to rally the masses in Fascist Italy. Prampolini, Tato, Esodo Pratelli, Amorino Tambesi and Marcello Nizzoli took part in grand exhibitions that commemorated the exploits of Fascism with vast educational panels for propaganda purposes, called "photo-plastics". This was a form of "photo-mosaic" with three-dimensional elements in relief that invade the physical space of the observer, thereby intensifying the emotive impact of the composition.

Even when it was not the result of compromise by one individual, the voluntary involvement of the Futurist movement in the social and political manœuvres of Fascism was Marinetti's aspiration and he never missed the opportunity to celebrate the interest of the régime in urban and industrial modernism. In 1933 Marinetti declaimed a "Futurist encomium with compenetration of lyrics+noise" live on radio to celebrate Italo Balbo's second Atlantic crossing by aeroplane, a spectacular exploit in which twenty-four Italian seaplanes flew over New York and Chicago. To welcome them on their return, Marinetti went up on to the roof of a radio station so that his voice declaiming Futurist verse could be heard by the audience with the noise of the seaplane engines in the background as they flew over Rome. Umberto Perticarari photographed this "performance",

Anon. ◆ *Marinetti and the Futurist group at the Galleria Pesaro, Milan* ◆ 1933, gelatin silver print, 18 x 19 cm ◆ MART, Archivio del '900, Rovereto

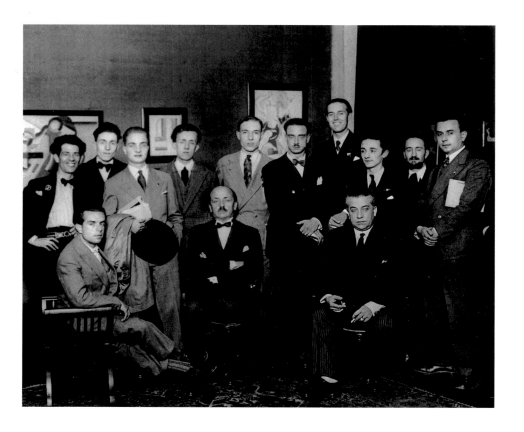

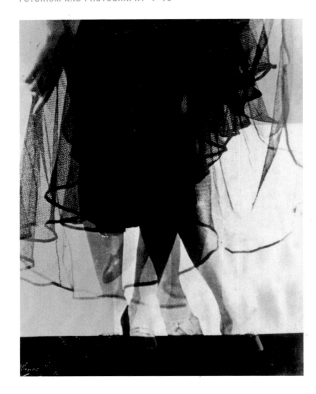

Wanda Wulz ◆ *Wunder Bar* ◆ 1932, reproduction on glossy paper, 27 x 21 cm ◆ Museo di Storia della Fotografia Fratelli Alinari – Wulz Archive, Florence

Wanda Wulz ◆ *Gymnastic exercise* ◆ 1932, reproduction on glossy paper, 29.5 x 22.5 cm ◆ Museo di Storia della Fotografia Fratelli Alinari – Wulz Archive, Florence

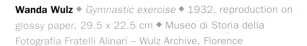

attempting to capture the sense of patriotic enthusiasm. Futurist photographs of mechanical art, sometimes similar to work by Germaine Krull, or the industrial photographs by Pedrotti, were intended to underpin the role of Fascism in modernizing the country and creating a feeling of unity among Italians. The dynamism of Futurism was quite exceptional. In Italy, Futurist art was supported by private galleries, such as the Galleria Pesaro in Milan, and was shown at all great cultural events, such as the Venice Biennale. The Futurists organized numerous exhibitions themselves, which bonded the movement together and made the various forms of avant-garde art popular, resulting in Futurism becoming an alternative mode of expression to the official culture of the régime. Meanwhile, abroad Futurism was considered an integral part of the new avant-garde culture and many artists continued to consider Marinetti as a spearhead of modernism. Mario Bellusi, Luigi Pirrone and Pedrotti exhibited their photographs in Germany and France, and when Marinetti visited Berlin in 1934 to open a Futurist exhibition, Schwitters publicly paid tribute to

Fortunato Depero ◆ *Discovering New York* ◆ 1931, photocollage, 34.5 x 23 cm ◆ MART, Archivio del '900, Rovereto

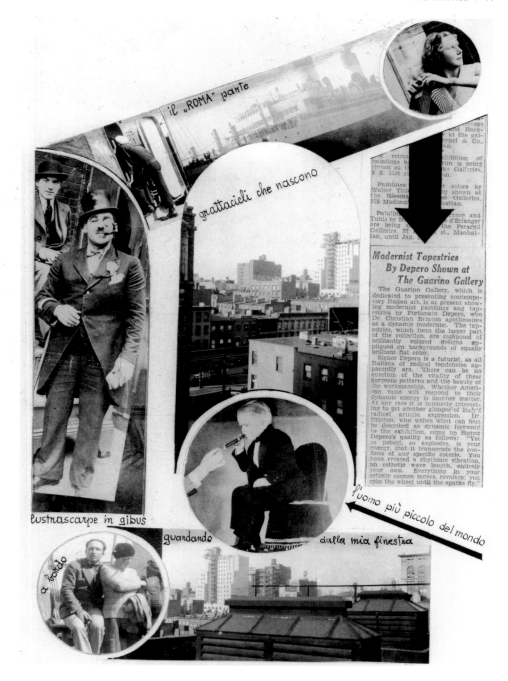

Studio Schuch ◆ *Meeting between Marinetti and the German abstract painter Rudolf Bauer in Berlin* ◆ 1934, gelatin silver print, 18 x 24 cm ◆ MART, Archivio del '900, Rovereto

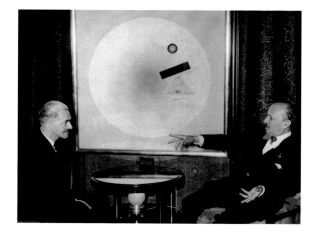

him. The photographer Lotte Jacobi made several portraits of Marinetti standing next to Futurist paintings, and the abstract artist Rudolf Bauer liked to be photographed in front of his works, in conversation with the Italian poet.

Contact with the foreign avant-garde groups reflected the cultural climate of the times and explains the similarity of much of the research carried out. Emanuele Lomiry produced group photographs on the "state-of-mind" theme, which, though belonging to the Futurist cultural tradition, also conjure up images of the Surrealist *séances de sommeil*. New photographs of the Turin shroud by Giuseppe Enrie aroused interest in the negative image, while Maggiorino Gramaglia and Parisio used it in fantastical and surreal compositions that allude to séances or dreams. There was also experimental research into abstract photography, inspired by the work of Man Ray, Moholy-Nagy and Oskar Nerlinger, which was based merely on the technical autonomy of the medium itself. Raffaele Baldi, Romeo and Umberto Baraldi created photographic impressions

without using a lens, while Tullio D'Albisola, Munari, Tato and Giuseppe Guarnieri obtained impressions of objects through direct contact, sometimes without any semantic reference in the image. Amedeo Ferroli produced solid geometrical landscapes in the style of Herbert Bayer, while the abstract photographs on the theme of movement and energy by Ottavio Bérard and Giuseppe Albergamo were pervaded by Futurist poetics. Bérard used scientific microphotography to create the sensation of immediacy and the infrasensorial elements of a physiological reaction. Albergamo, on the other hand, expressed the "webs of light" produced by the lamps and projectors in the night sky of Palermo. The Futurists were particularly interested in dematerializing the image. Parisio tried to express the atmosphere and the hubbub of the crowd through reflections on shop windows or the metal surfaces of signs outside clubs and bars. Munari, Maraini and Pirrone were fascinated by optical distortion and the distorting mirror, while Pirrone studied kaleidoscopic multiplication of the image in different reflections. The German artists explored Futurist ideas in their own way. Edmund Kesting used direct contact to create his conceptual images of enormous printed characters in the "words-in-freedom" style of Marinetti, while Marcello Nizzoli teamed up with Xanti Schawinski to carry out research.

The way in which Futurism honoured its commitment to the avant garde in a totalitarian régime is reflected in the way the Futurists developed their relationship with the medium of photography. Photo-performance was explored only by Tato, in his outrageous self-portraits and grotesque disguises that poke fun at his status of avant-garde artist. Depero planned a film-performance entitled *Futurismo italianissimo* (Very Italian Futurism), but never managed to produce it.[34] Futurist photo-performance, in fact, coincided with a stage of cultural militancy that could no longer be practised in a country dominated by Fascism. Emblematic photography, which was also a form of direct action, was abandoned in favour of an affective and intimist interpretation of the image. Instead of capturing the social activism and psychological boldness of the Futurist artist, Castagneri worked through metonymy, photographing only the hands of Depero. In doing so, he borrowed an iconographical theme – which had existed in literature since time immemorial and had already been followed by Loïe Fuller, Blaise Cendrars, Louis Vauxcelles, Rodin and many others – restoring an aesthetic function of the image that reflected a traditional vision of art. Futurist photography in the 1930s marginalized art as a mental process and as experience of life, and a return to institutional values considering the work of art as an object and art as a language articulated in conventional genres runs through all Futurism. The revival of the painting, sculpture and photograph – as opposed to the mixed media that worked by the interpenetration of codes like photocollage – was not an exhaustive phenomenon but was typical of research around the theme of the aeroplane and the aspiration to a distinctively Italian avant garde. Unlike mechanical art in the 1920s, which was the result of a cultural environment without any specific agenda, Futurism aspired to uniformity and officially collated the research carried out on the experience of flight.

The seminal work on the new poetics was the *Manifesto dell'aeropittura* (Manifesto of aeropainting), launched in 1929. Many other manifestos defined aerosculpture, aeropoetry, aeromusic, aerodance, aeroarchitecture, aeroceramics and so on, thereby creating what was in effect the theoretical corpus of an "aero aesthetic", which hailed Futurist art as the sole means of expression of modernism. In fact, thanks to Marinetti, Futurism continued to aspire to the leadership of the Italian cultural environment. At the basis of this new trend was experimental work by Azari, who had invented "aerotheatre" in the early post-war period. To the Futurists, who associated the view from a plane with the myth of the conquest of space, the experience of flight caused a revolution in perspective, which gave rise to a new visual language. In his aerophotographs, Azari took pictures of aeroplanes flying alongside him or views that, seen in movement and from above, seemed to be upside down and thus defy the laws of gravity.

The greatest interpreter of Futurist aerophotography was Filippo Masoero, who produced a great many photographs during aerobatics using the photodynamic technique, in which the

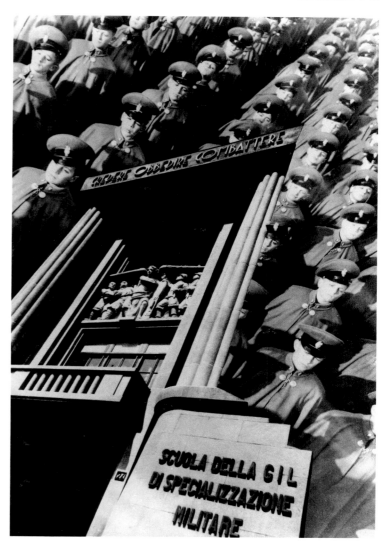

Enrico Pedrotti ◆ *Advertising still for GIL* ◆ *c.* 1938, gelatin silver print, 52 x 37 cm ◆ Foto Studio Pedrotti, Bolzano

Enrico Pedrotti ◆ *Advertising still for GIL* ◆ *c.* 1938, gelatin silver print, 64 x 45 cm ◆ Foto Studio Pedrotti, Bolzano

opening of the shutter is delayed. He would lean out of the plane at considerable risk to life and limb, holding the camera in a coaxial or right-angled to the trajectory of flight. In this method of photography, kinetics does not occur within the image (that is, seen in its totality in the object represented) but at the level of perception, expressed as a dynamic factor inherent in the lens. Remaining open for a few seconds, the lens records the movement of the plane in descent over an urban landscape, producing blurred or fragmented images that dematerialize the forms of reality. Anton Giulio Bragaglia immediately hailed these as "aerodynamic", considering them a direct result of the "dynamic vision"[35] he had posited back in 1913. The titles of these aerophotographs – *Looping*, *Vite*, *Tonneau*, for instance – refer to the types of manœuvres executed in flight and stress the subjective dynamism of the image. Masoero nearly always chose a perfectly square format so as to focus and block the gaze on the centre of the image, thus rendering the dizzy feeling produced by the perception of movement during flight even more subjective. Aerophotography was also particularly important because it enabled the Futurists to grapple with the reality of Italian cities. Faced with the "museum cities" of ancient and Renaissance Italy, which De Chirico depicted as fossils or lunar landscapes compared to the violence and dynamism

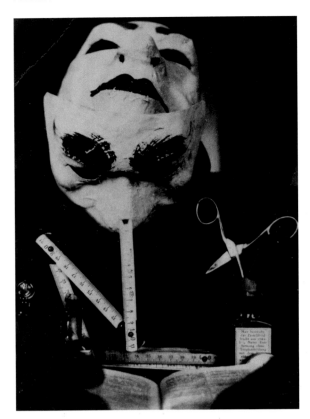

Giorgio Riccardo Carmelich ◆ *Photographic composition* ◆
c. 1928, gelatin silver print, 11 x 8.5 cm ◆ private
collection, Trieste

of modern life, Futurist photography preferred to ignore the visual experience of the city. So the problem was how to interpret in a Futurist dimension a static urban environment that was majestic in its monumentality. Masoero solved the problem by capturing Italian urban landscapes in a vibrant accelerated vision that, like an instant seismograph of a living experience, corresponded to a sort of photographic "action painting". Masoero's research into aerophotography, which began in the late 1920s, was continued by Willy Ruge in Germany and later by Byron C. Hale in Britain.

Still in 1929, the great international exhibition *Film und Foto* in Stuttgart, accompanied by the publication of books on the aesthetics of photography, was a momentous event that sparked a wide-ranging intellectual debate. The German exhibition endorsed the latest examples of avant-garde photography, the consequences of which were to spread like wildfire through Italy. The Futurists published new theoretical essays. Paladini wrote about photomontage, Anton Giulio Bragaglia claimed that photodynamism was of great historical importance, Marinetti illustrated the "photographs of vital radiation" that supposedly had been produced by Guido Cremonese, the director of the Department of Biology at the University of Rome. This significant reawakening of interest in photography led to the launch of the first National Photography Competition, and for the occasion Marinetti and Tato published the manifesto entitled *La Fotografia futurista* (Futurist photography)[36] in April 1930. The text was printed on a leaflet, then included in a catalogue. It was also published in a much longer version in the Italian daily press.[37] In the first edition of the manifesto, Marinetti and Tato decided that the three formal models for the relaunch of Futurist photography should be the Bragaglia brothers' photodynamism, the "Drama of Objects" of the Synthetic Futurist Theatre, and research on dynamism and simultaneity started by Boccioni and carried forward as far as aeropainting. In its definitive version, the manifesto contained a number of proposals for aesthetic research to be developed in the name of experimental Futurist photography. No mention was made of photomontage, abstract photography or other experimental techniques that had triumphed the year before at the international exhibition in Stuttgart. However, this was by no means a refusal of such work; in fact the research carried out in the 1920s was continued by Futurist photography. In the manifesto, Marinetti and Tato were mainly concerned with relaunching specific research by Italian Futurism, namely a return to the founding principles that would provide renewed endorsement for the Futurist avant garde. However, the operation also had a strategic purpose. Marinetti needed to rebuff the dangerous accusations of "Bolshevism" and "cosmopolitan Judaism" with which the Fascist régime intended to destroy Futurism. Thus, any defence of the Futurist movement meant reiterating that Futurism was at the service of Fascism, and that its artistic research dated back to earlier times than the research by the foreign avant-garde movements. But the manifesto *La Fotografia futurista* clearly expressed Marinetti's intention to bring about a new Italian Risorgimento country-wide in terms of culture and art. To Marinetti, what was at stake in Futurism was not only the defence of international avant-garde culture, but also, and above all, the creation of a modern identity for Italian art, namely the establishment of a typically Italian avant-garde tradition as opposed to the importance and grandeur of Italy's artistic heritage.

The manifesto of 1930 led to new research, which pointed to Italy as the major source of Futurist photography, and to a number of exhibitions. The first works were shown at a Futurist Salon in the exhibition, which concluded the First National Photographic Competition in Rome in September 1930. A year later an Experimental Exhibition of Futurist Photography was held in Turin, with twenty-two exhibitors. The show then moved on to Milan on the occasion of the Triennale, including work by other photographers, concluding in Trieste. In December 1932 the Futurists took part in the first International Biennale of Photographic Art in Rome, with a number of foreign avant-garde photographers: the Germans Edmund Kesting, Ernst, Kulley, Karkoska and Heinz Hajek-Halke, the Italian-American Severo Antonelli, the Belgian Stone and the Swede Rolf Winquist. Finally, an important show of photography was mounted at the Great National Exhibition of Futurism, held in Rome in October 1933. These events confirmed that the conflict between

Mario Bellusi ◆ *Shadows and lights* ◆ 1930, gelatin silver print, 20 x 16 cm ◆ MART, Archivio del '900, Rovereto

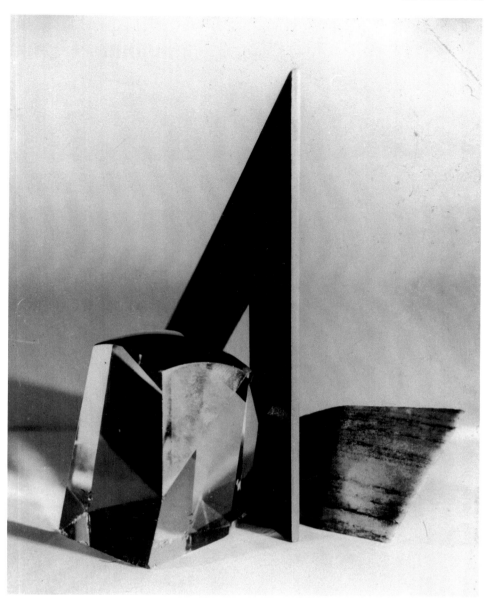

Wanda Wulz ◆ *Futurist breakfast* ◆ 1932, solarized print, 19 x 29 cm ◆ Museo di Storia della Fotografia Fratelli Alinari, Florence

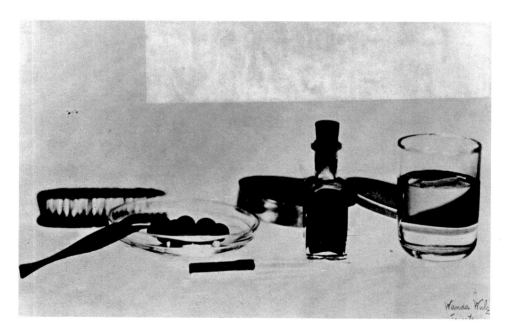

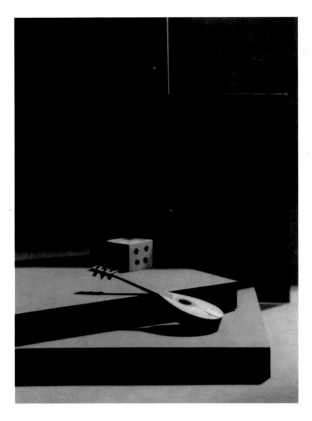

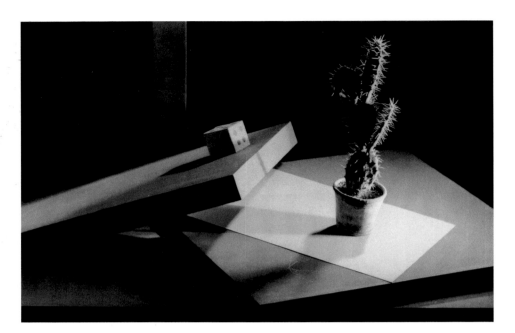

Gianni Croce ◆ *Composition of objects* ◆
1932, gelatin silver print, 9 x 13 cm
◆ MART, Archivio del '900, Rovereto

Gianni Croce ◆ *Composition of objects* ◆
1932, gelatin silver print, 12 x 9 cm
◆ MART, Archivio del '900, Rovereto

Futurism and photography was officially over, and sparked a debate on the relationship between technological determinism and artistic expression. Moreover, the events indirectly contributed to the launch of a new phase of research in Italian photography, ranging from abstract photography by Luigi Veronesi and Antonio Boggeri in Milan to industrial and aerophotography by Stefano Bricarelli and Carlo Mollino in Turin.

The relaunch of Futurist photography based on three formal models – photodynamism, the drama of objects and pictorial dynamism – led to wide-ranging research. Studies of the image of movement were conducted by correcting the tendency towards the dissolution of forms present in the early photodynamic images. Arturo Bragaglia produced some polyphysiognomic or out-of-focus portraits in which the repetition of form no longer appears as the recording of a real physical movement but rather as the evocation of a moment experienced, the projection of a wish, the theatricality of an obsessive gesture. The rendering of movement took on a psychic, surreal and magic connotation. In his approach to the theme of musical gestures, Montacchini used photodynamism for the sound to accompany the image. On investigating exercise in sport, Wanda Wulz expressed both movement and naturally graceful gestures by means of an irregular rhythmic scansion, thereby capturing the forms only in the most significant phases of kinetic activity. She seemed to transfix the mystery and intensity of a moment of emotional hypermnesia in her creation of a symbiosis of forms repeated in space in order to render the erotic attraction of the female body. Used in such a way, photodynamism contributed a fantastical and suggestive dimension to the image. Research on movement also developed along different lines, including the imaginary movement that stirs matter. Masoero worked on his aerial views of great Italian cities in the darkroom to animate the image with very rapid and regular geometric scansions. The virtual

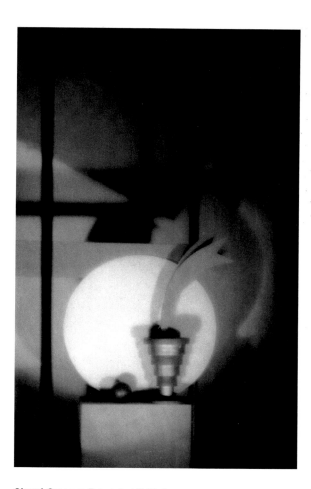

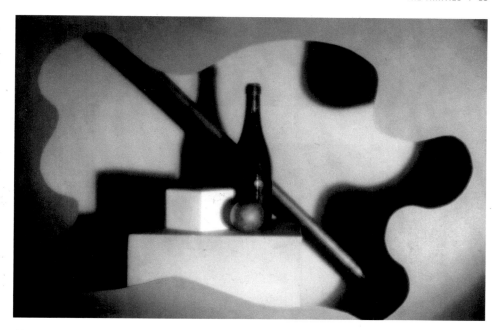

Gianni Croce ◆ *Harmony of lines* ◆
1932, gelatin silver print, 9 x 13 cm
◆ MART, Archivio del '900, Rovereto

Gianni Croce ◆ *Futurist still life* ◆
1932, gelatin silver print, 14 x 9 cm
◆ MART, Archivio del '900, Rovereto

expansion of the architectural form in space produced compositions with whirling, spiral and kaleidoscopic rhythms. Architecture as a formal game plan, as the opportunity for psychological intervention on the structure of form, belongs to the great tradition of Italian art, the cornerstone of which was the discovery of perspective. Through this research, Futurism also developed an aesthetic continuation of Marey's work. The photographs with strobe lamps by Harold Edgerton were considered by Moholy-Nagy to be an endorsement of the aesthetic validity of the ideas of the Futurists. A pupil of Edgerton and, like him, a photographer of movement, Gjon Mili, visited Rome in 1949 to meet Balla and present him with a photograph: an out-of-focus image of the theme of dance. A vast number of today's photographs, including the "dynamic decompositions" of Pol Bury, the "spectralizations" of Viktor Skrebneski, the "passages of time" of Stéphane Dabrowski or the fluid images of Franco Grignani, Sarah Moon, Etienne-Bertrand Weill and a whole host of others, followed in the footsteps of Futurist photodynamism.

The second part of the programme formulated in the manifesto *La Fotografia futurista* referred to the drama of objects of the Synthetic Futurist Theatre. Since 1915, Marinetti had theorized about the creation of a stage dominated not only by the three-dimensional properties of the object, but also by its "self-significance" as a protagonist of the show. By so doing, Futurism was to produce a theatre of matter inspired by both the cabaret and variety theatre, and by the archaic animistic philosophy in which objects speak and interact when they are not under the human gaze.[38] During the 1920s, Tato and Carmelich were the first to photograph compositions of objects, which were full of analogical, narrative or anthropomorphic allusions. As a formal category, the Drama of Objects opened up various lines of research. One variation on the theme was the "spectralization of objects", a direction in which Bellusi worked. Here, by using shadows

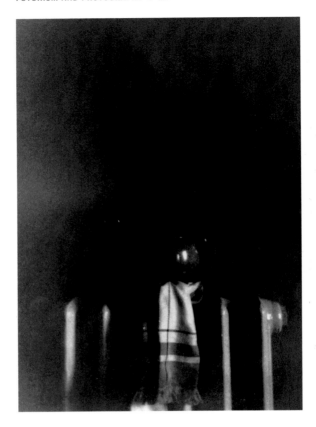

Giorgio Riccardo Carmelich ◆ *Photographic composition*
◆ *c.* 1928, gelatin silver print, 11 x 8.5 cm ◆ private
collection, Trieste

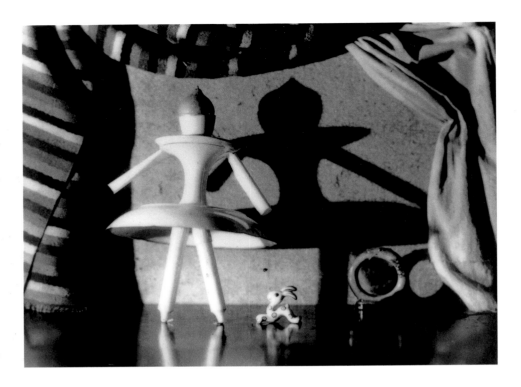

Tato ◆ *Synthetic ballet by the dancer Stearina Candelotti* ◆ 1930, gelatin silver print, 18 x 24 cm
◆ MART, Archivio del '900, Rovereto

and particular angled shots, the photographic image created the impression of a distancing of materials, giving them a special imaginary dimension and halo of mystery. In *Ombre e luci* (Shadows and lights), Bellusi suppressed the objective elements in order to obtain a plastic metaphor of the essence of female and male. Wanda Wulz photographed the objects of a "Futurist meal", which allude to the experiences of tactilism expounded by Marinetti. In the language of photography, angled shots, close-ups, transparencies and juxtapositions of the objects in space reconstruct the aesthetic sensation of the tactile elements of the image that Bernard Berenson had spoken about. The "Futurist still lifes" by Gianni Croce interpret this idea in a more formal manner by means of compositions of objects using diagonals, contrast between planes of light, inclined volumes, opposition between geometric spaces and natural plant elements and the alteration of the ratios of proportion. In the work of other Futurists such as Ricas and Munari, the drama of objects was tinged with narrative and literary resonances.

Tato explored the Drama of Objects as part of a mimetic vision. In his opinion, the image should "show a different object to the existing one".[39] He also spoke of "camouflaging objects", ironically referring to the camouflage used in military exercises and combat equipment. This position was neither original nor particularly Futurist. Years before, Auguste Herbin had made reference in all seriousness to the flat and continuous forms found in the camouflage of the French artillery to explain the origins of his vocation for abstract painting, while Fernand Léger also solemnly recalled the beauty of the breech of a cannon to praise the modernism of mechanical aesthetics. Tato's photograph of the *Borghese perfetto* (Perfect bourgeois) is one of the best compositions of this new genre. The image shows a man sitting stiffly at table during a meal. The bust of the character, though, is only a jacket on a coat-hanger. The realistic details of the photograph, such as the hands in the foreground, culminate in a void that loads the image with surreal effects and humorously recalls the manikins of De Chirico's metaphysical paintings. The surprise effect monopolizes the interpretation of the image and minimizes the other elements that

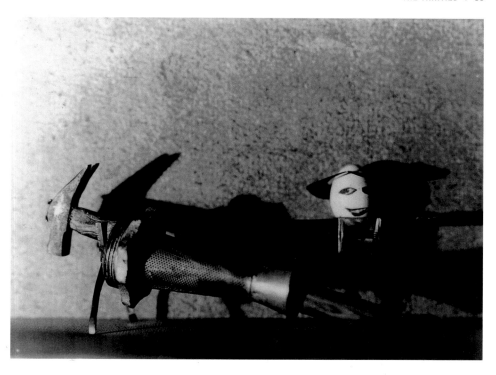

Tato ◆ *Shepherd with little donkey* ◆ 1930, gelatin silver print, 18 x 24 cm
◆ MART, Archivio del '900, Rovereto

are a criticism of society. For instance, the open book on the plate alludes to the intake of "culture" as a separate activity from life, orientated towards libraries, academies and museums. Instead, to the Futurists, culture meant experiencing what modernism would be in its future form. There are various versions of this photograph that document Tato's research on abstract signs and shadow outlines placed behind and above the character to stress the semantics of the image. In another photograph, Tato sets up a "synthetic ballet" of a ballerina, using two cigarettes, a lemon, an upside-down ice-cream bowl and a mirror. The anthropomorphic connotation of the objects is implicit in the structural arrangement of the forms, but only the carefully studied effects of light and shadow create the unity and fantastical effect of the image. The same thing happens in *Pastore con somarello* (Shepherd with little donkey), where the image of an assembly of *objets trouvés* instantly recalls juggling or the game of Chinese shadows in a variety theatre. Tato described these works as "humorous productions". In photography, he considered himself a follower of Fregoli and Méliès.

In a controversial essay, Prampolini claimed Tato's "camouflage of objects" predated the "ghostly objects" of the Surrealists. However, these two types of research, though conducted in parallel, really had very little in common. The poetics of the reinterpreted object had produced many other versions in the Dadaist and Surrealist tradition, from Man Ray's ready-made *corrigés* to Cocteau's *objets de poésie*, Victor Brauner's *objets magiques* and André Breton's *poèmes objets*. The Futurist tradition had begun even earlier, with the "sculptures of objects" by Marinetti and Cangiullo exhibited back in 1914 at the Galleria Sprovieri in Rome, though they had a very different meaning. Despite superficial affinities with the "objects with a symbolic function" of the Surrealists, the thrust of Tato's work is to suggest, through the visual code of photography, a different reality to the one represented, but which is still a reality inherent in the objects themselves. The expressive force of his "camouflage of objects" is not so much the composition with its mimetic connotations of materials, which occurs in Arcimboldo's paintings, as the reversal

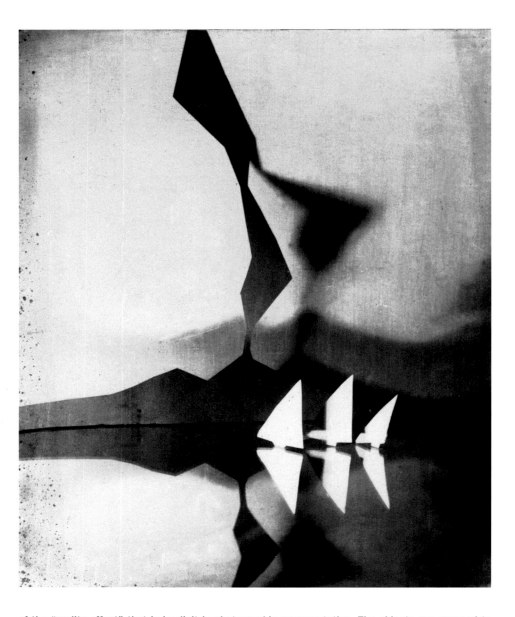

Giulio Parisio ◆ *Vesuvius*, photographic composition ◆
1930, carbon print mounted on wood, 30 x 24.5 cm
◆ Archivio Parisio, Naples

of the "reality effect" that is implicit in photographic representation. The objects are exposed to the gaze in a fundamentally ambiguous dimension, which tends to call into question the very language of photography. In other words, these works seek to prove that photography neither confirms nor endorses the appearances of the world. Subverting the capacity for realism of the medium in order to create strange and enigmatic images was a common feature in other avant-garde movements as well. However, to the Futurists this was a way of contesting the idea of the image as *rigor mortis*, or photography as the death of the vital dimension of reality.

The other applications of the Drama of Objects have a different meaning. Tato sometimes used a metaphorical interpretation of materials, for instance to express a feeling of depression in *Pesi e misure centrali* (Central weights and measures), which is also a self-portrait. On the other hand, in the genre that he called "photographic theatre" he created imaginary, poetic landscapes using matches, sheets of paper, boxes and everyday objects. By so doing he was asking the language of photography to complete the metamorphosis of the objects by making a magical, strange world visible. Thayaht invented the "photoscene", which was a montage of photographic frgaments arranged to resemble the scenes of a small theatre. The same expressive tendency can be found in Pirrone's "paper painting" and Parisio's "composition in paper", marked by a childishly naïve aesthetic. Without ever having seen the photographs of Francis Joseph Bruguière, which were technically similar but abstract, Pirrone produced two-dimensional compositions with pieces of

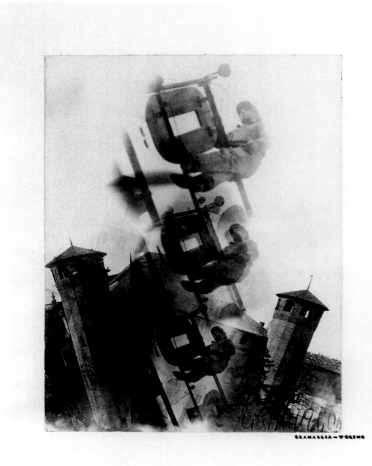

Maggiorino Gramaglia ◆ *Modernism* ◆ 1932, photomontage, 38.5 x 29.5 cm ◆ Museo Nazionale del Cinema, Turin

coloured paper that allude to vague narrative situations. By photographing them, he obtained an effect of low relief with a wide range of grey tones. Parisio built model theatres with actors made of paper using the Japanese technique of origami that were reminiscent of Rodchenko's famous photographs for a book by Sergei Tretiakov. As in a small-scale model of a theatre, a *théâtre d'ombres* or a *boîte optique*, the magic of the image derives from the linear rhythms that suggest the passing of time, and from the ethereal, light consistency of the characters, the effects of light and shadow and the sensation of a physical yet imaginary space. The playful and poetic theme of the "little theatre" seen as an imaginary stage set in miniature – a *leitmotiv* also used in work by Balla, Depero, Melotti, Regina, Fontana, Pistoletto and Pascali – is an expressive thread that runs through all Italian art. As such, it corresponds not only to a vision of art as mental control and experience conducted in a laboratory, but also to a genuine dimension of cultural anthropology. The "*teatrino*" embodies a tradition that draws on the visual and poetic archetype of the *presepe*, the traditional Italian Nativity scene, or Pinocchio the marionette, the one truly popular figure in Italian literature. Another version of this research is the photography of Emilio Buccafusca, who borrowed the idea of the *teatrino*, introducing it into an immaterial dimension, creating undefined spaces where he inserts volumes of light and shadow suspended in a starry vacuum. This kind of Futurist work has been reinterpreted by Muriel Olesen, Jerry N. Uelsmann and other contemporary photographers.

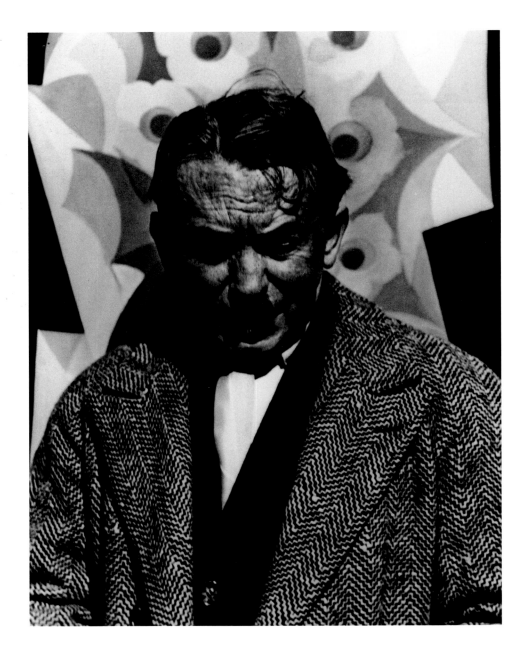

Anon. ◆ *The painter Giacomo Balla in front of his painting 'Balfiore'* ◆ 1930–32, gelatin silver print, 65 x 49 cm ◆ MART, Archivio del '900, Rovereto

The third and final part of the programme launched by the 1930 manifesto postulated the integration in photography of research into the pictorial dynamism of the state of mind, interpenetration of bodies, simultaneity of proximity-distance and memory-dream. This is basically an evolution of the last phase of photodynamism. The Bragaglia brothers had used photomontage to produce this form of expression, using a technique of double printing or double exposure. In a humorous vein, Tato returned to the formula of the "transparency of opaque bodies" to define this technique, which dematerializes the forms of reality. Bellusi used it to destroy the mythical image of Rome the Eternal City, showing the streets of the capital submerged by modern-day traffic. The problematic theme for the Futurists – the monumental character of Italian cities – was also tackled by Gramaglia. The technique of photomontage enabled him to contrast two different faces of Turin – a blue-collar worker in a factory and the medieval façade of the Palazzo Madama. The repeated superimposition of the worker, who embodies industrial modernism, cuts diagonally across the image and causes the archaeological monument to explode. However, in his portraits of Depero, Castagneri used photomontage to express the skyscrapers of New York as a psychological reality that fuels the Futurist inspiration of the artist. The technique of superimposition is, in fact,

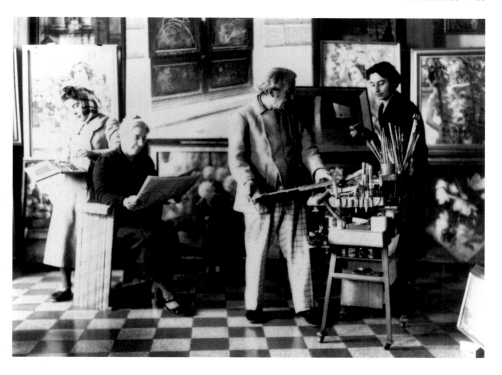

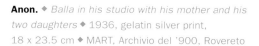 **Anon.** ◆ *Balla in his studio with his mother and his two daughters* ◆ 1936, gelatin silver print, 18 x 23.5 cm ◆ MART, Archivio del '900, Rovereto

more suitable than any other to portray psychic, dreamlike and mental values, and to provide a subjective vision that is inward-looking rather than outward, towards society and the world of history. For this reason, the Futurists used it above all for portraits, thus becoming part of a visual tradition that, in the Italian culture, dates back centuries, to the pictorial ostentation of the Renaissance.

Between the nineteenth and twentieth centuries, the photographic portrait developed into an indisputable record of an individual's inner identity, as the photograph was perfectly capable of documenting being through appearance. In positivist science, physical reality was endowed with the value of a "symptom", so the lens had the power of preserving the conscious from any doubts that might arise concerning the human nature of the sitter. According to the singular classifications of the anthropologist and psychiatrist Cesare Lombroso, the human face reveals visible traces of each psychic phenomenon. Futurist photography, on the other hand, guaranteed that the portrait would preserve the sitter's *élan vital*, the complexity of personality and the myriad signs that fix the physical permanence in reality. In the 1930 manifesto, Tato and Marinetti put forward two "operational" suggestions for Futurist portrait photography. The first of these was "the transparent and semi-transparent overlapping of people and objects in their physicality and of their semi-abstract spirits with the simultaneity of a memory-dream", while the second involved "the organic composition of an individual's different states of mind". This was how Tato photographed the poet Mario Carli, covering his face with a pile of his books; the Futurist dancer Trisno, doubling the image and adding neon lights of the variety theatre; finally Tato himself, associating his identity with a propeller, which labels him as an aeropainter. Ivos Pacetti had his portrait taken surrounded by a dynamic representation of the objects relating to his creative work as a Futurist artist. Castagneri doubled the image of a face so as to express psychic echoes and emotive urgency. Arturo Bragaglia projected a vision of Marinetti's "simultaneity of expression" in a diptych, while Parisio photographed the painter Carlo Cocchia, engulfing his face in the world of one of his works.

The Futurist portrait revealed allegorical, narrative, imaginary, psychological and character aspects of the sitter. It creates a conceptual coat of arms; it even manages to make up what Tato called his "spiritualistic portrait". The method employed here was differentiated exposure of the

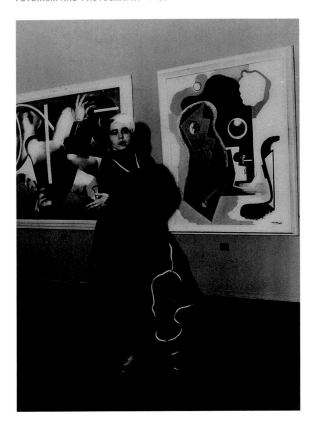

Enrico Prampolini ◆ *'Aerodance' by Wy Magito, Galerie de la Renaissance, Paris* ◆ 1932, gelatin silver print, 17 x 12 cm ◆ private collection, Rome

subject, aiming to capture the multi-faceted psyche of the Ego that exists inside the shell of the body. The techniques he used included surreal superimpositions, fantastical studies of movement, repetitions with very diverse content, distortions and alterations of expression, partial fluidity of the image, analogical juxtapositioning and memory visualizations. In a fantastical aeropainting of the poet Mino Somenzi, who was a strenuous champion of Futurist research, Tato split the image along two diagonals crossed in the form of an X, the symbol of cosmic orientation, so as to render the basic components of aeropainting, namely the physical and psychological experiences of flight. The former is expressed as dynamism and the desire to conquer by showing a frontal image of the face and the movement of a propeller. The latter is expressed as an attraction towards the mystery of the infinity of cosmic life achieved by photographing the face with its tense emotion and echoes of the suprematist forms of Malevich, obtained by direct contact in the darkroom. Also by means of direct contact, Tato added the profile of a harp, the musical instrument that, as a symbol of *harmonia mundi*, inspired Futurist aeropoetry. One of the masterpieces of Futurist photography is the self-portrait *Io+gatto* (I+cat) by Wanda Wulz, in advance by some decades of the extraordinary experiments of biomorphing in contemporary mass media. The imaginary facial metamorphosis is caught in perfect equilibrium between animal and human nature, between metaphor and reality. Her work on shadow, particularly the impenetrable obscurity whence the feline sensuality of the female form emerges, suspends the portrait in continual movement between concealment and revelation of the deepest psychic reality. However, this was by no means Surrealism. Wanda Wulz has created a magnetic image of "Futurist woman" that is totally Mediterranean. Her self-portrait has a strong iconographical affinity with the sixteenth-century plates of *De humana physiognomonia* by Giovan Battista Della Porta, and upholds the essentially Italian character of Futurism claimed by Marinetti. This Futurist research on the relationship between identity and image, being and appearing, that had begun with the Bragaglia brothers' "polyphysiognomies", was to influence artists and photographers in foreign avant-garde movements, such as Umbo, Germaine Krull, El Lissitzky, Karl Straub, Val Telberg and Edmund Kesting. In fact, Kesting produced a notable series of portraits of dancers, in a style between Futurism and Expressionism, using distanced doubling, which captures the aesthetic tempo of the dance. The Futurist portrait has led to contemporary research on similar themes or ones that are dialectically different, such as Krzysztof Pruszkowsky's "photo-synthesis" or Nancy Burson's "identity-simulacrum".

Futurist photography has developed by denying the image as *rigor mortis*, in an attempt to express both the complexities and continuity of life "as it happens". Rather than the process of cut-out, which means the photographer must use a "cut-and-paste" method resulting in a materialist version of photomontage, Futurism has always preferred the technique of partial superimposition of photographic details, or double exposure, which produces a more flexible and cinematographic structure and language. Behind this particular choice is the idea of "duration", which Bergson defined as a potential state of awareness that retains a continual flow of data from memory and vision, from knowledge and intuitive creation. The Futurist poetics of "universal dynamism", which introduced a simultaneous and dematerialized vision of things, capturing them in a fluid and incessant stream of *élan vital*, produced the "state-of-mind" image in photography. The psychic reality and the appearances of the world, the invisible and the invisible, were combined in an organic composition capable of uniting the discontinuous and heterogeneous within a single stream of time, defined as "duration". To violate the alleged realism inherent in the very language of photography meant trying to grasp the changing nature of existence, to perceive the mobility of things through the vague and continual equilibrium of *kinesis* and *dynamis*, movement and energy, action and *élan vital*. In both aspects, Futurist photography sought to express the uninterrupted immanence in the process of regeneration of life, to harmonize being with the rhythms of cosmic infinity and to celebrate the pulse of becoming as the ultimate and secular form of eternity.

NOTES

1 Anton Giulio Bragaglia, 'L'Arcoscenico del mio cinematografo', *Penombra,* January 1919, p. 32.

2 See the bibliography for the publications in France ad Italy of this chapter of Rodin's book.

3 Umberto Boccioni, *Altri inediti e apparati critici*, ed. Zeno Birolli, Milan (Feltrinelli Editore) 1972, p. 25.

4 Anton Giulio Bragaglia, 'La Fotografia dell'invisibile', in *Humanitas,* no. 51, 21 December 1913, p. 31.

5 Anton Giulio Bragaglia, *Fotodinamismo futurista, prima edizione,* Rome (Nalato Editore) 1913, p. 1.

6 Anton Giulio Bragaglia, 'L'Arte nella fotografia', *La Fotografia artistica,* VIII, no. 4, April 1912, p. 98.

7 Giovanni Di Jorio, 'L'Arte fotografica dei fratelli Bragaglia', *La Fotografia artistica,* IX, no. 6, July 1912, p. 109.

8 Cf. Anton Giulio Bragaglia, 'Témoignage', in Giovanni Lista, *De Chirico et l'avant-garde*, L'Age d'homme, Lausanne 1983, pp. 230–31.

9 This photodynamic image has, until today, been mistakenly attributed to Giannetto Bisi, among whose papers it was conserved for a long time.

10 Anton Giulio Bragaglia, *Fotodinamismo futurista, op. cit.,* p. 2.

11 Anton Giulio Bragaglia, 'Che cos'era la fotodinamica del movimento', *La Stirpe,* III, no. 11, November 1925, p. 788.

12 Anton Giulio Bragaglia, 'La Fotografia dinamica', *Novella,* 3 March 1925, p. 25.

13 Unpublished autograph letter, written on headed paper of the Circolo della Caccia of Rome and dated 4 April 1913, with the address "Anton Giulio Bragaglia, via Banchi Vecchi 139, Roma" (Archivi Giovanni Lista, Paris).

14 Anton Giulio Bragaglia, *Fotodinamismo futurista, op. cit.,* p. 46.

15 Umberto Boccioni, 'Il Dinamismo futurista e la pittura francese', *Lacerba,* I, no. 15, 1 August 1913, p. 171.

16 Published in the journal *Il Tirso,* 13 July 1913, p. 4.

17 This photodynamic image, neglected until today in studies of Futurist photography, was published in the journal *Primavera,* III, no. 9, September 1913, p. 195. It was printed by Capaccini in Rome.

18 These six photodynamic images, likewise neglected until today in studies of Futurist photography, were published in the journal *Italia!,* II, vol. 2, no. 7, July 1913, pp. 34–38. The image entitled *The poet declaiming a lyrical poem* is probably the same as the one exhibited by Bragaglia in Galleria Romagna, in March 1913, with the following caption: *Il poeta Marcellusi che dice una sua poesia* (The poet Marcellusi declaiming one of his poems).

19 Anton Giulio Bragaglia, *Fotodinamismo futurista, op. cit.,* pp.10–11.

20 Anton Giulio Bragaglia, *Fotodinamismo futurista, op. cit.,* p. 19.

21 Anton Giulio Bragaglia, *Fotodinamismo futurista, op. cit.,* p. 41.

22 Anton Giulio Bragaglia, *Fotodinamismo futurista, op. cit.,* p. 39.

23 Anton Giulio Bragaglia, *Fotodinamismo futurista, op. cit.,* p.15. This passage already appeared in his first draft of Bragaglia's lecture, even though it was mistakenly omitted by the printer in the first proofs of the book, as is confirmed by the philological collation of the text carried out by Antonella Vigliani Bragaglia; cf. Anton Giulio Bragaglia, *Fotodinamismo futurista*, rev. edn ed. Antonella Vigliani Bragaglia, Turin (Einaudi) 1970, p. 160. Medardo Rosso's sculpture had in fact been presented in 1911 at the Rome exhibition; cf. Giovanni Lista, *Medardo Rosso, le destin d'un sculpteur*, Paris (L'Echoppe), p. 88.

24 Anton Giulio Bragaglia, *Fotodinamismo futurista, op. cit.,* p. 30.

25 Anton Giulio Bragaglia, *Fotodinamismo futurista, op. cit.,* p. 44.

26 Anton Giulio Bragaglia, *Fotodinamismo futurista, op. cit.,* p. 45.

27 Autograph text, dated 15 November 1913, published in Marcello Vannucci, *Mario Nunes Vais, fotografo fiorentino*, Florence (Bonechi Editore), p. 25.

28 The concept of "transcendental photography", born out of the photography of the invisible, inspired by spiritualism and parascience, is found in the statements of Bragaglia, who defined photodynamism as the "transcendental photography of movement", but also in those of Boccioni, who spoke of Futurist painting in terms of "physical transcendentalism".

29 Carlo Ludovico Bragaglia played no role in the creation of photodynamism, as all the contemporary documents, published or unpublished, that I have beeeen able to consult testify. Moreover, in the course of my research during the 1970s I met Carlo Ludovico on a number of occasions, who told me that Anton Giulio and Arturo were the sole creators of photodynamism. On this latter stance, see the biographical notes concerning the Bragaglia brothers.

30 Anton Giulio Bragaglia, 'I Fantasmi dei vivi e dei morti', *La Cultura moderna. Natura e arte,* XXII, no. 23, 1 November 1913, p. 756.

31 Vincenzo Bonafede, 'Fotodinamica e futurismo', *L'Ora,* 5–6 January 1914, p. 6. The journalist evokes the 'sectarianism' of Boccioni, but from Bragaglia obtained only an elusive response that avoids any polemics.

32 Anton Giulio Bragaglia, 'Arte e fotografia', *Il Mondo,* V, no. 21, 25 March 1919, p. 10.

33 Cf. Giovanni Lista, *L'Art postal futuriste*, Paris (Jean-Michel Place Editeur) 1979, p. 42.

34 Cf. Giovanni Lista, 'La Ricerca cinematografica futurista', in *Cinema, avanguardie e immaginario urbano*, Trento (Manfrini Editori) 1990, pp. 30–38.

35 Anton Giulio Bragaglia, 'Fotodinamismo e aerodinamica', *Illustrazione Toscana e dell'Etruria,* November 1936, p. 7.

36 The text of the leaflet is reprinted in Giovanni Lista, *Futurismo e fotografia*, Milan (Edizioni Multhipla) 1979, p. 318.

37 Filippo Tommaso Marinetti-Tato, 'La Fotografia futurista', *Il Futurismo,* no. 22, 11 January 1931, p. 1.

38 Cf. Giovanni Lista, *La Scène futuriste*, Paris (Editions du Centre National de la Recherche Scientifique) 1989, pp. 212–13.

39 Tato, 'La Fotografia futurista nell'avvenire', *Oggi e Domani,* II, no. 11, 8 December 1930, p. 3.

Filippo Masoero ◆ *Dynamised view of the Roman Forum* ◆
1934, gelatin silver print, 20 x 30 cm ◆ TCI/Gestione
Archivi Alinari, Milan

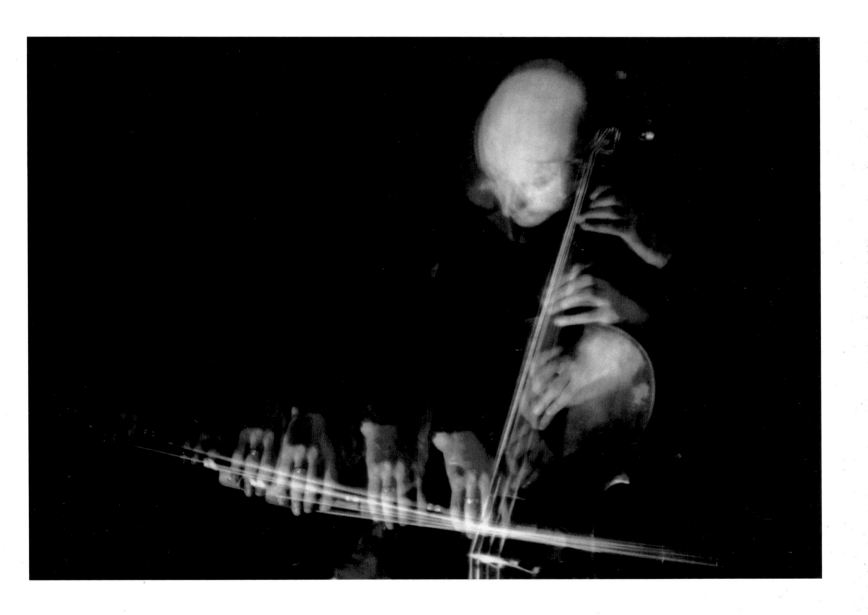

Alberto Montacchini ◆ *Musical alchemy: the soloist* ◆ 1930, gelatin silver print, 11.5 x 16 cm ◆ MART, Archivio del '900, Rovereto

Arturo Bragaglia ◆ *Polyphysiognomic portrait* ◆
1930, gelatin silver print, 10 x 12 cm ◆ The J. Paul
Getty Museum, Los Angeles

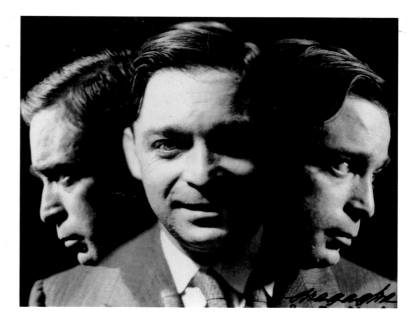

Emanuele Lomiry ◆ *States of mind* ◆ c. 1932,
gelatin silver print, 16 x 11 cm ◆ private collection

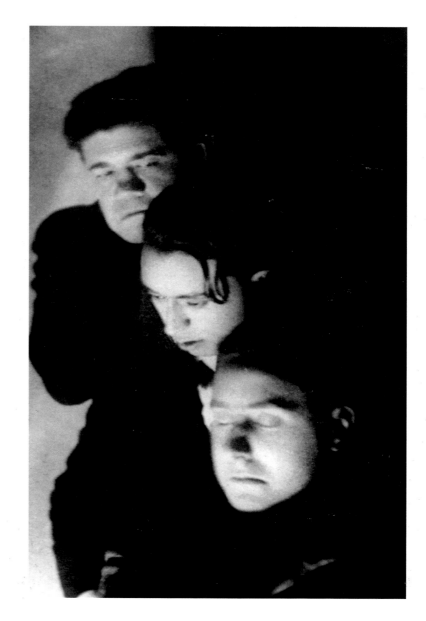

Mario Castagneri ◆ *Depero's hands: clarity and will* ◆
1930, gelatin silver print, 18 x 26 cm ◆ MART, Archivio
del '900, Rovereto

Maggiorino Gramaglia ◆ *Woman with serpent* ◆
1930, gelatin silver print, 28.5 x 38.5 cm ◆
Museo Nazionale del Cinema, Turin

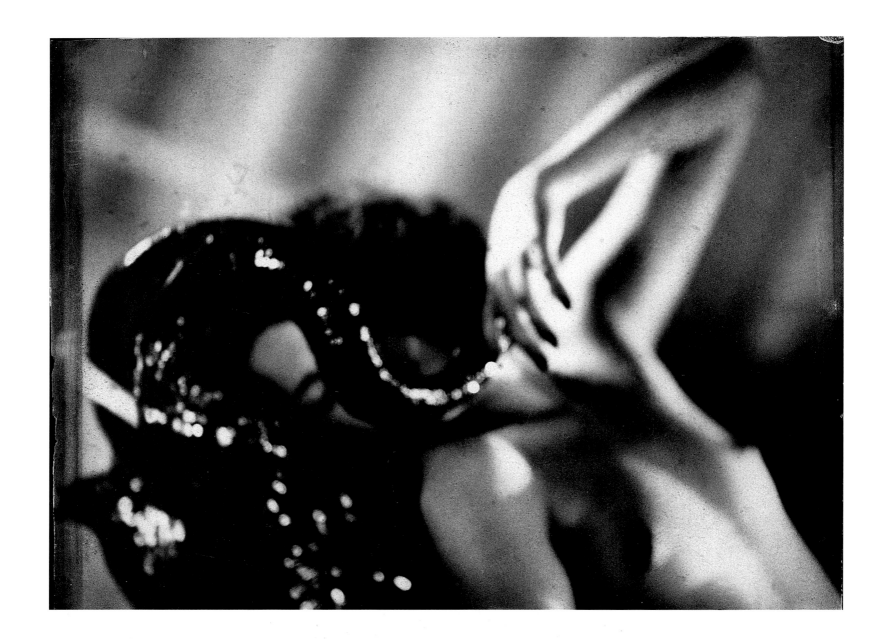

Tato ◆ *Amorous or violent penetrations: dynamic nude* ◆
1933, gelatin silver print, 21 x 15 cm ◆ MART, Archivio del
'900, Rovereto

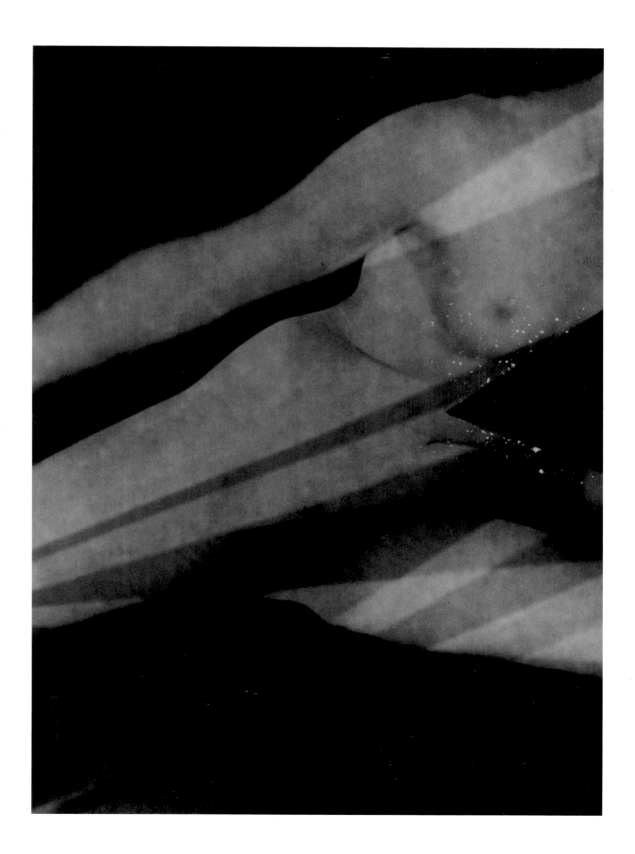

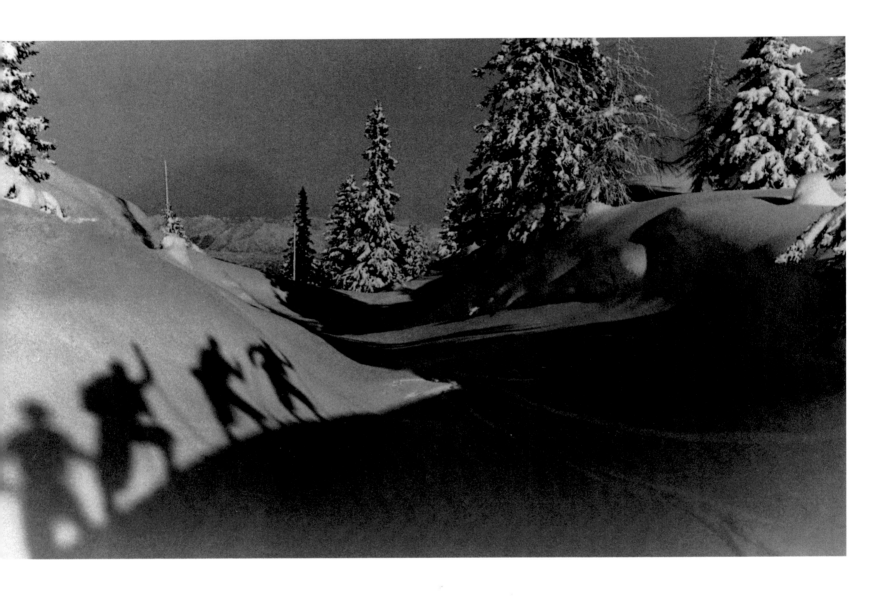

Enrico Pedrotti ◆ *Shadows* ◆ *c.* 1938, gelatin silver print,
30 x 46 cm ◆ Foto Studio Pedrotti, Bolzano

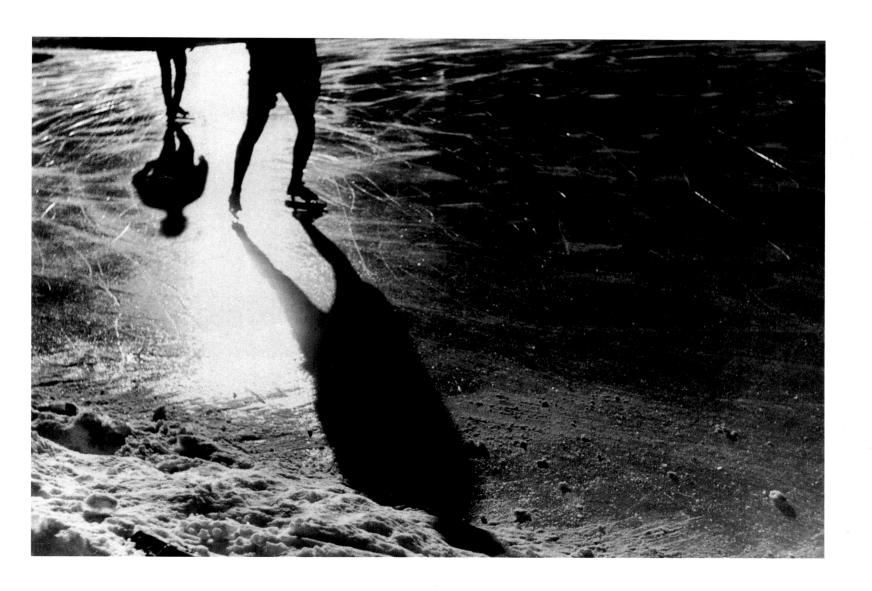

Enrico Pedrotti ◆ *Skaters* ◆ *c.* 1939, gelatin silver print, 26 x 38 cm ◆ Foto Studio Pedrotti, Bolzano

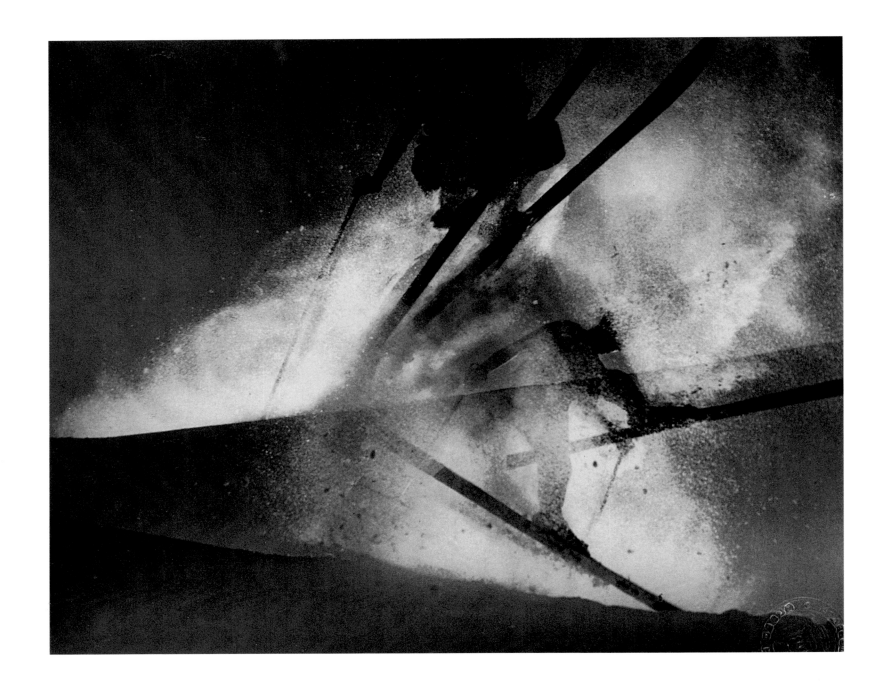

Enrico Pedrotti ◆ *Acrobatic skiing* ◆ *c.* 1930, photomontage,
18 x 22 cm ◆ MART, Archivio del '900, Rovereto

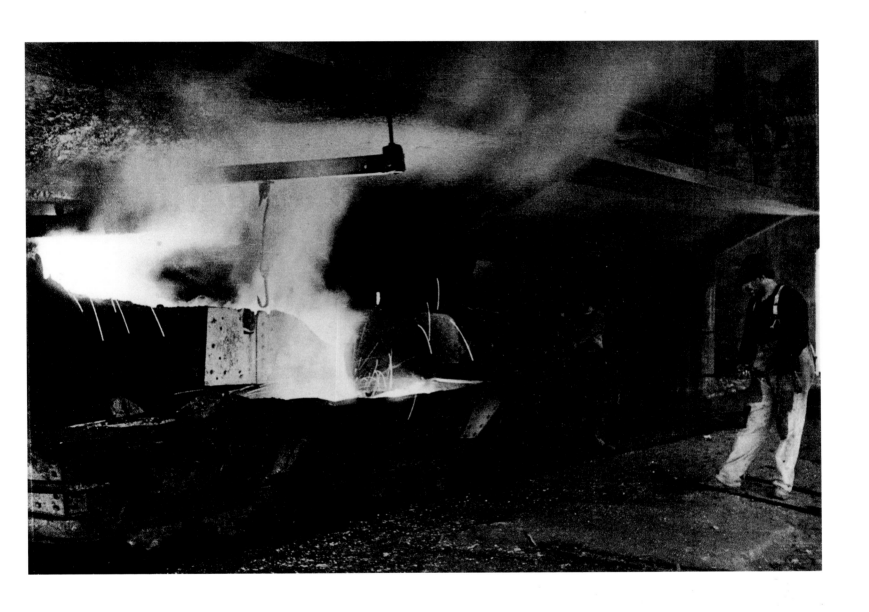

Enrico Pedrotti ◆ *Foundry* ◆ 1935, gelatin silver print,
21 x 29 cm ◆ Foto Studio Pedrotti, Bolzano.

Mario Castagneri ◆ *Fortunato Depero in New York*, photomontage for Depero's book *New York film vissuto* ◆ 1931, 30 x 24 cm ◆ MART, Archivio del '900, Rovereto

Mario Castagneri ◆ *Fortunato Depero among the skyscrapers* ◆ 1933, photomontage, 30 x 24 cm ◆ MART, Archivio del '900, Rovereto

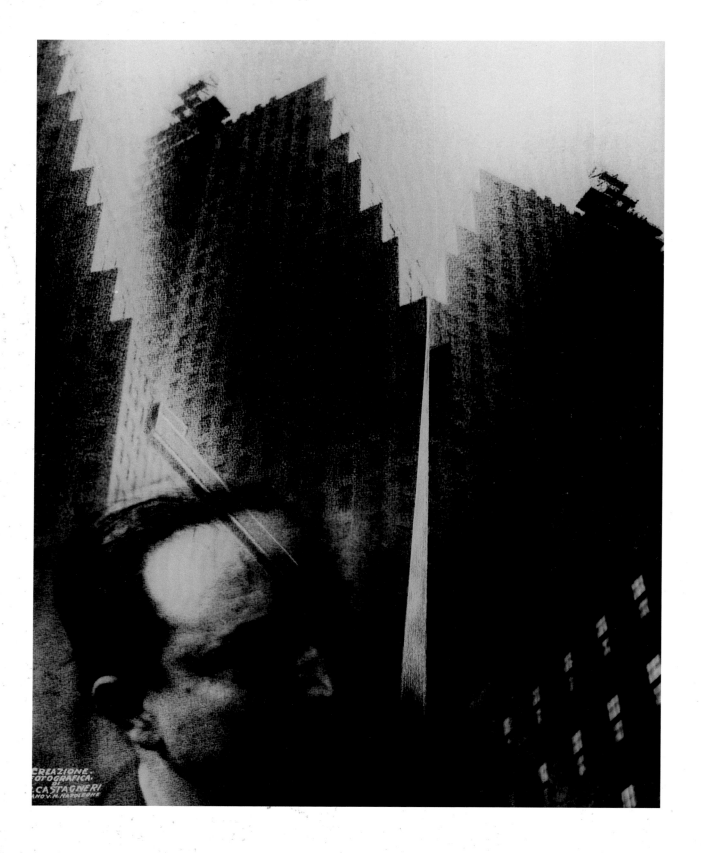

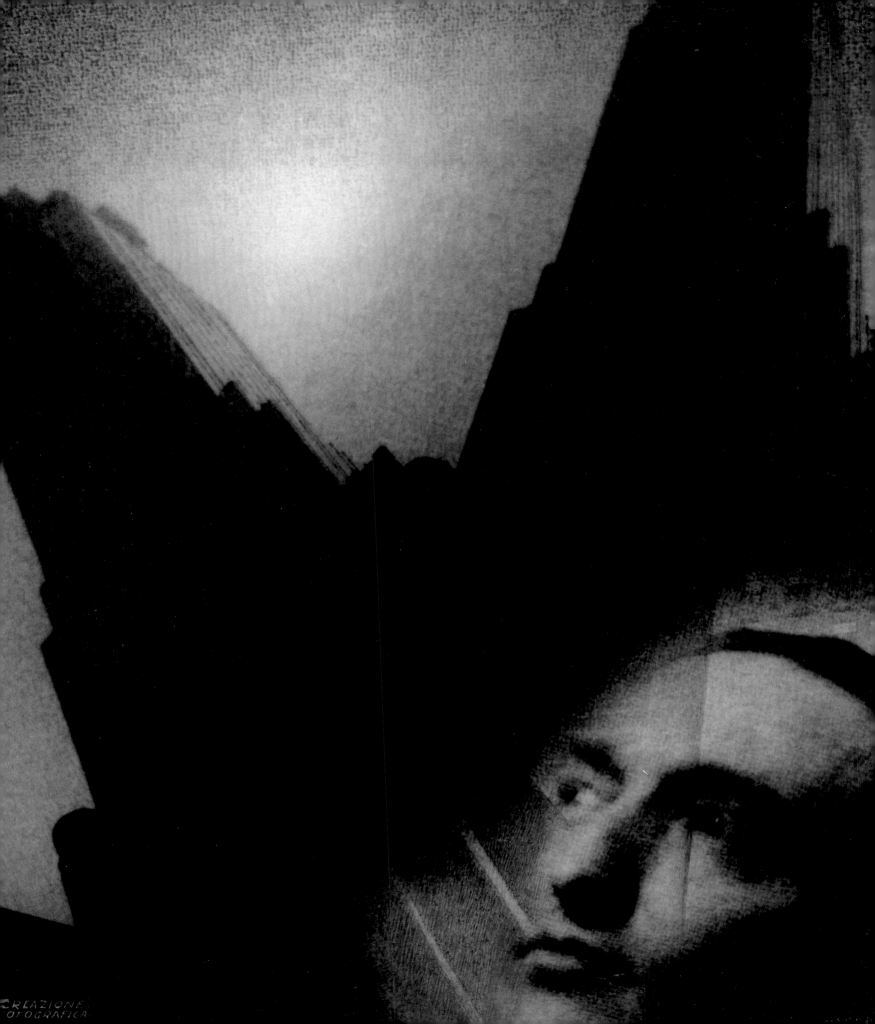

CREAZIONE
OTOGRAFICA

Ottavio Berard ◆ *Futurist photograph: punch in the eye* ◆
1932, gelatin silver print, 9.5 x 14.5 cm ◆ MART, Archivio
del '900, Rovereto

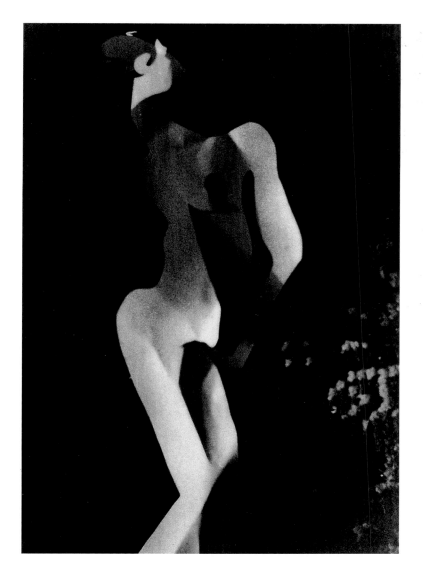

Giorgio Riccardo Carmelich ◆ *Photographic composition* ◆
c. 1928, gelatin silver print, 11 x 8.5 cm ◆ private
collection, Trieste

Emilio Buccafusca ◆ *Women in space* ◆ 1933,
gelatin silver print, 16.5 x 11.5 cm
◆ Archivio D'Ambrosio, Naples

Studio Coletti ◆ *Portrait of the aeropoet Mino Somenzi* ◆
1932, gelatin silver print, 22.5 x 16 cm ◆ MART, Archivio
del '900, Rovereto

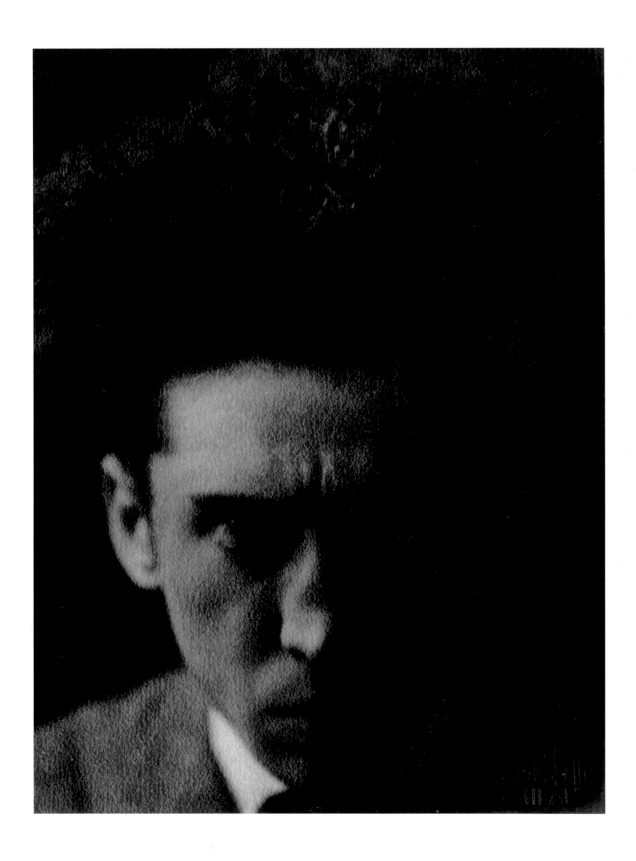

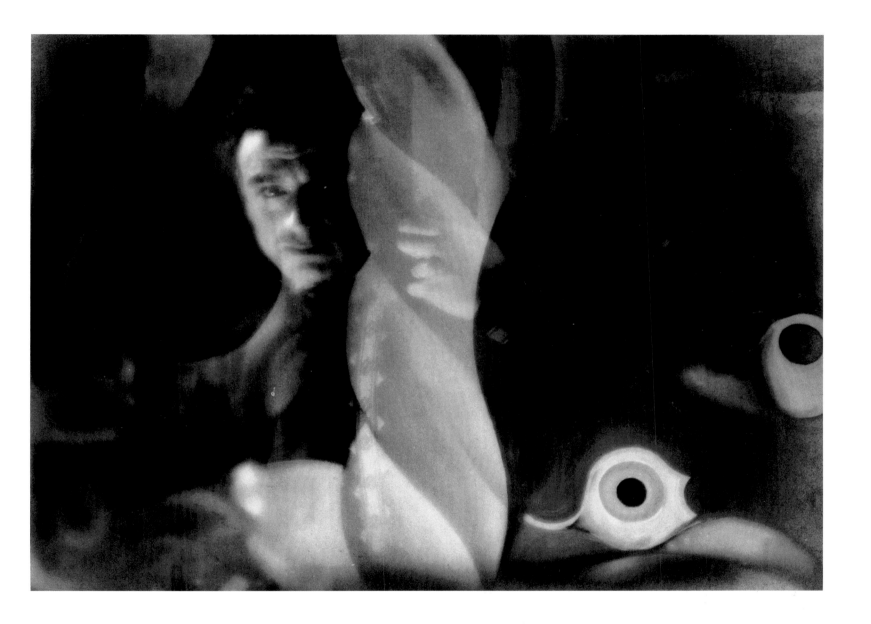

Giulio Parisio ◆ *Photodynamic portrait of the Futurist painter Carlo Cocchia* ◆ 1930, photomontage, 16.5 x 22.5 cm ◆ MART, Archivio del '900, Rovereto

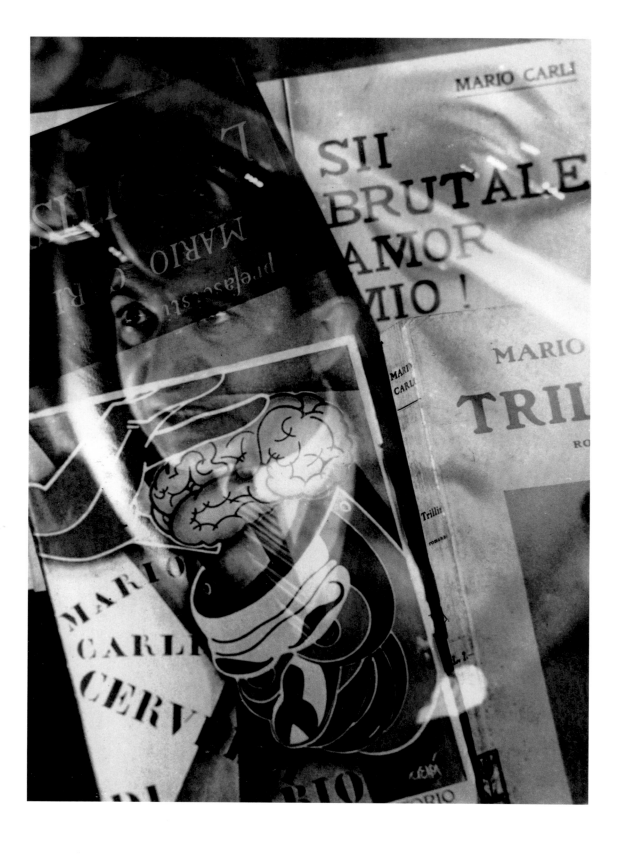

Tato ◆ *War-like literary portrait of Mario Carli* ◆
1930, photomontage, 25 x 18 cm ◆ MART,
Archivio del '900, Rovereto

Mario Bellusi ◆ *Modern traffic in ancient Rome* ◆
1930, photomontage, 15 x 20 cm ◆ MART,
Archivio del '900, Rovereto

Tato ◆ *Aero self-portrait* ◆ 1930, photomontage,
24 x 18 cm ◆ MART, Archivio del '900, Rovereto

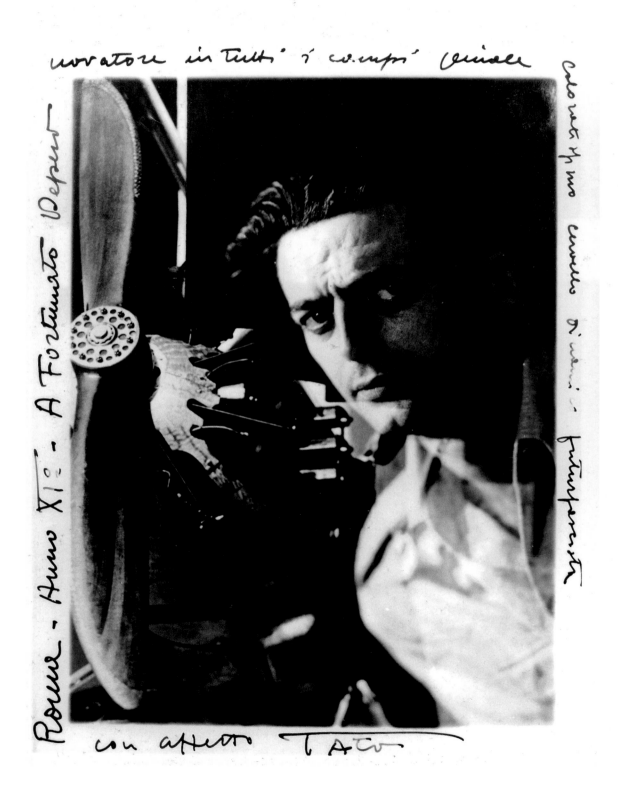

Wanda Wulz ◆ *Jazz Band* ◆ 1930, gelatin silver print,
29.5 x 22.5 cm ◆ Museo di Storia della Fotografia Fratelli
Alinari – Wulz Archive, Florence

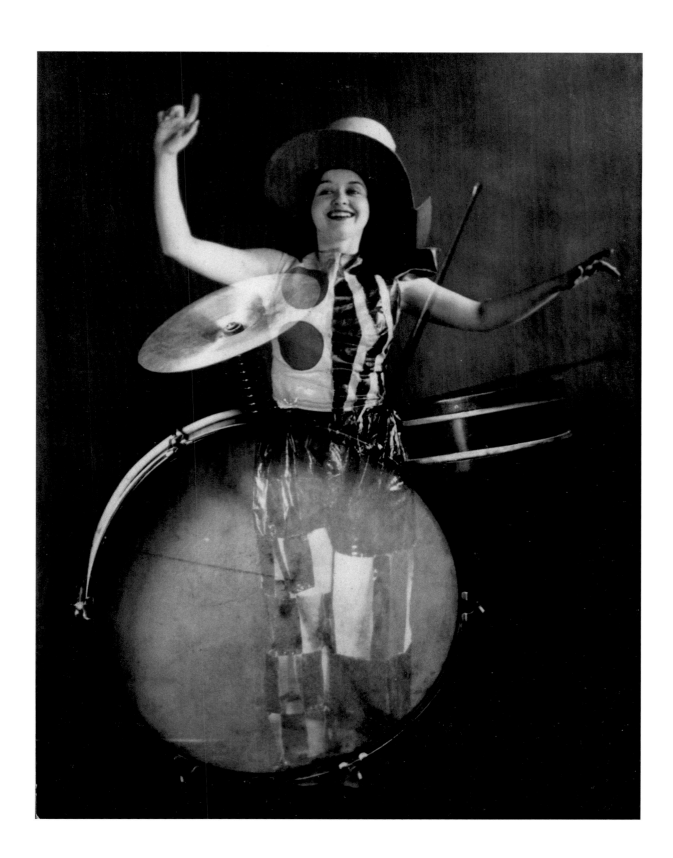

Maggiorino Gramaglia ◆ *Spectralization of the Ego*
◆ 1931, photomontage, 37.5 x 28 cm ◆
Museo Nazionale del Cinema, Turin

Wanda Wulz ◆ *Cat+I* ◆
1932, gelatin (chlorobromide)
silver print, 29.5 x 23.5 cm ◆
Museo di Storia della
Fotografia Fratelli Alinari –
Wulz Archive, Florence

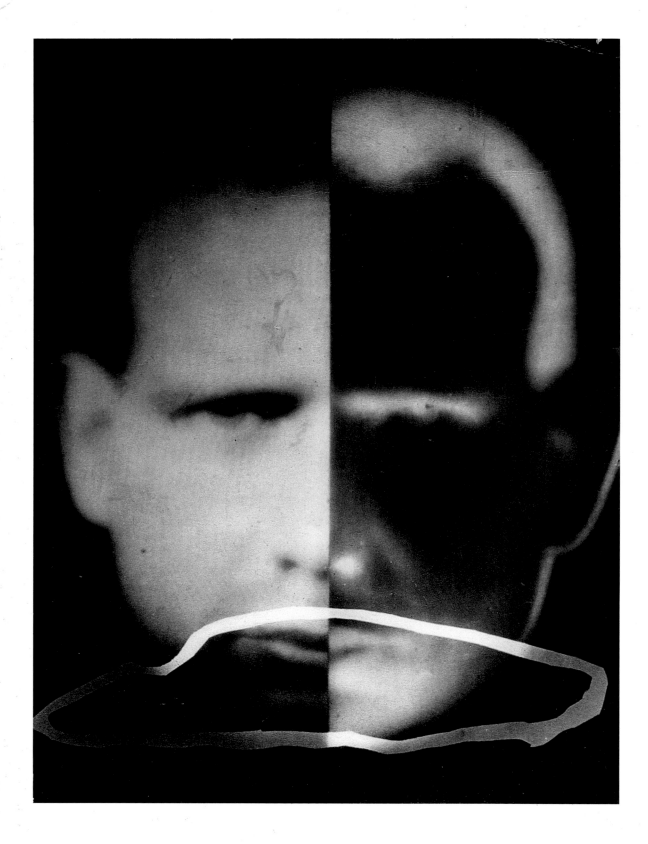

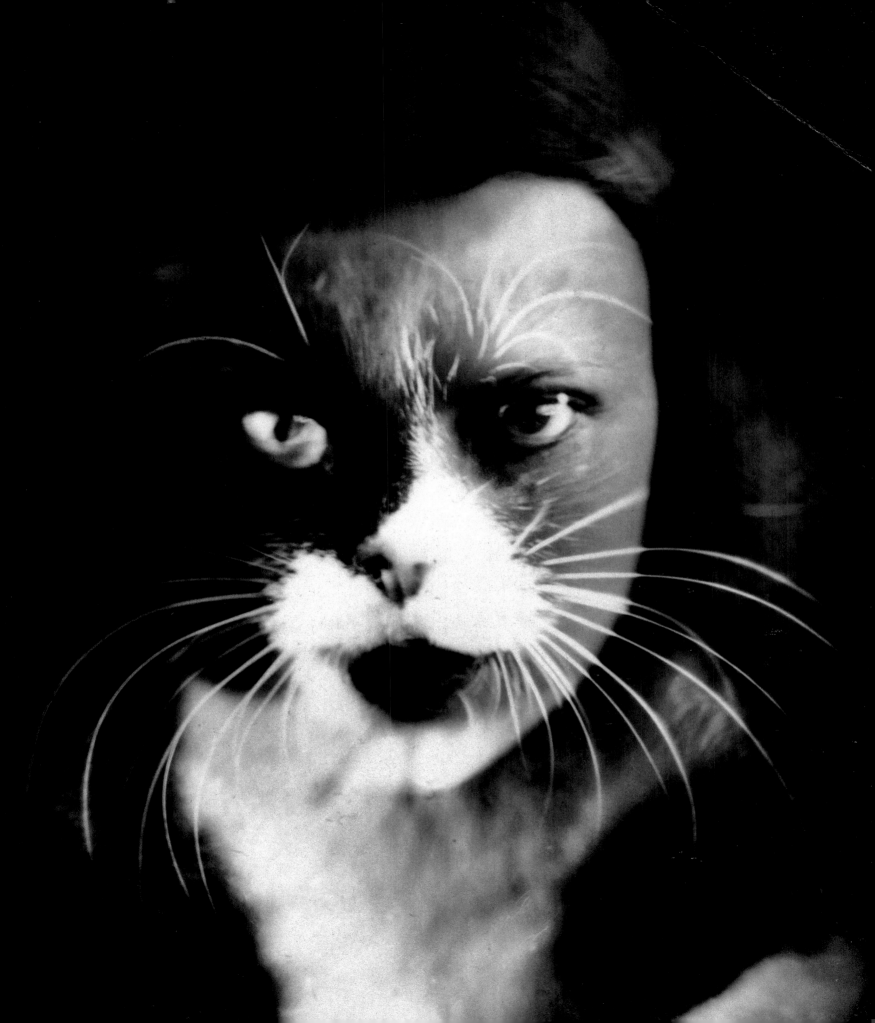

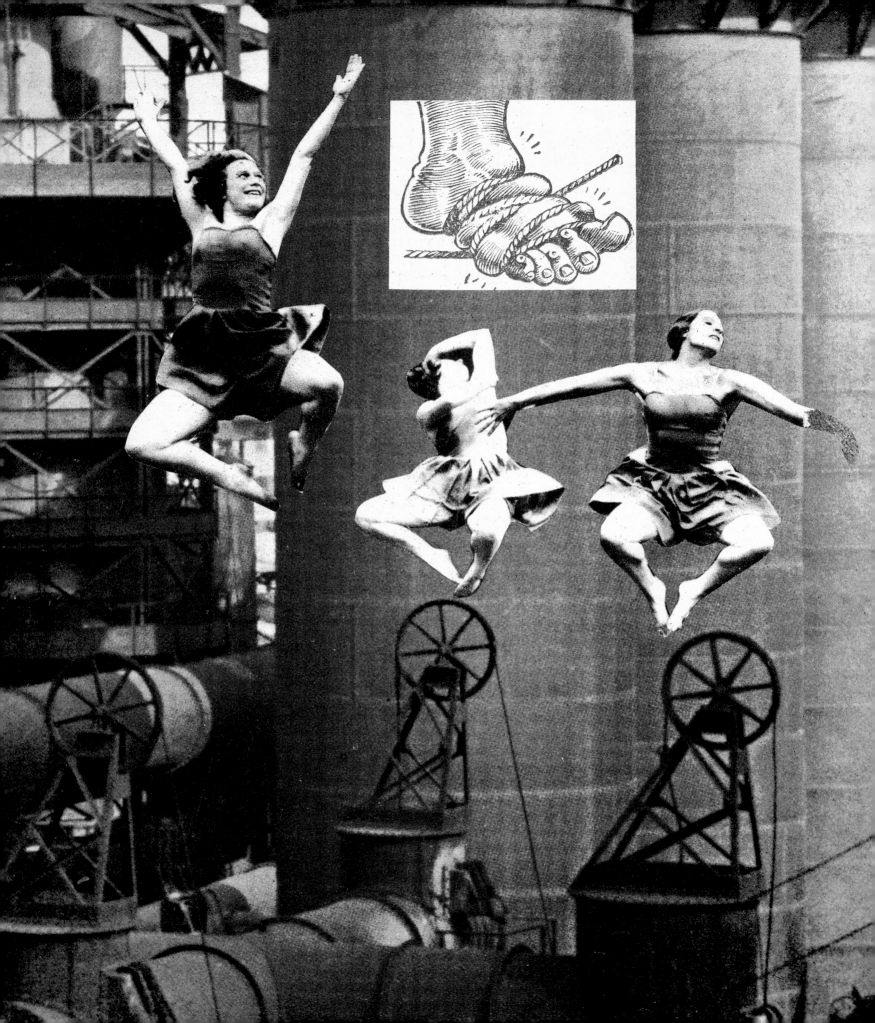

Bruno Munari ◆ *Nothing is absurd to those who fly*
◆ 1939, photocollage and ink, 26.5 x 20 cm ◆
Museo Aeronautico Gianni Caproni, Trento

Fortunato Depero ◆ *Crossing the Hudson on the ferry-boat* ◆ 1930–31, photocollage, 32.3 x 21 cm ◆ MART, Archivio del '900, Rovereto

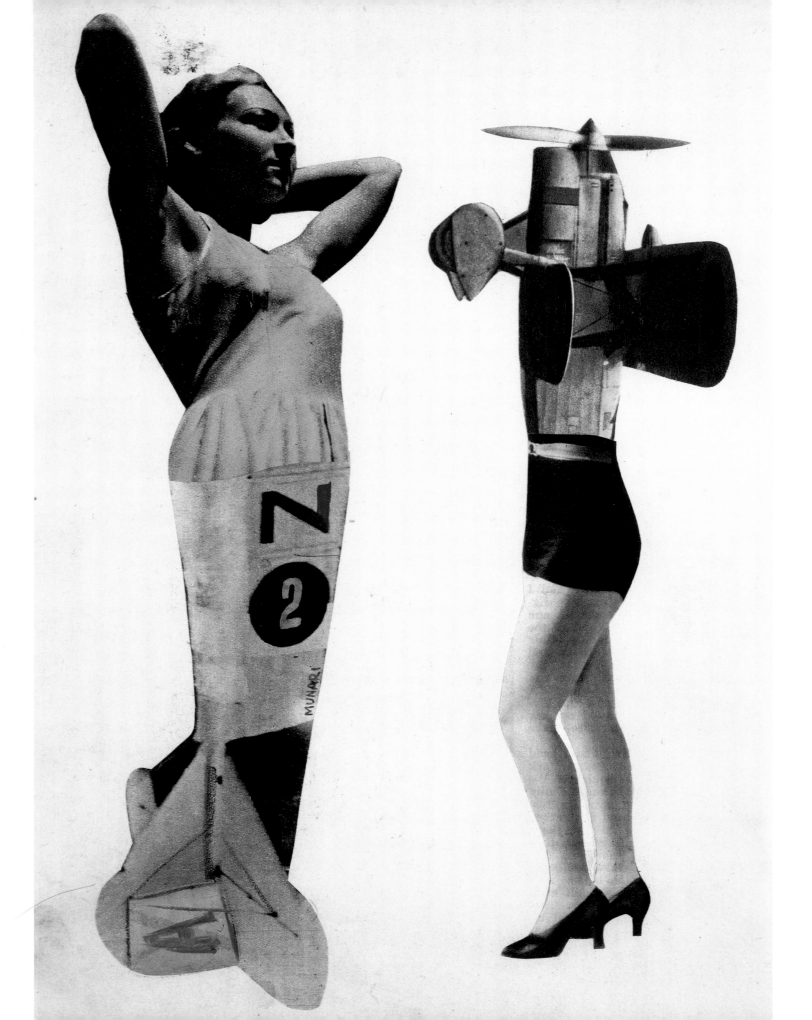

Bruno Munari ◆ *And thus we would set about seeking an aeroplane woman* ◆ 1939, photocollage, 27.5 x 18 cm ◆ Museo Aeronautico Gianni Caproni, Trento

Bruno Munari ◆ *They've even invented this. The world's gone mad* ◆ 1939, photocollage, 24 x 18 cm ◆ Museo Aeronautico Gianni Caproni, Trento

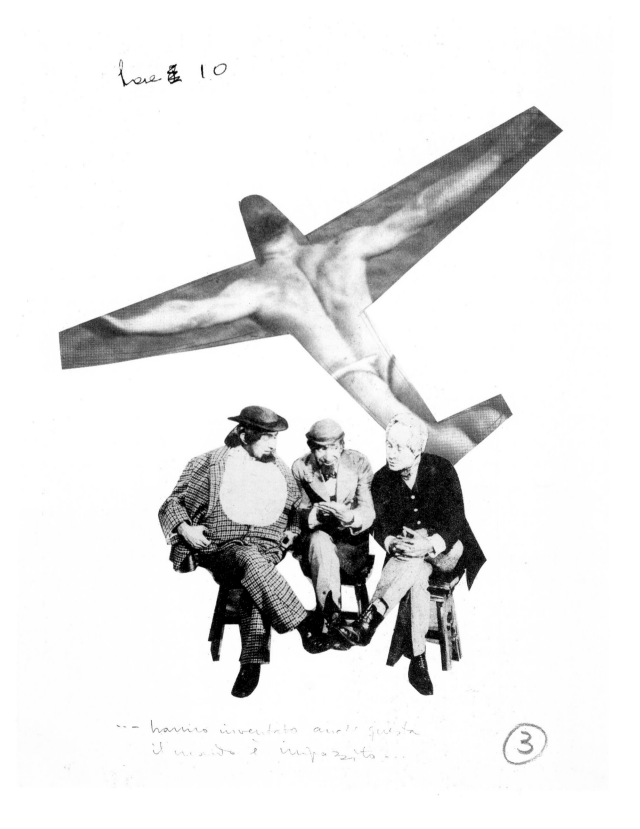

Vinicio Paladini ◆ *Scene from Molnar's 'The Legend of Liliom'* ◆ 1932, photocollage, 51 x 66 cm ◆ private collection

Vinicio Paladini ◆ *Olympic Games* ◆ 1934,
photocollage, 28.5 x 18.5 cm ◆ Museo di Storia
della Fotografia Fratelli Alinari, Florence

Vinicio Paladini ◆ *Olympic Games*
◆ 1934, photocollage,
28.5 x 18.5 cm ◆ Museo di Storia
della Fotografia Fratelli Alinari,
Florence

Vinicio Paladini ◆ *Olympic Games*
◆ 1934, photocollage,
28.5 x 18.5 cm ◆ Museo di Storia
della Fotografia Fratelli Alinari,
Florence

Vinicio Paladini ◆ *Olympic Games* ◆ 1934, photocollage, 28.5 x 18.5 cm ◆ Museo di Storia della Fotografia Fratelli Alinari, Florence

Vinicio Paladini ◆ *Olympic Games*
◆ 1934, photocollage,
28.5 x 18.5 cm ◆ Museo di Storia
della Fotografia Fratelli Alinari,
Florence

Enrico Unterveger ◆ *Filippo Tommaso Marinetti* ◆ 1932,
gum bichromate print, 28.5 x 25 cm ◆ Museo di Storia della
Fotografia Fratelli Alinari – Unterveger Archive, Florence

Tato ◆ *Fantastical aeroportrait of Mino Somenzi* ◆ 1934,
photomontage, 24 x 18 cm ◆ MART, Archivio del '900,
Rovereto

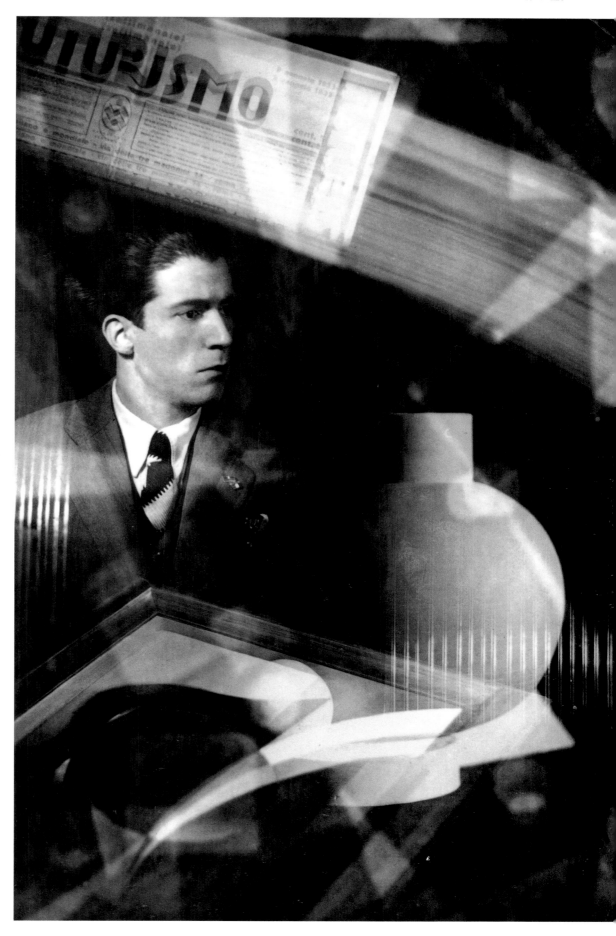

Ivos Pacetti ◆ *Futurist self-portrait* ◆
1933, photomontage, 17 x 11 cm
◆ MART, Archivio del '900, Rovereto

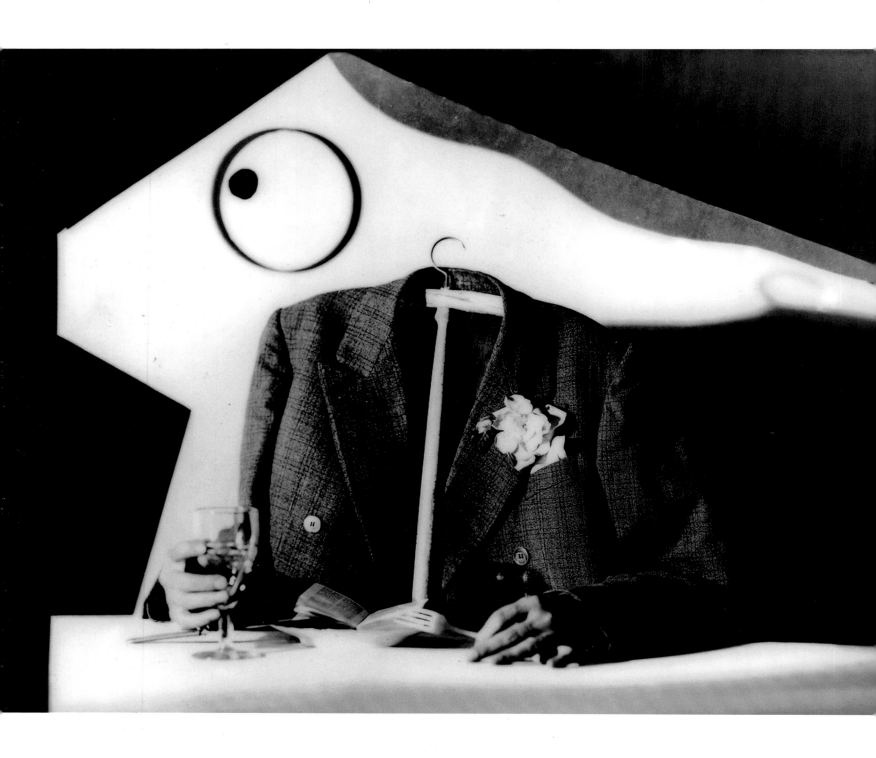

Tato ◆ *Perfect bourgeois* ◆ 1930, gelatin silver print, 18 x 24 cm ◆ MART, Archivio del '900, Rovereto

Tato ◆ *Central weights and measures* ◆ 1932, gelatin silver print, 24 x 18 cm ◆ MART, Archivio del '900, Rovereto

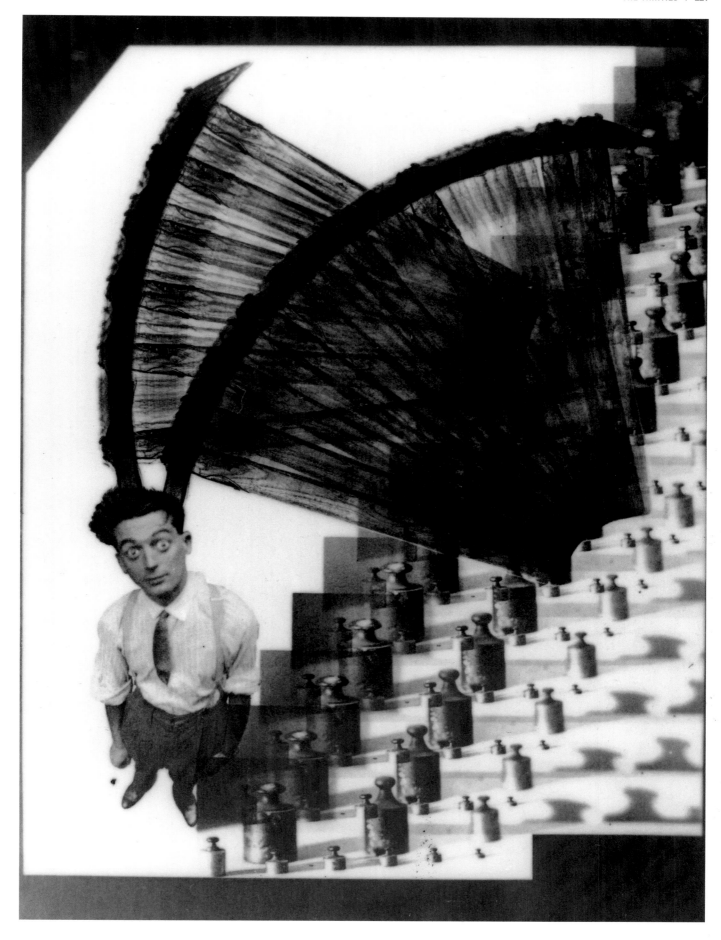

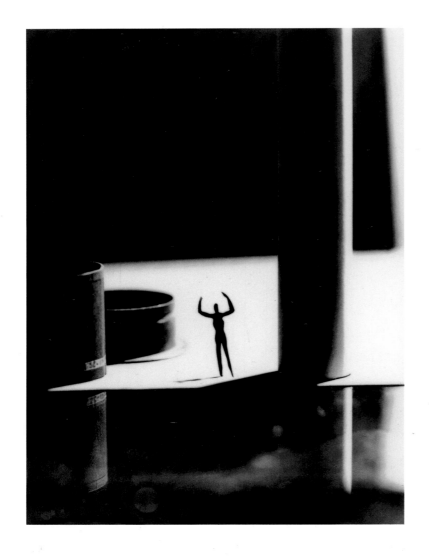

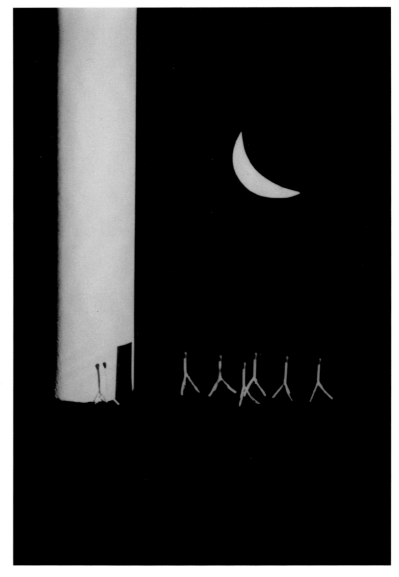

Tato ◆ *Drama of shadows and objects* ◆
1932, gelatin silver print, 24 x 18 cm
◆ MART, Archivio del '900, Rovereto

Tato ◆ *The last patrol: Futurist scenography* ◆
1933, gelatin silver print, 18 x 12 cm
◆ MART, Archivio del '900, Rovereto

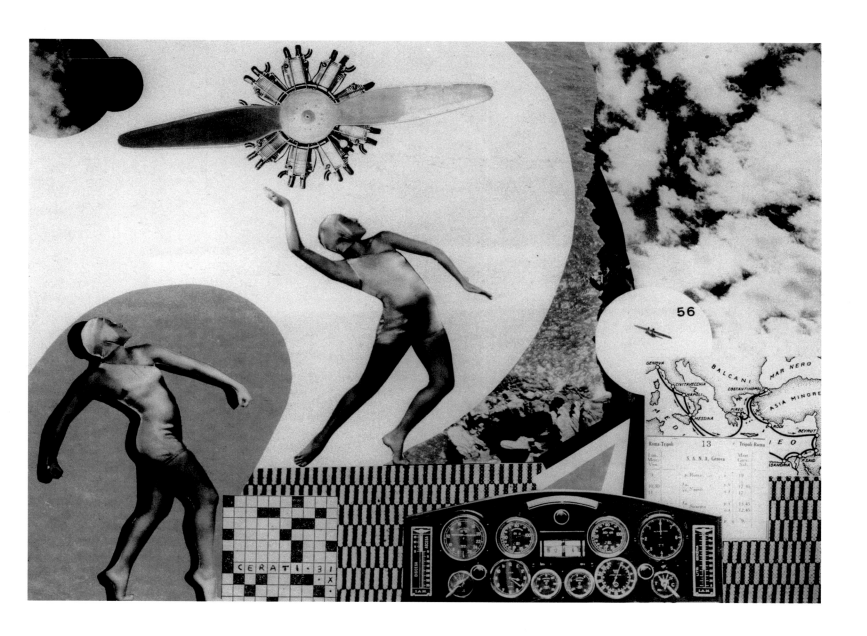

Cesare Cerati ◆ *Propellers: free-photo aerocomposition* ◆ 1931, photocollage, 14.5 x 19 cm ◆ MART, Archivio del '900, Rovereto

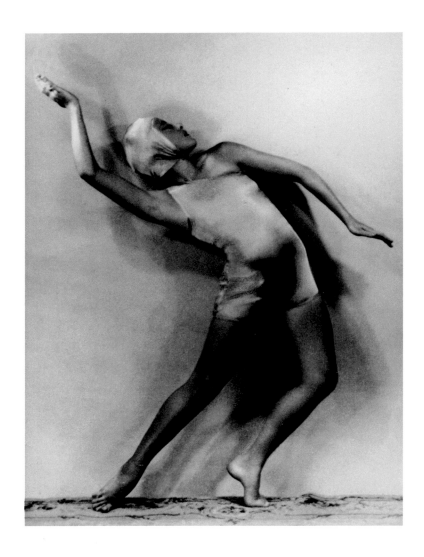 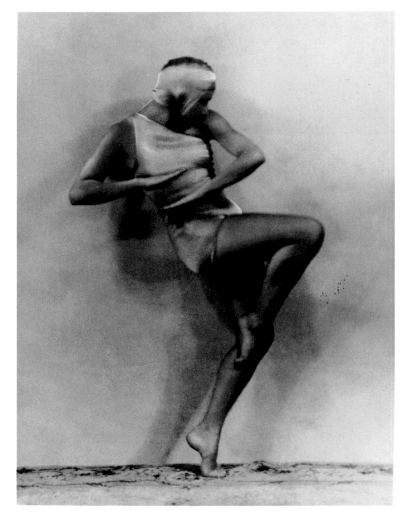

Studio Santacroce ◆ *Giannina Censi: Aerofuturist dance* ◆
1931, gelatin silver print, 17.5 x 12.5 cm ◆ MART, Archivio
del '900, Rovereto

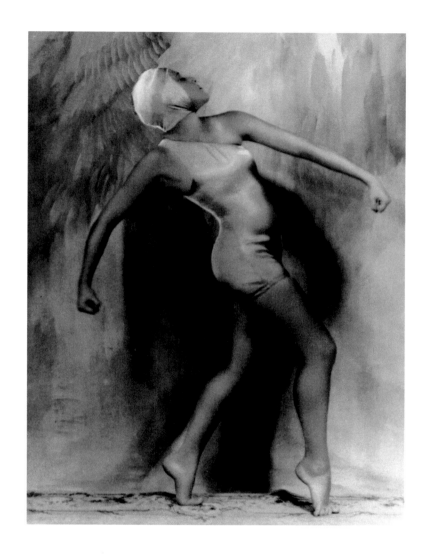
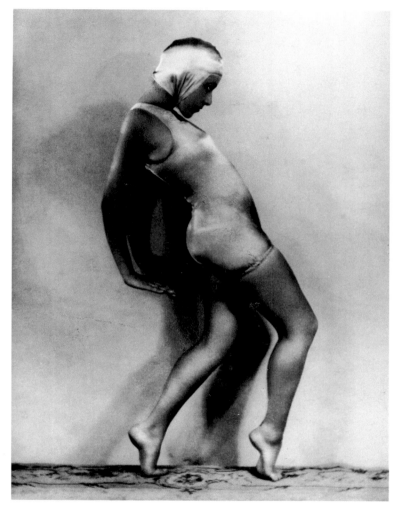

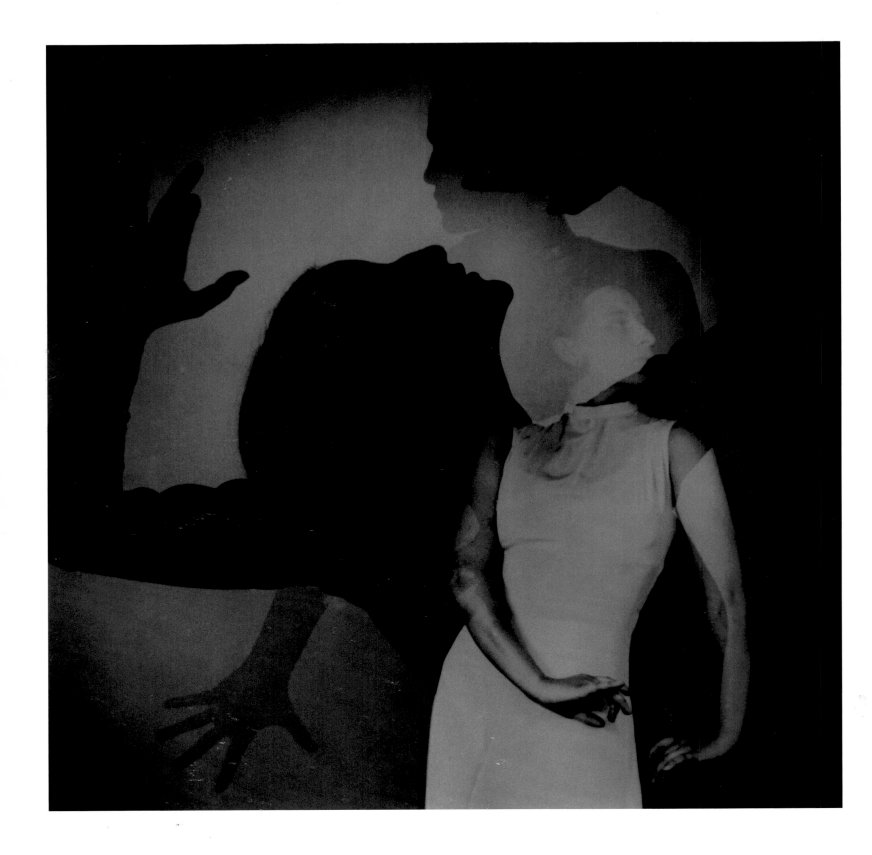

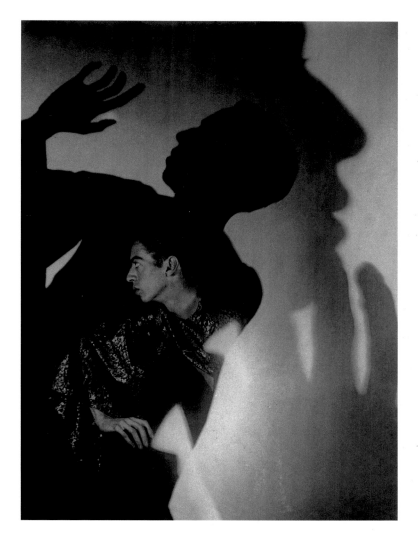

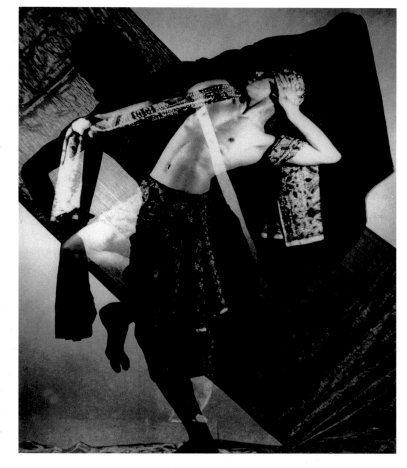

Edmund Kesting ◆ *Image of a male dancer* ◆
c. 1933, photomontage, 24 x 18 cm ◆ MART,
Archivio del '900, Rovereto

Edmund Kesting ◆ *Image of a female dancer* ◆
c. 1933, photomontage, 17.5 x 17.5 cm ◆
MART, Archivio del '900, Rovereto

Edmund Kesting ◆ *Image of a male dancer* ◆
c. 1933, photomontage, 22 x 18 cm
◆ MART, Archivio del '900, Rovereto

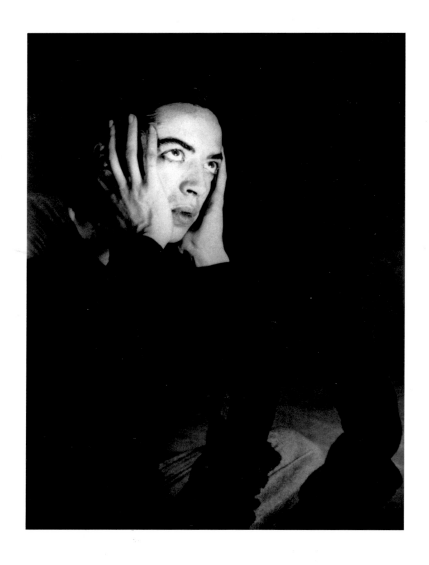

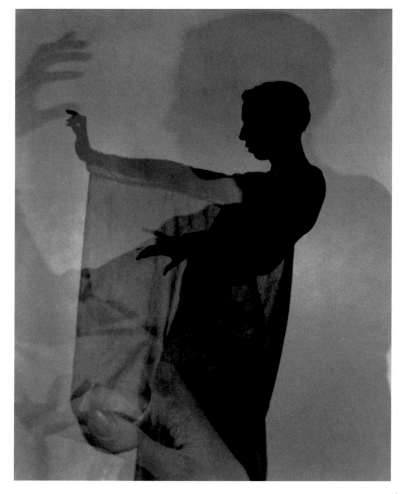

Edmund Kesting ◆ *Image of a male dancer* ◆
c. 1933, photomontage, 21 x 17 cm ◆ MART,
Archivio del '900, Rovereto

Edmund Kesting ◆ *Image of a male dancer* ◆
c. 1933, photomontage, 24 x 17 cm ◆ MART,
Archivio del '900, Rovereto

Edmund Kesting ◆ *Image of a female dancer* ◆
c. 1933, photomontage, 23.5 x 17 cm ◆ MART,
Archivio del '900, Rovereto

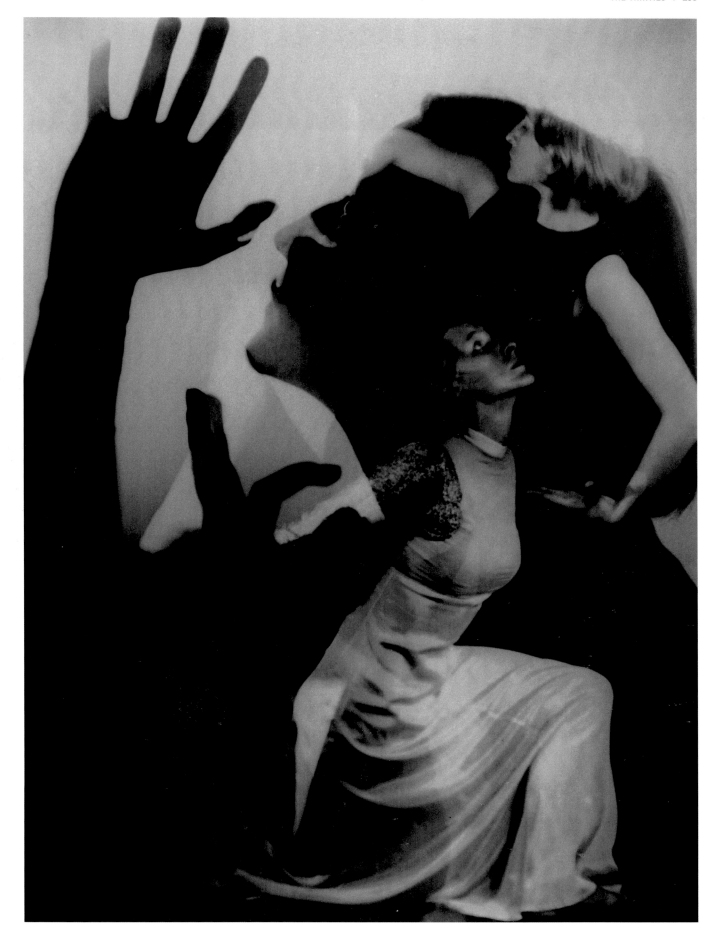

AZARI
BALLA
BELLUSI
BÉRARD
BISI
BOCCIONI
BONAVENTURA
BRAGAGLIA
BUCCAFUSCA
CARMELICH
CARRÀ
CASTAGNERI
CERATI
CROCE
DEPERO
FILIPPINI
GRAMAGLIA
KERTÉSZ
KESTING
LOMIRY
MARAINI
MARINETTI
MASOERO
MONTACCHINI
MUNARI
NAKAYAMA
NUNES VAIS
PACETTI
PALADINI
PAPINI
PARISIO
PEDROTTI
PERTICARARI
PRAMPOLINI
RUSSOLO
SETTIMELLI
SOFFICI
SOMENZI
TATO
UNTERVEGER
WULZ

BIOGRAPHIES

AZARI

The painter and aviator Fedele Azari was born in Pallanza on 8 February 1895 and died on 27 January 1930 in Milan. Through the musician Ferruccio Busoni he developed a friendship with Umberto Boccioni while still a student in 1916. That same year Boccioni executed a portrait of him in sanguine. Shortly thereafter he met F.T. Marinetti in Milan and joined the Futurist movement. He graduated in Law in 1917. During the First World War he carried out aerial reconnaissance photography above enemy lines, an experience that had a decisive impact on his artistic sensibility. At the end of the War he had his manifesto printed on leaflets that he tossed from an aeroplane as he flew over Milan Cathedral. Inspired by the principles of 'mechanical art', he produced his first photographs, which concerned industrial themes, and gave lectures on the technical capabilities of aeroplanes. In December 1919 he settled in Milan, where for a few years he pursued a career as a lawyer, but without renouncing either his passion for flying or his enthusiasm for Futurism. In 1924 he was among the organizers of the Primo Congresso Nazionale Futurista, held in Milan, during which he delivered three lectures, which he later developed into theoretical texts on the 'protection of machines', 'artificial flora' and the 'Futurist simultaneous life'. As a pilot he was the inventor of aerial publicity in Italy, performing acrobatic flights over its most important cities while launching leaflets into the skies. He also visited New York, where he was awarded various patents in the field of aeronautical engineering. Always keeping his camera with him wherever he went, he sought to keep a visual record of everything he did. Accordingly, he produced numerous photographs on the theme of aviation, which ranged from the sublimation of flight as a conquest that exalts human greatness, to attempts at capturing the dynamism and the spiritual dimension of the aerial vision. His close friend Fortunato Depero taught him to paint, and between 1924 and 1926 he produced a series of works entitled *Prospettive di volo* (Perspectives of flight),

as well as some multimedia assemblages. In his paintings he revisited the iconographical elements of his 'aerophotographs': eccentric perspectives viewed from on high, slanting horizons, topsy-turvy landscapes and so on. Of such works only *Volo librato* (Gliding flight) remains, which was exhibited at the 1926 Venice Biennale. During this same period he founded S.I.A.C. (Società Italiana Aviazione Civile), thus playing an important role in the development of air transport in Italy. Through the intervention of the industrialist Castaldi, this became the Istituto Nazionale Trasporti e Propaganda Aerea, of which Azari was the financial director for several years. Abandoning the visual arts, he founded the publishing house Dinamo-Azari and, in 1927, printed the celebrated book-object *Depero futurista*, which was bound by two bolts. Together with Marinetti, who was to appoint him national secretary of the Futurist movement, he compiled the *Primo dizionario aereo italiano* (First Italian aerial dictionary) in 1929. This book aimed to modernize the Italian language, challenging the archaic-styled neologisms coined years earlier by the poet Gabriele D'Annunzio to describe flight; but its publication was also a prologue to the researches into 'aeropainting' that took place immediately thereafter. By day an ace pilot in the sphere of sporting aviation, and by night a gallant *viveur*, Azari led a disorderly existence and, after having squandered his fortune, began a career as a flying instructor. He committed suicide in a Milanese nursing home where he had gone to recover from a severe nervous breakdown related to drug abuse.

BALLA

The painter Giacomo Balla was born in Turin on 18 July 1871 and died on 1 March 1958 in Rome. He attended courses at the Accademia Albertina in Turin before moving with his mother in 1895 to Rome, where he was to establish himself as one of the most innovative artists of his generation. He travelled to Paris in 1900 to visit the Exposition Universelle, and to Turin two years later to see the Esposizione Internazionale d'Arte Decorativa Moderna. This inspired him to join the association run by the journal *Novissima*, the programme of which was the modernization of art in Italy. His works locate him among those protagonists of Italian Divisionism whose paintings were of a realist, socially-committed character, while also revealing him equally attentive to the modern visual language of photography. Among the pupils who frequented his studio in those days were the young artists Boccioni, Arturo Ciacelli and Gino Severini, who came to understand the Divisionist technique through studying his canvases. Encouraged by Boccioni, Balla was to sign the *Manifesto dei pittori futuristi* (Manifesto of the Futurist painters) in 1910, although it was three years before he was to exhibit with the group for the first time. By this point his work was characterized by a treatment of the image that had its basis in experimental scientific photography: his formal analysis of kinetics and dynamism were inspired by the 'chronophotography' of Etienne-Jules Marey and the 'dynamography' of Ernst Mach. At the same time, he perceived in photography a means of documenting the alternative lifestyle of the Futurist artist and his rejection of conventional modes of conduct. In 1914 he published his manifesto *Il vestito futurista* (Futurist clothing), thereby launching Futurist fashion, and produced his first typographical compositions.

The following year, together with the young artist Depero, he signed the manifesto *Ricostruzione futurista dell'universo* (Futurist reconstruction of the universe), in which he theorized the creation of abstract, kinetic sculptures. He was also one of the authors of the *Manifesto della cinematografia futurista* (The Futurist cinema), and participated in the production of the film *Vita futurista*, to which he brought his theatrical sensibility and some ideas for scenes that would seem to have been inspired by the interpretative dancing of Loie Fuller. In 1917 Sergei Diaghilev commissioned him to direct and design the Roman production of Stravinsky's *Feu d'artifice*. Balla's idea was to create a play of coloured lights over a variety of three-dimensional abstract forms and to exclude the use of dancers or any narrative elements in varying visual effects on the stage. In 1918 he published his *Manifesto del colore* (Manifesto of colour) and presented a one-man exhibition at the Casa d'Arte Bragaglia in Rome. Inspired by a playful conception of art, he was attracted to the notion of creating household objects and interior designs that would enable the incorporation of the revolutionary Futurist programme into the fabric of daily life. At the beginning of the 1920s his work moved towards geometric abstraction, responding to the influence of 'mechanical art', and he continued to be represented in all the exhibitions organized by the movement, within which his influence came to be second only to that of Marinetti himself. In 1929 he signed the *Manifesto dell'aeropittura futurista* (Manifesto of Futurist aeropainting), but he was soon to distance himself from Futurism, gradually returning to more traditional forms of figurative painting. In 1937, refusing to follow the latest ideological directions taken by Marinetti, he severed his links with the movement definitively. Painting from 'real life' once more, he intended to distance himself from the new rhetoric of the Futurist painters, who had become enslaved by the political régime then governing Italy.

BELLUSI

The poet, engraver and photographer Mario Bellusi was was born in Ferrara on 20 February 1893 and died on 21 November 1955 in Rome. His first passion was for poetry, which he wrote under the pseudonym Marius De Paolis, the Latinized form of his mother's surname. Immersed in D'Annunzian aesthetics and attracted to the works of Adolfo De Karolis, he produced a number of Symbolist-inspired xylographs, which he exhibited in a gallery in Ferrara. Through the poet Corrado Govoni he discovered the Futurist movement, which he joined in 1913. His belief in the myth of the Futurist revolution was such that when his first child was born in August 1914 he baptised him Mafarka, the name of a literary character created by Marinetti in a novel of 1909. His woodcuts were reproduced in numerous journals, such as *Poesia e Arte*, *Cronache d'Attualità* and *L'Eroica*, besides being used for the covers of various books. The artist Filippo De Pisis put him in contact with Tristan Tzara, who wrote to him during the First World War. At the end of the War Bellusi moved away from Marinetti, adhering to Lionello Fiumi's *movimento liberista* and, in 1919, participated in the Terza Esposizione d'Arte Moderna at the Museo Civico in Verona. Immediately thereafter he undertook new research, and dedicated himself to photography, exploring in particular depth the technique of photomontage and the 'spectralization of objects'. In 1929

he moved to Rome, where he opened a photographic studio and renewed his links with the Futurist movement. The following year he was appointed secretary-general of the Primo Concorso Fotografico Nazionale, and was among the organizers of the Prima Biennale Internazionale d'Arte Fotografica in Rome, which displayed many avant-garde works. He participated in all the exhibitions of Futurist photography held in Italy during the 1930s, initally under the pseudonym Biemme, but later under his real name.

BÉRARD

The photographer Ottavio Bérard was born in San, in the province of Turin, on 18 July 1896 and died on 27 March 1975 in Aosta. He attended a technical institute and devoted himself to photography, but also acquired a sound physical education and became an accomplished skier. He was drafted in 1916, and was sent to the Front as an Alpine lieutenant. After the War he accepted the task of organizing the Scuola Alpina of Predazzo, where Customs and Excise officials were trained to ski, but never abandoned his photography. For many years he coached military sporting groups, which won many cups and trophies at international level, while continuing his photographic work, usually taking mountain landscapes and sports as his subjects. At times imbued with mystical overtones, his photographs testify to a sensibility profoundly attracted by the most fascinating aspects of mountainous landscapes. However, having installed his own studio at the Scuola Alpina, he also carried out research in the field of experimental photography. In 1924 he published a book entitled *Come va affrontata la montagna* (How to tackle a mountain), illustrating it with his own photographs. He became interested in Futurism and was in contact with Depero, who supplied him with avant-garde publications, inspiring him to produce still-life compositions and abstract works achieved through the manipulation of the image in the darkroom. He moved to Verona and in 1941 was a volunteer on the Greco-Albanian front. Many of his photographs are conserved in the Museo Storico della Guardia di Finanza in Rome.

BISI

The writer Giannetto Bisi was born on 14 December 1881 in Ferrara, and died on 2 August 1919 in Verona. He graduated in humanities and worked in the field of cultural journalism. Focusing on music, the theatre and art criticism, he published numerous articles in Milanese magazines and newspapers. In addition, he translated the writings of Heine and Barbusse, wrote poetry, drew political caricatures and produced photographic work. In 1912 he met Boccioni and the Bragaglia brothers and became involved with Futurism, following the movement's artistic experiments with intense interest and taking part, experimentally, in the exploration of Futurist aesthetics. He directed the journal *Il Mondo*, in which he published Futurist works.

BOCCIONI

The painter and sculptor Umberto Boccioni was born in Reggio di Calabria on 19 October 1882 and died on 17 August 1916 in Verona. Along with Severini he frequented Balla's studio in Rome. After living in Russia, Paris and Venice for short spells he settled in Milan, where he met Gaetano Previati and Giuseppe Pellizza da Volpedo. He became interested in experimental photography, while his painting was Divisionist in style and reflected Socialist beliefs. He adhered to the Futurist movement in 1910 after meeting Marinetti, and immediately established himself as the foremost theoretician of 'plastic dynamism', which he believed to be the central principle of Futurist art. He was certainly attracted by the photographic sequences of Eadweard Muybridge, the dynamographies of Mach and the chronophotography of Marey, this being as evident in his pictorial works as in his writings. For the official photographs of his sculpture *Forme uniche della continuità nello spazio* (Unique forms of continuity in space) he selected a photographic procedure almost identical to that used by Marey and the Bragaglia brothers, but, after a brief moment of enthusiasm, harshly rejected the latter photographers' concept of photodynamism. His embracing of Cubist aesthetics, following his visits to Paris, was to induce him to condemn anything that could reveal the close ties that had actually existed between painting and photography in the early days of Futurist research. In 1915 he enlisted as a volunteer in the First World War. Soon after, he began to drift away from Marinetti and his work ceased to adhere to Futurist principles.

BONAVENTURA

The photographer Gustavo Ettore Bonaventura was born on 4 February 1882 in Verona and died on 14 April 1966 in Rome. He began a career as a civil servant but abandoned it shortly after moving to Rome. He opened his photographic studio in via Tomacelli, but also experimented in the fields of fashion and the decorative arts, designing items of furniture and costumes and creating furnishings and fabrics printed with abstract geometric motifs. He adhered to Art Nouveau aesthetics, then to those of modernism, thereby approaching the art of the avant garde. As a photographer he produced landscapes and views of Rome, but above all he was a pictorialist portrait artist who specialized in gum-based printing. In Paris in 1906 Robert Demachy published some of his portraits. He established many international contacts and often visited Austria and Germany. His photographs were included in the *Photographische Kunst* yearbook of 1912, the year in which he photographed Rodin during his visit to Rome. He published many articles in the Milanese journal *Il Progresso fotografico*, writing on technical processes and the theme of 'photography as art'. He met the Bragaglia brothers, participated in the meetings of the Roman Futurist group and became interested in photo-dynamism, carrying out experiments with superimpositions, simultaneity and split images.

BRAGAGLIA

Before 1914, this name corresponds to the joint research undertaken by the two brothers Anton Giulio and Arturo Bragaglia. The former was born in Frosinone on 11 February 1890 and died on 15 July 1960 in Rome. The latter was also born in Frosinone, on 7 January 1893, and died on 21 January 1962 in Rome. Following the advice of his uncle, Monsignor Albino Bragaglia, Anton Giulio entered a seminary when he was very young and completed his secondary education there, leaving only in 1910, by which time he had developed a passion for archaeology and literature. He hoped to work in the field of journalism, despite the disapproval of his father, and to this end began to take an interest in photography. Additionally, the two brothers frequented the Cines film studios, of which their lawyer father was the general manager. Self-taught and fascinated with mechanical gadgets, Arturo had a purely technical and pragmatic approach towards photographic matters, while Anton Giulio preferred taking pictures and elaborating theories. However, the two brothers were inseparable. They were certainly well informed about Futurist activities and theories, and, after discovering chronophotography, began their research into photodynamism in 1911. This was a new technique, by which they believed movement could be captured in accordance with a vitalist aesthetic, as opposed to the analytical positivism of Marey's approach. The first such works were produced using three lamps and a camera bought at the Campo dei Fiori market in Rome, while a bedroom in the Bragaglias' house at via Banchi Vecchi 139 served as both a studio and a darkroom. Anton Giulio immediately set about promoting photodynamism, organizing exhibitions with slide shows in which he lectured on the theoretical bases of this new art and planned to publish the typewritten text of his talk, which he was to rewrite several times, developing his reflections on art and the photography of dynamism. In 1912 the two brothers entered into contact with various figures belonging to the artistic and literary circles of Rome. In this way they came to meet Luciano Folgore and Balla, the latter having recently returned from Düsseldorf. Through them, they came to know Boccioni and Marinetti. After a meeting in the Aragno café in Rome, Balilla Pratella and Luigi Russolo returned to the Bragaglias' house along with Marinetti and Boccioni, where they posed for portraits and several 'photodynamic' works. Marinetti provided the two brothers with financial support, thereby officially establishing photodynamism as another medium of the Futurist avant garde, despite the fact that Boccioni was to refuse the inclusion of such work in an exhibition organized by the Futurist painters. Anton Giulio wrote a new extended version of his essay *Fotodinamismo futurista* (Futurist photodynamism), in which Balla's pictorial researches were cited for the first time, and took part in the Futurist evening held on 21 February 1913 at the Teatro Costanzi in Rome, flinging copies of his manifesto from the gods. He published a manifesto entitled *La fotografia del movimento* (The photography of movement), organized various exhibitions with the backing of Marinetti, Balla, Folgore and Libero Altomare, and published his book *Fotodinamismo futurista* at the end of June 1913. Boccioni, however, pressed Marinetti to withdraw the official support of Futurism for the researches of the two brothers, and the separation became final in early October of the same year. They nevertheless continued their work, experimenting with 'spiritualist photography' and producing photomontages through the superimposition of several negatives upon one

another. Anton Giulio also became interested in ancient Roman excavations, and in 1915 published a volume entitled *Nuova archeologia romana* (New Roman archaeology), illustrated with the photographs of his brother Arturo. Arturo's departure for the War brought about the end of their researches into photodynamism and spiritualist photography. Anton Giulio turned to literature, writing experimental novels, which he defined as 'cerebral convulsions', before devoting himself once and for all to the field of the performing arts. In 1916 he produced the film *Thaïs*, with an abstract-geometrical Secessionist-influenced set design created by Enrico Prampolini. He opened the Casa d'Arte Bragaglia in via Condotti, Rome, on 4 October 1918, which comprised a theatre and a complex of rooms as well as Arturo's own photographic studio. In a periodically updated room was held a permanent exhibition of Arturo's 'artistic photoportraits', in which he attempted to characterize his subjects by means of heavily stylized poses. Among these were portraits of the Futurists Marinetti, Ruggero Vasari, Bruno G. Sanzin, Mino Somenzi, Antonio Valente, Franco Casavola, Virgilio Marchi, Folgore and Mario Carli, although Arturo's clients were predominantly figures who moved in the glamorous and artistic worlds of the film industry and the theatre in Rome. A large exhibition displaying portraits of celebrated actresses, including Lyda Borelli, was mounted in 1919 at the Cova in Milan and the Kursaal in Rimini. Its success was such that Arturo enlisted the assistance of his younger brother Carlo Ludovico in his work as a portraitist. Carlo Ludovico Bragaglia was born in Frosinone on 8 July 1894, and died on 4 January 1998 in Rome. He was later to be at the centre of a lively controversy regarding the origins of photodynamism. Until 1979 Carlo Ludovico attributed its invention and realization to his older brothers in all his writings and interviews on the subject. However, at the beginning of the 1980s, surprised by the success of an exhibition of Futurist photography at the Museé d'Art Moderne de la Ville de Paris, he suddenly began to claim that, for fun, he too had participated in the early experiments with photodynamism, aged little more than fourteen years old. In old age these claims were to become assertions that he had been the *inventor* of the technique, something that led to much confusion among art historians who were unaware of the true circumstances of its development. In reality, Carlo Ludovico's photographic output comprised some 'photoportraits' of minor film actresses, which were exhibited in the post-war period in the Casa d'Arte Bragaglia. In 1922, moving this establishment to via degli Avignonesi, Anton Giulio founded his Teatro degli Indipendenti, in which he staged numerous avant-garde performances. Although now devoting himself entirely to the theatre, he never ceased defending in his writings the historical significance of photodynamism in the evolution of avant-garde art. Arturo, on the other hand, continued to pursue his career as a professional photographer. He also began to revisit his Futurist research, experimenting with optical distortions and producing new photodynamic works on the theme of dance, which were posed for by the ballerina Ya Ruskaia, besides participating in various exhibitions with works of a more traditional character. In 1925 he was a member of the organizing committee of the Mostra Fotografica Italiana, which was held in Genoa, and was appointed National Adviser of the Federazione dei Fotografi. Around this time he deepened his research into photodynamism, as well as photographing all the performances at the Teatro degli Indipendenti, but left there in 1929

to open a studio with the photographer Bettini in via Bocca di Leone, Rome. The following year he was one of the organizers of the Concorso Nazionale Fotografico in Rome, in which he was himself represented in the Futurist section, and his works were to be included in all the exhibitions of Futurist photography at that time. At the beginning of the 1930s, while Carlo Ludovico began to work in the film industry, Arturo opened a new studio in via Regina Elena, which later moved to via San Nicola da Tolentino 60 and, finally, to Piazza di Spagna. Specializing in photographing stage and cinema sets, Arturo was to become director of the photographic department at Cinecittà in Rome. In addition, from 1937 he acted in such important films as Vittorio De Sica's *Miracolo a Milano* and René Clair's *La Beauté du Diable*, frequently starring alongside much more renowned actors. In 1942 he was appointed professor of photographic optics at the Centro Sperimentale di Cinematografia in Rome.

BUCCAFUSCA

The painter and poet Emilio Buccafusca was born in Castelnuovo on 6 February 1913 and died on 1 March 1990 in Paris. After completing his studies in medicine he embarked upon a professional career in this field without, however, relinquishing his passion for poetry and painting. In 1931 he met Marinetti and became an active member of the Neapolitan Futurist group the following year. He contributed to such Futurist journals as *Elettroni*, *Battaglie* and *Prima linea*, publishing theoretical texts and 'aeropoetry'. He exhibited his paintings in group shows and, in frequent contact with the Futurist photographer Giulio Parisio, experimented with photography and the technique of photomontage.

CARMELICH

The painter, photographer and poet Giorgio Riccardo Carmelich was born on 12 April 1907 in Trieste and died on 27 August 1929 in Bad Nauheim. While a student he devoted himself to drawing and the graphic arts, and, having developed a passionate interest in the art of the avant garde, issued the journal *Le Cronache* in 1921, which he wrote and decorated entirely by hand. He was drawn to the carnival, to the 'art of childhood' and nonsensical, absurdist humour, thereby opposing bourgeois culture through a conception of avant-garde experimentation as a liberating regression. After meeting the poet Emilio Mario Dolfi, with whom he developed a close friendship, he joined the Futurist movement. He produced the books *La storiella di Lenin* (The tale of Lenin), *Il sindaco di Cork e il cane inglese* (The mayor of Cork and the English dog), *Fantasia* (Imagination), *Parole* (Words) and *La solita storia* (The same old story) in limited editions of only seven copies. These were hand made, containing autograph texts and pastel illustrations. In 1922 he designed the graphic and editorial layout of Dolfi's journal *Epeo*, which was likewise produced in accordance with an aesthetic of craftsmanship and included Expressionist-influenced engravings as well as stylistically naïve pastel works, ornamentation and drawings. Carmelich travelled between Vienna, Florence, Munich and Rome in order to gather information on the activities of the international avant garde. In September 1922 he and Dolfi organized the Primo

Convegno d'Epeo with the aim of exploring the themes and formal problems of avant-garde art on a deeper level. This led to weekly meetings nicknamed 'Les Mardi des Amis' attended by young artists from Trieste and Gorizia. For each meeting Carmelich produced a pamphlet outlining its agenda, which contained pastel illustrations and booklets of original photographs decorated with coloured drawings. He explored new techniques and aesthetics, such as the 'synthetic novel', the collage of coloured paper and the 'grotesque synthesis' in painting and sculpture. Together with Dolfi he founded the journal *Parva*, which was dedicated to the world of childhood, and wrote poems on themes from Ridolini, Charlie Chaplin, Arsène Lupin, the circus and the carnival. In April 1923 he released his manifesto *La sensibilità artistica moderna* (The modern artistic sensibility), produced the hand-made text *Ricordi capovolti* (Topsy-turvy memories), and two collections of verse entitled *Eeeet, antologia dell'anima mia* (Eeeet, anthology of my soul) and *Ridolini e gli altri corridori* (Ridolini and the other racers). He executed drawings and works in pastel and Indian ink inspired by the artists Robert Delaunay, Kasimir Malevich and Paul Klee. He also published the album *L'arte nuovissima* (The very new art) and the manifesto *Verso un nuovo cartellone* (Towards a new poster art), in which he laid out his plans for revitalizing advertising graphics. He collaborated on the Futurist journals *L'Aurora*, *La Nuova Venezia*, *Originalità* and *Energie futuriste*, of which he was the editor. He met Prampolini and participated in the exhibition of Futurist scenography that he arranged in Vienna in 1924. During the 1920s his work embraced the principles of 'mechanical art', a recent development of Futurism. He published the manifestos *La rappresentazione ambientale* (Environmental representation), *I creatori di estetiche* (The creators of aesthetics) and *Valutazione avanguardista degli spettacoli teatrali* (Avant-garde evaluation of theatrical performances). In February 1925 he launched the journal *25*, the aim of which was to unite the avant gardes in the name of Futurism and Constructivism. He designed the cover and layout of Pocarini's poetry anthology *Lollina*, and came into contact with Cernigoj, with whom he shared an enthusiasm for Constructivist aesthetics. Together with him and Dolfi, he was to found at the end of the year a private art school orientated towards Constructivism. At the annual exhibitions of the Circolo Artistico of Trieste he showed watercolours, pastels, collages of coloured paper and xylographs, often of a somewhat primitivist and Expressionist character. He began to experiment with photography, producing distorted images, photomontages, still lifes, masked portraits and photographs of grotesque disguises. Between October and December 1927 he exhibited three works in the Esposizione del Sindacato Belle Arti at the Padiglione Municipale in Trieste. On this occasion he showed alongside the artists Vlah and Stepancich of the Gruppo Costruttivista founded by Cernigoj, but was to distance himself from this initiative shortly thereafter. He went on to study architecture in Turin and Venice, and produced 'grotesque syntheses' during a trip to Prague, drawing the palaces and Baroque architecture of that city. In 1928 he and Dolfi wrote the screenplay for a film entitled *Il Carro di Tespi* (The cart of Thespis), although this project was never realized. At the time of his death he was producing special cardboard marionettes with which he planned to further his avant-garde cinematic experiments.

CARRÀ

The painter Carlo Dalmazzo Carrà was born on 11 February 1881 in Quargneto and died on 13 April 1966 in Milan. After briefly living in both Paris and London he established himself in Milan, where he attended painting classes at the Accademia di Brera. He read texts by Marx and Labriola, moved in anarchist circles and joined the Famiglia Artistica. He was among the signatories of the *Manifesto dei pittori futuristi* (Manifesto of the Futurist painters) and participated in all of the group's early exhibitions. In 1915 he gathered together his theoretical writings in a book entitled *Guerrapittura* (Warpainting), which also contained one of the earliest examples of Futurist photocollage. Shortly thereafter, however, he was to distance himself from the ideas of Marinetti and adhere to the metaphysical art of Giorgio De Chirico.

CASTAGNERI

The photographer Mario Castagneri was born in Alexandria, near Turin, on 28 June 1892 and died on 22 December 1940 in Milan. After completing his technical studies he worked first in Brescia with his brother-in-law, the photographer Testani, then in Milan in the Bassani studio. In 1915 he opened his own studio in corso Garibaldi, Milan, and quickly established himself as a photographer of the Milanese bourgeoisie and high society. Additionally, D'Annunzio, Toscanini, Guido Keller, the sculptor Medardo Rosso and some of the most noted literary and political figures of the day were visitors to his studio. In 1921 he was appointed official photographer of performances at the Teatro alla Scala. He exhibited his 'artistic portraits' at the Galleria Pesaro and the Saletta Lidel. In 1924 Marinetti appointed him official photographer for the Primo Congresso Nazionale Futurista in Milan. On this occasion he published the portfolio *Onoranze nazionali a F.T. Marinetti animatore d'italianità* (National honors to F.T. Marinetti, promoter of Italian-ness), which included one of his portraits of the poet and an autograph poem of Marinetti's reproduced in facsimile. But his most celebrated images from the congress are those of the Futurists on stage at the Teatro Dal Verme holding their abstract pennants designed by Prampolini. Immediately thereafter he began his Futurist research, creating photomontages by means of the superimposition of several negatives, as well as photographs of symbolic poses and works in which the forms depicted took on fluid qualities. He also experimented with chromatic toning. Particularly notable was his use of an intense blue to endow his female 'multiportraits' with a dreamlike character. He established a long-standing friendship with Depero, who collaborated on his researches, bordering his photographs with asymmetrical, pointed and radiating forms expressive of the Futurist aesthetics of dynamism and aggressiveness. At the beginning of the 1930s he produced a series of photographs in which the personalities and 'states of mind' of various Italian poets and writers (including Depero, Petrolini and Martini) were captured in photographs of their hands. He produced a number of book covers, and contributed to the journal *Terra d'Italia*. In 1932 he designed the cover of Depero's book-object *New York film vissuto* (New York – a real life film), although this was never published. In 1934 he abandoned photography and worked as a restorer of old paintings.

CERATI

The dramatist, journalist and photographer Cesare Cerati was born in Pavia on 28 April 1898 and died on 1 November 1969 in Ventimiglia. He participated in the activities of the Pavia Futurist group founded by Angelo Rognoni and Gino Soggetti. Moving to Milan he met Marinetti, Dessy, Rampa Rossi and Nelson Morpurgo. He embarked on a career as a journalist, also working in the field of graphic design, which led him to collaborate on newspapers such as *L'Eco d'Italia*, *Il Secolo*, *La Sera* and *L'Ambrosiano* before working as a manager at the publishing house Rizzoli. He composed works of Futurist synthetic theatre and attended the theatrical events organized by Marinetti, but never stopped writing plays and dramatic works of a more traditional kind, such as *C'è teatro e teatro* (There is theatre and theatre), co-written with Ada Salvatore, and *Costruire* (Constructing), co-written with Carlo Roggero, which were staged in the G.U.F. (Gioventù Universitaria Fascista) Hall in Milan. He also experimented with 'free-word' poetry, creating typographical compositions similar to those of Francesco Cangiullo, and theorized his research in the unpublished *Manifesto dei ritratti alfabetici* (Manifesto of alphabetical portraits) of 1923. His avant-garde experimentation extended to the production of abstract photography, as well as photomontages and postal collages composed from newspaper cuttings. In 1934 he wrote a weekly column for Milan's *L'Ambrosiano* entitled '*Obiettivi del dilettante fotografo*' ('Objectives of the amateur photographer'). He studied yoga, interpreting it in the context of Marinetti's 'philosophy of artificial optimism'. Between June 1940 and December 1942 he was in Africa, serving as a captain in the Italian army. There, he established a theatre for the soldiers, adapted works for the stage and 'violently modernized' some of Molière's comedies. Examples of Futurist synthetic theatre were also performed, as were his other works and those by Rognoni and Krimer (Cristoforo Mercati), and the theatre undertook tours in the regions of Tripoli and Tobruk. For these performances he conceived some synthetic and simultaneous set designs with Rognoni, in accordance with Futurist theatrical theory. However, following the War, he abandoned all creative activity in order to concentrate on his journalistic career.

CROCE

The photographer and painter Gianni Croce was born in Lodi on 14 April 1896 and died on 1 May 1981 in Piacenza. After completing his technical education he opened a photographic studio in Piacenza in 1923. His work consisted mainly of landscapes and portraits, but he also produced numerous works of reportage photography, focusing on city life. As a painter he took landscapes and still lifes as his subject-matter and employed an austere, realist style. At the end of the 1920s he met the painter Oswaldo Bot and joined the Futurist movement. He became interested in the principles of 'mechanical art', photographing Bot's metallic assemblages and compositions made up of various objects, producing playful, stylistically naïve pictures that he termed 'Futurist still lifes'. He participated in exhibitions of Futurist photography throughout the 1930s but afterwards began to move away from the movement. However, although continuing with his professional career, he never ceased his avant-garde experimentation.

DEPERO

The painter and sculptor Fortunato Depero was born in Fondo on 30 March 1892 and died on 29 November 1960 in Rovereto. He attended an art institute before devoting himself to painting and poetry, and discovered Futurism in 1913. Shortly afterwards he visited an exhibition of Boccioni's Futurist sculptures in Rome, and began to frequent Balla's studio, where he experimented with abstract sculpture. In 1915 he and Balla published their manifesto *Ricostruzione futurista dell'universo* (Futurist reconstruction of the universe), in which a new form of art was theorized: the abstract, kinetic assemblage, constructed from a wide range of diverse materials. He participated in Futurist events as a declaimer of free-word poetry and quickly came to consider photography an extraordinarily fertile medium, creating a number of symbolic self-portraits, which were fully-fledged 'photo-performances'. In 1916 he designed the set for Diaghilev's production of the ballet *Le Chant du Rossignol*, but the project was never realized. Following this he created the *Balletti Plastici* for marionettes, and the 'mechanical ballet' *Anihccam del 3000* (Enihcam [the word "machine" as read in a mirror] of the year 3000), which featured robot-like dancers. He devoted much of his time to the theatre and the applied arts, working in the spheres of interior design and advertising. In 1925 he moved to Paris, where he unsuccessfully attempted to realize a number of 'films for marionettes' with Henri Gad. During the 1920s plans to produce films entitled *Futurismo Italianissimo* (Very Italian Futurism) and *Equatore* (Equator) likewise never came to fruition. He resumed his photographic experimentation with Castagneri, creating photographs in irregular formats and with edges cut into zig-zag forms, and realized photomontages and photocollages for his book-object *New York film vissuto* (New York – a real life film). Although this was never published, a promotional leaflet advertising its imminent release testified to its exceptional character. After living in New York for a short spell he settled for the rest of his life in Rovereto, where he published Futurist journals and several books detailing his activities as an avant-garde artist.

FILIPPINI

The photographer Emidio Filippini was born on 20 June 1872 in Levico Terme in the province of Trento and died on 19 May 1936 in Rovereto. He learned his craft in the studio of Beniamino Pasquali, after which he worked as an itinerant photographer for a number of years in and around Bolzano before being employed by the Segatini photographic company of Rovereto. In 1903 he opened his Premiato Studio Fotografico in Rovereto at via Dante 3. At the outbreak of the First World War he and his family were deported to Innsbruck in Austria, where they were to remain for two years. On returning to Rovereto in 1919 he opened a new studio, renting the Bonmassari atelier. Assisted by his two sons, he was to become the most renowned photographer in that city, producing high-quality portraits, snapshots and images of events of popular interest. He received numerous commissions, both from public organizations and individuals. He contributed to the journal *L'Illustrazione italiana* and published important photographic albums such as *La prima visita dei sovrani d'Italia a Rovereto redenta* (The first visit of Italy's rulers to reclaimed Rovereto), *La città di Rovereto alla mostra di Vercelli* (The city of Rovereto in the exhibition of Vercelli) and *La rinascita di Rovereto* (The rebirth of Rovereto). He met the young Depero and became his collaborator and friend, photographing his work and its development and Futurist parties that the artist organized in Rovereto. Filippini was thus drawn into the Futurist movement, believing in its mythology of industrial progress. Some of his most interesting images, which are truly modern journalistic investigations of the world of work, testify to this. In the mid-1920s he produced hundreds of photographs depicting, among other things, the manufacturing stages at a tobacco factory, and of the ranks of workers and machines at the Ponale hydroelectric power station in Riva del Garda. In June 1933 he ceased his photographic activities, handing his studio over to his son Alcide, who was forced to close it four years later owing to bankruptcy.

GRAMAGLIA

The photographer Vittorino Gramaglia, who went by the name Maggiorino Gramaglia, was born in Turin on 12 September 1895 and he died there on 15 April 1971. He taught himself photography, opened his own studio in 1923 at Piazza Castello 9 in Turin and began to move in that city's Communist circles. In his early photographic experiments he insisted on working "solely with artificial light", believing that only in this way might "photography still become an art form". His professional work was predominantly portraiture, and he photographed numerous stars of stage and screen. He created advertising posters and took part in various exhibitions in those years with compositions of a poetic character. His adherence to Futurism came in 1926, when he developed a friendship with the artist Fillia (Luigi Colombo), who was keen on his extensive collection of antique books and who frescoed the walls of his studio with abstract Futurist designs. Three years later he established the Centrale futurista association in Turin with Ugo Pozzo, Fillia and Nicola Diulgheroff, working in the spheres of decorative and promotional photography, and was involved in organizing the Mostra Sperimentale di Fotografia Futurista, which was held in Turin in 1931. His avant-garde works focused predominantly on the portraits and photomontages produced by the superimposition of several negatives. He also used the negative image in his work, a distinctive technique whose only other proponent among those photographers affiliated with Italian Futurism was Parisio. He signed his avant-garde works with a miniaturized reproduction of his self-portrait *Spettralizzazione dell'Io* (Spectralization of the Ego), a work in which he employed formal solutions similar to spiritualist photography. He would also seem to have been aware of Russian Constructivism, as is apparent from some of his images of modern industry celebrated by the Futurists. In 1932 he made several portraits of Marinetti with Fillia, who published his works in the journals of the Turin Futurist group. For many years he was involved in trade union activities, concerning himself with professional issues. A passionate bibliophile, he formed an impressive collection of books, although this has now been broken up.

KERTÉSZ

The photographer André Kertész was born in Budapest on 2 July 1894 and died on 28 September 1985 in New York. He attended courses at a school of economics and commerce, and in 1912, after receiving his diploma, worked in the stock exchange. As an amateur photographer he produced numerous images of the streets of Budapest and of the surrounding countryside. He was called up for active service in 1914 in the Austro-Hungarian army. He photographed the activities of the soldiers in the trenches and was seriously injured the following year. In 1917 he published his first photographs in *Erdekes-Ujsag*, and, at the end of the War, returned to work at the stock exchange in Budapest. From 1925 he devoted himself entirely to photography. Moving to Paris, he worked freelance for several French and foreign newspapers such as *Berliner Illustrirte Zeitung*, *Il Nazionale*, *Vu* and *The Sunday Times*. He met Prampolini and produced a number of portraits of him and several symbolic photographs, such as *Omaggio a Marconi* (Tribute to Marconi), which portrayed the Italian artist together with Michel Seuphor and Paul Dermée. He explored anamorphosis using curved reflective surfaces, and subsequently drew near to Surrealism with the celebrated 'distortions'of his female nudes. In 1936 he travelled to New York at the invitation of Keystone Studios. The War forced him to remain in the United States, where he was to work for fashion and interior design journals.

KESTING

The painter, photographer and engraver Edmund Kesting was born in Dresden on 27 July 1892 and died on 21 October 1970 in Birkenwerder. He studied at the Kunstgewerberschule, devoting himself to painting and watercolours. In 1919 he was one of the founders of Der Weg art school in Dresden. He met Herwarth Walden in Berlin and contributed to the journal *Der Sturm*. He organized a one-man exhibition, which was presented by Walden, and began research in photography. In 1924 he created in Dresden a Society of the Friends of Der Sturm, and, two years later, founded a branch of Der Weg art school in Berlin. He participated in several group exhibitions in Berlin, Dresden, Moscow and New York, and, in 1927, made an extended visit to Italy. He produced numerous photomontages, experimenting with double exposures and the superimposition of negatives in works in which the dancer Dean Godell posed. In 1932 he participated in the Prima Biennale Internazionale d'Arte Fotografica in Rome and came into contact with the Futurist movement. He contributed writings and photographic works on the theme of dance to Mino Somenzi's newspaper *Futurismo*. In 1933 Der Weg art school was closed by the Nazis and, no longer being able to exhibit, he accepted a position in an optics company, where he was in charge of photography. His works were seized and banned in 1937 when the Nazis pursued their campaign against 'degenerate art'. After the War he returned to teaching, working at the Academy of Fine Arts in Dresden, and later at the School of Cinematography in Potsdam.

LOMIRY

The photographer Emanuele Lomiry was born on 13 October 1902 in Ancona and died on 23 August 1988 in Rome. The son of Countess Noemi Piccini, a journalist and writer, he completed his technical studies in Milan and began as an actor in the theatrical company Filodrammatica. In the mid-1920s he opened his photographic studio S.A.F. Lomiry in the Galleria Vittorio Emanuele. Through his mother he met Marinetti and the Futurists Depero, Gerbino, Loris Catrizzi, Baroni, Celeste Ravelli, Azari and Paolo Buzzi, who frequented his studio and of whom he executed several photographic portraits. He later opened a new studio in via Broletto and became the manager of a cinema in Merate. His Futurist photography, in a similar way to that of Amedeo Ferroli, explored the theme of 'states of mind' through the use of multiple and differentiated images. However, he also collaborated with Depero, who embellished the margins of his photographs with geometrical indentations that enhanced the dynamism of the image. He mounted an exhibition of Futurist photographs of an emblematic character in his studio, which was inaugurated with a lecture delivered by Marinetti. He filmed several documentaries before 1938, at which time he moved to Rome. There he opened a studio in via Baronio but worked predominantly as a director of photography on several films produced by the company F.A.R. of Turin, as well as by Scalera Film and Cinecittà of Rome. Because of his interest in the cinema, which, in addition, led him to produce more than sixty short feature films and documentaries, actors and directors such as De Sica and Nazzari frequented his final photographic studio in via Sistina. In 1947 he moved to Milan, where he worked as first cameraman for Settimana Incom. He produced many documentaries on sport and moved into television, making several visits to the United States.

MARAINI

The photographer Fosco Maraini was born in Florence on 15 November 1912 and is still alive. The son of a noted art critic, he studied ethnography at Florence University, using photography to document his research. He was also interested in landscape photography, and, after having met Ernesto Thayaht (pseudonym of Ernesto Michahelles), adhered to Futurism in 1930. Thereafter, he participated in exhibitions of Futurist photography with photomontages and compositions of abstract rhythms. He founded and edited the Florentine journal *Il Feroce*, gave lectures on avant-garde photography, exhibited his photographs in London, Palermo, Florence and Amsterdam and was the motivating force within the Gruppo Fotografico Toscano. Additionally, he produced photographs recording Futurist events. At the end of the 1930s he made several study trips to Japan, and moved away from avant-garde experimentation in order to dedicate himself exclusively to ethnographic photography.

MARINETTI

Filippo Tommaso Marinetti, whose real name was Filippo Achille Emilio Marinetti, was a writer and the first theoretician of the historical avant garde. He was born in Alexandria, Egypt, on 22 December 1876 and died on 2 December 1944 in Bellagio. As a young Symbolist poet, writing in French, he published the journal *Poesia*, which aimed to counter the provincialism of Italian literature. In 1909 he founded the Futurist movement with the intention of establishing a collective structure for the experimental and innovative research of the avant garde. He published numerous Futurist manifestos, theorizing such concepts as 'words-in-freedom' and 'synthetic theatre'. Following the emergence of Fascism, he continued to maintain the unity of the Futurist group, drawing the movement into a long-running political compromise with the régime whereby it even provided support for its colonial campaigns and military ventures. In 1930 he published the *Manifesto della fotografia futurista* (Manifesto of futurist photography) with Tato (Guglielmo Sansoni). His activism was at the root of all the manifestations of avant-garde culture in Italy during the first half of the twentieth century.

MASOERO

The photographer, screenwriter and director Filippo Masoero was born in Milan on 26 May 1894 and died on 19 January 1969 in Rome. Fatherless, he was educated in Vercelli by his uncle, Pietro Masoero, a photographer renowned for his research on colour and technical innovations in the sphere of experimental photography. He gained his diploma from the Accademia delle Belle Arti and decided to devote himself to photography and the cinema. He found work at Itala Film in Turin and participated in the making of the film *Cabiria* by Pastrone. He met Marinetti and Boccioni in 1915 when leaving for the War as a volunteer in the cyclist battalion of the *bersaglieri*. Seriously injured in May 1917, he lost his right forearm and was demobilized. However, following the military defeat at Caporetto he was among the founders of the Corpo Volontario Mutilati and returned to the Front. A fierce patriot, he was in Fiume in 1920 and was appointed governor of one of the Dalmatian islands by D'Annunzio. He met Marinetti several times and produced a propagandistic photographic project on the activities of the Fiume soldiers. At the end of the occupation of Fiume he entered the army with the rank of captain of the *bersaglieri* and was transferred to Piacenza. He was a technical consultant to Milano Film and Cines in Rome. In 1926 he was transferred to Rome, where Italo Balbo appointed him director of photographic and cinematographic research in the Ministero dell'Aeronautica. He filmed several documentaries and created his first aerophotographs, recklessly leaning out of aeroplanes during flights over the historic centres of Italian cities. In 1930 he was the organizer of the Trasvolata Atlantica (Atlantic flight) of Italo Balbo, who was shortly afterwards to appoint him director of the Istituto L.U.C.E. (L'Unione per la Cinematografia Educativa) in Rome. In 1935 he volunteered for service in the Ethiopian war, and was involved in aerial reconnaissance. He was injured during an emergency landing behind enemy lines and, in April 1937, was decorated with the Medaglia d'Argento at an official ceremony held at Ciampino airport in Rome. After retiring, with the title of lieutenant-colonel,

he devoted himself to journalism and the cinema. Among other things he conceived the celebrated and semi-autobiographical film *Luciano Serra pilota* (The pilot Luciano Serra), which won an award at the Venice Film Festival in 1938. After the War he founded the production company Centaurus Film in Rome and produced several documentaries, such as *Firenze minore* (Unknown Florence), which examined the folklore and artistic treasures of Italian cities.

MONTACCHINI

The photographer Alberto Montacchini was born in Parma on 12 April 1894 and died there on 20 August 1956. He taught himself photography before working as an assistant in the studio of Luigi Vaghi, who was at that time the official photographer to the House of Savoy. He then worked as an itinerant photographer before opening his own studio in 1924 in Parma. He became a correspondent for the daily newspaper *La Gazzetta del Popolo* of Turin and provided photographic services for the Teatro Regio Parmense. He produced portraits of theatre actors and photographs of the company in costume on the stage. He was acquainted with D'Annunzio and undertook research on symbolic compositions and works of literary inspiration. At the end of the 1920s he met Marinetti and became involved in the Futurist movement. He then began to explore photodynamics, compositions of objects and masked portraits, at times creating surreal images imbued with a magical poetry. In search of new experiments, he exhibited 'coloured photographs' with the Futurist group in Rome in 1930, but also carried out numerous photographic excursions into the Emilian countryside, compiling a large study on the end of rural civilization and on the first industrial installations. He participated in several national photographic exhibitions and published his photographs in the form of postcards and advertising posters.

MUNARI

The artist and graphic designer Bruno Munari was born in Badia on 24 October 1907 and died on 30 September 1998 in Milan. After completing an erratic university education he became involved in the Futurist movement, joining the group of aeropainters and aerosculptors. He participated in the group exhibitions that took place at the Galleria Pesaro in Milan. He signed various Futurist manifestos and constructed his 'useless machines': kinetic sculpture-objects, which were contemporary with Alexander Calder's first mobiles. He dedicated himself to advertising graphics and became interested in avant-garde photography through studying the work of Man Ray. He then executed several photograms by placing objects on light-sensitive paper to create, through analogical metamorphoses, humorous landscapes each imbued with a dreamlike, poetic atmosphere. The semiological reinterpretation of the object was at the heart of this first phase of his research. In his subsequent experimentation with photocollage and photomontage he produced works inspired by the formal models of Max Ernst and Mieczyslas Berman, although always infused with irony. He designed the layout and illustrations of several important Futurist book-objects, including Marinetti's *Poema del vestito*

di latte (Poem of the dress of milk), as well as numerous journals during the 1930s. He also devised the graphic and iconographical innovations that characterized the *Almanacco letterario Bompiani* (Bompiani literary almanac) during those years. In the period following the Second World War he participated in the activities of the M.A.C. (Movimento Arte Concreta), becoming one of its most important figures.

NAKAYAMA

The photographer Iwata Nakayama was born on 3 August 1895 in Yanagawa, Japan, and died on 20 January 1949 in Kobe. After completing his secondary education he attended the Academy of Fine Arts in Tokyo, enrolling in the experimental class in photography. His training was marked by a taste for pictorialism, and in November 1918, eight months after having obtained his diploma, he left Japan for California. He lived in San Francisco, then in New York, where, in September 1921, he opened the Laquam Studio on Fifth Avenue. His portraits, published in the *American Annual of Photography*, were included in photographic exhibitions in Buffalo and Pittsburgh. He also produced numerous images on the themes of dance and the theatre, but remained a professional photographer who preferred to express his artistry in painting. In May 1926 he moved to Paris, where he worked for the magazine *Femina* as a fashion photographer, continuing to consider photography as a purely commercial activity. Nevertheless, he immediately made contact with the Japanese artists based in Paris, such as Foujita, Isamu Noguchi and the Futurist Seiji Togo, who introduced him to Prampolini. Converted to the avant garde, he photographed the sets and costumes used in the performances of the Futurist Pantomime that Prampolini presented at the Théâtre de la Madeleine in May 1927. In August of the same year, following a trip to Spain to see the works of El Greco and Goya, he left for Berlin, but soon after decided to return to Japan for good, settling in Ashiya in the province of Hyogo. In January 1928 the journal *Asahi Camera* published his text 'Pure Artistic Photography', in which he proclaimed the specificity of the photographic language and its autonomy with respect to painting. Increasing his activities, he became the most active promoter of avant-garde photography in Japan during the following years. He began new experimental research that led him to discover the principle of the photogram, wrote further theoretical texts, founded the photographic journal *Koga*, received the young photographers of the Hanshin Artists Club in his studio, gave lectures and lessons on modern photography, participated in numerous exhibitions and published books of photographs. At the beginning of the 1930s he reused his photographs of the performances of the Futurist Pantomime, incorporating them as fragments in photomontage compositions and mural panels. In 1936 he moved to Kobe, where he opened a new studio. He produced compositions made up of various objects and still-life images, and was to draw near to Surrealism, conferring a dreamlike dimension upon his photographs of fossils and minerals.

NUNES VAIS

The photographer Mario Nunes Vais was born in Florence on 16 June 1856 and died there on 27 January 1932. A member of a wealthy family, he dedicated himself to photography in 1885, characterizing himself as a "self-taught and amateur photographer". His early work took the form of reportage, and he produced photographs documenting the activities and customs of rural Tuscan communities. He was a member of the Società Fotografica Italiana, and his Florentine palazzo was to become an important centre for the cultural and social life of that city during the early years of the twentieth century. As a portrait artist he photographed numerous figures belonging to Italy's artistic and cultural milieux, whose psychological character he always strove to define.

PACETTI

The painter, ceramicist and photographer Ivo Pacini Pacetti, known as Ivos Pacetti, was born in Figline di Prato on 2 December 1901 and died on 2 August 1970 at Albissola. After completing his technical studies he worked as a restorer before moving to Albissola, where he opened a ceramics studio in 1920. He undertook experimental research in the field of photography, producing 'multiple portraits', dynamic compositions and photomontages, and joined the Futurist movement in the second half of the 1920s. Thereafter, he organized several shows of avant-garde art, exhibited kinetic and noise-making works, participated in exhibitions of Futurist photography and developed friendships with Marinetti, Bot and Fillia, while his ceramics workshop was frequented by Giacomo Manzù and Lucio Fontana. In 1937 he participated in the Mostra Fotografica Nazionale in Fiume with eight works, and four years later organized the Prima Mostra Fotografica in Genoa. His avant-garde experiments ceased at the end of the Second World War.

PALADINI

The painter and architect Vinicio Paladini was born in Moscow on 21 June 1902 and died on 30 December 1971 in Rome. He received his architectural training entirely in Rome, where he had been living since 1903. Self-taught as a painter, his work was inclined towards a symbolist interpretation of metaphysical art prior to his discovery of the avant garde in 1921, when he frequented Balla's studio. His earliest Futurist paintings attempted to combine the kinetic visions of Balla with Boccioni's 'plastic dynamism'. He moved in the Communist circles that centred around the Casa del Popolo in Rome. The journal *Avanguardia*, organ of the youth wing of the Partito Comunista Italiano, published three of his manifestos in 1922: *La rivolta intellettuale* (Intellectual revolt), *Arte comunista* (Communist art) and *Appello agli intellettuali* (Appeal to the intellectuals). The first theorist of mechanical art in Italy, he promoted the formation of a revolutionary alliance between the proletariat and the artists of the avant garde. During the same year he published the manifesto *L'arte meccanica futurista* (Futurist mechanical art) with Ivo Pannaggi and created a *Balletto meccanico*, which was performed at the Casa d'Arte Bragaglia in Rome. His ideological positions were inspired by Russian

Constructivism, yet his paintings constitute a marriage of the austere figuration of metaphysical art with the mechanical aesthetics of *L'Esprit Nouveau* discovered through the painting of Fernand Léger. He painted a series of works on the theme of *Il proletario della Terza Internazionale* (The proletarian of the Third International). In 1923 he openly contested the political ideas of Marinetti and was to distance himself from the Futurist movement shortly thereafter. When Jacques Mesnil's text *Nationalism in Art* was released in Italy, he wrote a new manifesto entitled *Arte, comunismo, nazionalismo* (Art, Communism and nationalism), in which he specified the criticisms that applied to Marinetti and his brand of Futurism. At that time he also published the book *L'arte nella Russia dei Soviet* (Art in Soviet Russia), which contained the first analysis of Malevich's Suprematism to be written in Italy. He became interested in scenography and advertising graphics. In 1926 he founded the Movimento Immaginista with a programme intended to bring about a fusion of the various avant-garde movements – in particular, Dadaism, Futurism and Surrealism – to create a new aesthetics of the image. One year later he released the journal *La Ruota dentata*, in which he published the manifesto *Prima rivelazione dell'Immaginismo* (First revelation of Imaginism). He helped to conceive the Imaginist film *Luna Park traumatico* (Traumatic Luna Park), although this project was never realized, and composed numerous photomontages. Through his visits to Russia he learned about Constructivism and came into contact with the producers of revolutionary Soviet propaganda. He created many covers for avant-garde journals and books, publishing photomontages that incorporated the humour of his Imaginist Dadaism within an overall Constructivist design. He utilized iconographical motifs from the work of Muybridge, images of Classical temples and the faces of actresses in the composition of his photomontages on the themes of sport, the city and the dynamism of modern life. He also conceived numerous set designs for Bragaglia's Teatro degli Indipendenti, as well as for the Teatro delle Arti, but these were seldom realized.

PAPINI

The writer and philosopher Giovanni Papini was born in Florence on 9 February 1881 and died there on 8 July 1956. Actively involved in the development of Italian nationalism in the early years of the twentieth century, he wrote poems and stories, translated the writings of Enrico Bergson and played a significant role in the diffusion of European philosophical thought in Italy. He joined the Futurist movement in 1913 with the foundation of the Florentine journal *Lacerba*, bringing to it a considerable polemical force. Owing to his profound cultural knowledge his writings and lectures possessed a virulence superior to the invective of Marinetti. He consequently became the spokesman of a moralist and intransigent brand of Futurism, the embodiment of an austere ideology of the avant garde entirely impervious to the parody and ironic dimension that, despite everything, remained part of Marinetti's own conception of it. The official images of himself that he left behind, photographed in his studio or in the company of Soffici, convey to perfection the refusal of any critical distance that marked his brief but intense engagement with Futurism.

PARISIO

The photographer Giulio Parisio was born in Naples on 14 March 1891 and died there on 17 February 1967. After completing his technical studies he was drafted into the air force and executed several flights of photographic reconnaissance over Dalmatia. At the end of the War he worked as a newspaper photographer, later opening his own studio in Naples, at the Porticato di San Francesco di Paola. He was interested in ethnographic photography and made long visits to Sicily and all the regions of southern Italy. He photographed both marine and mountainous landscapes, the caves at Pertosa, scenes of farming and factory work, the various forms of rural culture and fishing off the shores of Calabria, in this way compiling one of the most important photographic archives in Italy during those years. He participated in numerous national and international exhibitions. In 1926 he opened the Sala Paola art gallery, turning several rooms of his studio into an exhibition space where he showed work by Neapolitan artists, such as the sculptor Vincenzo Gemito and members of the Futurist group of 'circumvisionist painters'. That is how, in 1928, he met the painter Carlo Cocchia, who encouraged him to join the Futurist movement, introducing him to Marinetti. He carried out his first experiments with avant-garde photography, signing the photographs exhibited in his studio with the pseudonym Paris, but participated under his real name in all the exhibitions of Futurist photography during the early 1930s. In his avant-garde experimentation he used the technique of solarization, negative images, the direct impression of objects on light-sensitive paper, photomontage, optical distortion, composition with cuttings of paper, allusive and analogical shadow play and the disguising of objects, in this way carrying out a long period of research, rich in inventiveness. However, he never abandoned his sociological or ethnographical photography. He travelled to Libya to photograph scenes of daily life and the customs of local communities, as well as the large-scale works connected with Italian colonialism. He then undertook new photographic projects portraying the phases of industrial, agricultural and aeronautical development in the Italy of the 1930s. His works were projected from slides during open-air meetings in the squares of the most important Italian cities, serving as political propaganda for the Fascist régime's construction of the new Italy.

PEDROTTI

The photographer Enrico Pedrotti was born in Trento on 1 May 1905 and died on 31 March 1965 in Bolzano. He worked as an assistant to the pictorialist photographer Giuseppe Brunner before opening the Studio Pedrotti in 1929 with his brothers in via Roggia Grande, Trento. He specialized in images of mountainous landscapes and Alpine sports. He met Depero and embarked on new research creating photomontages in a Futurist style. However, he was attracted most of all by the play of light, lines and shadows, capable of conferring a lightness on the image that bordered on abstraction. He accentuated this aspect of his work to the point that he may be considered a precursor of so-called 'high-key' photography, characterized by the greatest luminosity. His photographs were published in prestigious journals, such as *Luci e Ombre* and *Galleria*, and were included in important exhibitions,

winning, among other things, the first prize at the international exhibition organized by Zeiss-Ikon in Dresden in 1935. He became interested in the cinema and made the short feature film *Tecnica di roccia* (Rock-climbing technique), which won an award at the Venice Film Festival in 1938. The same year he moved to Bolzano, where he opened a new studio in via della Mostra. He produced advertising-related photomontages and found new inspiration in creating photographs of industrial themes. Following the Second World War he participated in photography exhibitions and competitions throughout the world. In 1953 he made the film *Monologo sul sesto grado* (Monologue on the sixth degree) and began new advertising campaigns for Ferrania of Milan and the steelworks of Bolzano, besides producing a theoretical study on the portrait as a professional subject.

PERTICARARI

The photographer Umberto Perticarari was born in Rome on 8 June 1901 and died on 28 February 1972 in Caracas. The son of a painter, he was taught photography by the famous portraitist Pesapane, before opening his own photographic studio in Rome in 1925. He gravitated towards the Roman Futurist group that centred around the offices of the newspaper *Futurismo*, edited by Mino Somenzi, where some of his photographs were published. He produced playful and grotesque images, attempting to illustrate the 'lifestyle' of the Futurist artist. In 1933 he photographed Marinetti while, during the triumphant arrival of Italo Balbo's seaplanes, he declaimed a 'Futurist exaltation' of the second Atlantic crossing live on Italian radio. Full of enthusiasm for this aerial feat, he enlisted in the air force, where he held the rank of sergeant major. In 1936, during the colonial war, he was dispatched to eastern Africa, where he was responsible for military photographic projects. In May 1939 he moved to Asmara, where he stayed for a number of years, working as a portraitist. Called up for service once more on the outbreak of the Second World War, he fought in Africa and was taken prisoner. He returned to Italy only in 1948, but shortly afterwards emigrated to Venezuela, where he opened a photographic studio in Puerto La Cruz. He later lived in Maracaibo and Barquisimeto, working always as a photographic portraitist.

PRAMPOLINI

The painter and set designer Enrico Prampolini was born in Modena on 20 April 1894 and died on 17 June 1956 in Rome. He studied at the Accademia di Belle Arti in Rome, where he was the pupil of Duilio Cambellotti, thus receiving an education marked by a Secessionist taste for linear decorativeness. He prepared a study on synesthesia, which, however, he abandoned in 1914 on joining the Futurist movement. He frequented Balla's studio in Rome, but was excluded the following year at the request of Boccioni, who did not accept his contentious attitude regarding the invention of the Futurist 'plastic complex'. He worked as a set decorator, released the manifesto *Scenografia futurista* (Futurist scenography) and published numerous theoretical articles, including *Pittura pura* (Pure painting), in

which he challenged the stance of Kandinsky. He established a long-running correspondence with Tristan Tzara and participated in the first Dada exhibition in Zürich. He published the journals *Avanscoperta* and *Noi*, in which he assumed independent avant-garde positions, establishing important international contacts. In 1917 – that is, after the death of Boccioni – Marinetti invited him to join the Futurist ranks once more. He became interested in photography in 1918 and was in frequent contact with the Bragaglia brothers. His first experiments used the technique of photocollage. In October 1922 the American journal *Broom* published on its cover one of these works, composed in red and black, with fragments of images of 'mechanical art'. He moved to Paris, where he associated with the photographers Marc Vaux, André Kertész and Iwata Nakayama, among others, and shared his studio with Florence Henri. He was to pose for a series of symbolic images produced by Kertész, and appointed Nakayama the official photographer of the performances at the Teatro della Pantomima Futurista, which he presented in Paris in 1927. However, he intervened at length in these photographs, through masking and intensifying the lighting effects, to the point that they became fundamentally autonomous works. During the early 1930s he utilized photocollage and the medium of the monumental 'photoplastic' in creating panels intended for political propaganda and advertising. He conceived the avant-garde film *Mani* (Hands), but this project was never realized. He wrote on avant-garde photography, publishing, among other works, an article in 1936 on the artists of the Bauhaus entitled *Conquiste e strategie della camera oscura* (Conquests and strategies of the darkroom).

RUSSOLO

The painter and musician Luigi Russolo was born in Portogruaro on 30 April 1887 and died on 4 February 1947 in Cerro di Laveno. He completed his studies at the seminary of Portogruaro and considered becoming a musician before moving to Milan, where, as an unregistered student, he attended courses at the Accademia di Brera. He became involved with the Famiglia Artistica group, where he first met Boccioni and Carrà. His earliest works, exhibited in 1909, were engravings and paintings that revealed Symbolist influences. The following year he joined the Futurist movement and, after having signed the *Manifesto dei pittori futuristi* (Manifesto of the Futurist painters), began his research into dynamism. Passionately interested in experimental science, he was certainly familiar with Marey's chronophotography. In fact, among Marinetti's followers he was the first to convey movement in his works through the repetition of forms. He participated in the exhibitions of the Futurist group until 1913, the year in which he released the manifesto *L'arte dei rumori* (The art of noises) and dedicated himself to designing the 'intonarumori' ('noise intoners'), the instruments necessary for the production of this new form of Futurist music. At the outbreak of the War he enlisted as a volunteer and was to receive serious head injuries. He underwent cranial surgery and was unable to work for several years. His resumed his activities in 1924, executing paintings and constructing a 'noise' keyboard that he called the 'Rumorharmonium'. An anti-Fascist, he chose exile and moved to Paris in 1927. There, he

participated in the activities of the Cercle et Carré group, met Edgar Varèse and constructed the Russolophone, a new improved version of the Rumorharmonium. He used this in the avant-garde cinema Studio 28, in particular to accompany with grotesque dissonances the scientific films of Jean Painlevé, thereby creating an aural counterpoint to the abstract and often tediously repetitive image of the scientific experiment: cellular movements, biological pulsations, gradual mutations and so on. He also invented and patented "the enharmonic bow for the longitudinal vibrations of the musical strings". His later work included a large study of Eastern philosophy and the occult sciences.

SETTIMELLI

The poet and dramatist Emilio Settimelli was born in Florence on 20 August 1891 and died on 12 February 1954 in Lipari. Together with his friends Bruno Corra, Arnaldo Ginna and Remo Chiti he created an avant-garde group that upheld the theories of 'cerebrismo', proclaiming a concept of art as consisting of the pure manipulation of cerebral data, in opposition to the social activism of the Futurist movement. He co-edited various cerebrist journals, such as *Il Centauro*, *La Difesa dell'arte* and *Saggi critici*, before meeting Marinetti and joining the Futurist movement in 1914. The following year he was one of the inventors of Futurist synthetic theatre of which he organized several performances. In 1916 he worked with the Florentine group on the film *Vita futurista* (Futurist life) and shortly afterwards became involved in the political campaign mounted by Marinetti in the name of Futurism. After 1922 he dedicated himself almost exclusively to journalism but claimed the title of 'independent Futurist'.

SOFFICI

The painter and poet Ardengo Soffici was born in Rignano on 7 April 1881 and died on 12 August 1964 in Vittoria Apuana. After early disagreements with Boccioni he became a follower of Futurism in 1913 along with his friend Papini. He founded the journal *Lacerba* in the same year and became the galvanizing force within the Florentine Futurist group. He assumed an important role within the movement as a theoretician, attempting to define the aesthetics of Futurist dynamism in the face of criticisms and attacks mounted by figures belonging to the Cubist circles of Paris. However, he often went to Paris, where he had a liaison with the Russian Cubo-Futurist Alexandra Exter. He experimented with typography, producing examples of 'free-word' poetry, and formed friendships with Picasso and Guillaume Apollinaire. He was a frequent visitor to the studio of Nunes Vais, who photographed him together with Papini and Medardo Rosso. On a visit to Florence, Marinetti and the other Milanese Futurists were taken by Soffici to Nunes Vais's studio, where the first group photographs of the movement's members were taken. In 1915 Soffici was to publicly distance himself from Marinetti and, shortly afterwards, abandoned his avant-garde experimentation.

SOMENZI

Stanislao Somenzi, better known as Mino Somenzi, was a writer and a journalist. He was born in Marcaria on 15 January 1899 and died on 19 November 1948 in Rome. After the First World War he was in Fiume, supporting D'Annunzio's occupation of that city and his campaign for its annexation by Italy. After meeting Marinetti he joined the Futurist movement in 1920 and was intensely active in the propagation of its ideas. In 1924 he was one of the organizers of the Primo Congresso Nazionale Futurista in Milan. During the 1930s he founded the newspapers *Futurismo*, *Sant'Elia* and *Artecrazia* in order to maintain the continuity of avant-garde culture in Italy. Obstructed by the Fascist régime, which censored and suppressed the latter publication, he gathered together a series of his polemical articles in the book *Difendo il futurismo* (I defend Futurism) of 1937. Somenzi was very interested in photography, and closely followed the research of Tato, Kesting, Montacchini and various other Futurist exponents, whose works and theoretical texts he published in his newspapers.

TATO

Tato was the pseudonym of the painter and photographer Guglielmo Sansoni, who was born in Bologna on 29 December 1896 and died on 18 January 1974 in Rome. He undertook his studies specializing in agriculture and taught himself to paint. Drafted in 1915, he discovered Futurism at the end of the War when he was assigned to the Military Academy in Novara. Thereafter, he abandoned the figurative style of his early works and, in 1919, founded the second Futurist group of Bologna together with Longanesi, Fanelli and Caviglioni. In 1922 he met Marinetti and organized a group exhibition of Futurist painting, which was shown in Bologna, Parma, Turin and Salsomaggiore. At this time, living between Rome and Bologna, he began to experiment with photography and the decorative arts. He executed mural paintings, worked as a restorer of frescoes and paintings, conceived sets for a performance by Anna Fougez at the Modernissimo Theatre in Bologna and designed multicoloured carnival floats, revealing his particular passion for the theatre. The ambiguity between the real and the artificial was to be one of the themes of his photographic research. In January 1925 he opened a Casa d'Arte Futurista in Bologna, but by the following January had succeeded his brother in the direction of the Agenzia Fotografica La Serenissima in via Due Macelli 66, Rome. He then executed his first photomontages by means of the superimposition of several negatives, realizing the most important ideas of Futurist photography: the 'transparency of opaque bodies', the 'camouflaging of objects', the 'visualizations of states of mind' and dreamlike spectralizations. He executed symbolic portraits of the Futurists Carli, Depero, Fanelli, Gerardo Dottori, Balla, Marinetti and Mario Dalmonte as well as numerous self-portraits. He signed the *Manifesto dell' aeropittura futurista* (Manifesto of Futurist aeropainting) and began a series of works on the theme of aviation. In 1930 he published the *Manifesto della fotografia futurista* (Manifesto of Futurist photography) with Marinetti, from which point his name was to replace that of the Bragaglias as the leading exponent of Futurist photography. His 'disguised objects' rely on humour and surprise: the *bricolage*

of the objects takes place on the level of a semantics of form similar to that of
the humorous conjuring tricks of the variety theatre. Moreover, in his
photographic self-portraits he carried out accomplished performances as a
quick-change actor, adopting caricatural grimaces and grotesque disguises.
He entitled his Futurist memoirs *Tato racconTato da Tato* (Tato narrated by
Tato), thereby paraphrasing the celebrated title of the memoirs of Fregoli,
the greatest quick-change actor of all time. He contributed to both Italian
and foreign newspapers and created numerous photomontages for book covers
and postcards. His experiments with photography continued until the end
of the 1930s.

UNTERVEGER

The photographer Enrico Unterveger was born in Trento on 1 January 1876 and
died there on 1 May 1959. The son of a photographer, he acquired his early
training working in his father's studio. In 1895 he attended a technical school
of photography in Vienna, completing his studies two years later in Nuremberg
with a course in phototype. Mountainous landscape was his preferred subject-
matter. A patriot and a socialist, he supported the Irredentist campaign, which
fought for the freedom and Italian-ness of the Trentino against Austrian
domination. In 1909 he was arrested by the Austrians and imprisoned in
Vienna for seven months. Three years later he took over the running of his
father's photographic studio, specializing in pictorialist portraiture. At the
outbreak of the First World War he was deported to Katzenau and his studio
was destroyed. However, in 1919 he resumed his activities as a photographer
and as a photography theorist. Many of his articles were published in the
most important photographic journals of Italy, Austria and Germany. At the
beginning of the 1930s he met Marinetti and undertook new experiments with
photomontage, in this way becoming drawn into the Futurist movement.

WULZ

The photographer Wanda Wulz was born in Trieste on 25 July 1903 and died
there on 16 April 1984. The last representative of an illustrious family of
photographers, she undertook her own training working alongside her father
in the Studio Fotografico Wulz, which had been founded by her grandfather in
Trieste in 1868. She worked as a portraitist, but also produced her own avant-
garde works: photomontages, multiple portraits and still-life compositions.
After meeting Marinetti in Trieste in 1931 she joined the Futurist movement
and participated in exhibitions of Futurist photography, producing works
of photodynamism and creating 'photoplastics', in which she revealed an
autonomous and profoundly original sensibility. At the end of the 1930s
she abandoned her Futurist experiments, concentrating on strictly
professional work.

WORKS IN THE EXHIBITION

Works are listed alphabetically by artist, then chronologically,
then alphabetically by title

Anon. *Boccioni in his studio, in front of the sculpture 'Head+House+Light'* ◆
1913, gelatin silver print, 6 x 8.5 cm ◆ Calmarini Collection, Milan ◆ see p. 16

Anon. *Fortunato Depero, Fedele Azari and Franco Rampa Rossi: after the flight* ◆
1922, gelatin silver print, 8 x 10.5 cm ◆ MART, Archivio del '900, Rovereto ◆
see p. 35

Anon. *Fortunato Depero, Fedele Azari and Franco Rampa Rossi: before a flight* ◆
1922, gelatin silver print, 8 x 10.5 cm ◆ MART, Archivio del '900, Rovereto ◆
see p. 35

Anon. *Fortunato Depero, Fedele Azari and Franco Rampa Rossi beside Azari's
aeroplane at Turin airport* ◆ 1922, gelatin silver print, 10.5 x 8 cm ◆ MART,
Archivio del '900, Rovereto ◆ see p. 35

Anon. *Fortunato Depero, Guglielmo Jannelli and friends with Depero's tapestries
at Castroreale Bagni* ◆ 1924, gelatin silver print, 8.5 x 13 cm ◆ MART, Archivio
del '900, Rovereto ◆ see p. 54

Anon. *Depero in front of the Book Pavilion* ◆ 1927, gelatin silver print,
23 x 17 cm ◆ MART, Archivio del '900, Rovereto ◆ see p. 55

Anon. *Depero's Futurist typographical architecture: 'The Book Pavilion of the
Bestetti, Treves and Tuminelli publishing houses' at the III Mostra Internazionale
delle Arti Decorative, Monza* ◆ 1927, gelatin silver print, 23 x 28.5 cm ◆
MART, Archivio del '900, Rovereto ◆ see p. 55

Anon. *Interior view with display cases of Depero's Book Pavilion* ◆ 1927, gelatin
silver print, 23 x 16.5 cm ◆ MART, Archivio del '900, Rovereto ◆ see p. 55

Anon. *Luigi Russolo seated in front of his painting 'Music' and between two
models of his Rumorharmonium* ◆ 1928, gelatin silver print, 29 x 23 cm ◆
MART, Archivio del '900, Rovereto ◆ see p. 50

Anon. *Depero waiting to embark for New York* ◆ 1928, gelatin silver print,
18 x 21 cm ◆ MART, Archivio del '900, Rovereto ◆ see p. 53

Anon. *The painter Giacomo Balla in front of his painting 'Balfiore'* ◆ 1930–32,
gelatin silver print, 65 x 49 cm ◆ MART, Archivio del '900, Rovereto ◆ see p. 88

Anon. *Marinetti and the Futurist group at the Galleria Pesaro, Milan* ◆ 1933,
gelatin silver print, 18 x 19 cm ◆ MART, Archivio del '900, Rovereto ◆ see p. 75

Anon. *Balla in his studio with his mother and his two daughters* ◆ 1936, gelatin
silver print, 18 x 23.5 cm ◆ MART, Archivio del '900, Rovereto ◆ see p. 89

Mario Bellusi *Modern traffic in ancient Rome* ◆ 1930, photomontage,
15 x 20 cm ◆ MART, Archivio del '900, Rovereto ◆ see p. 109

Mario Bellusi *Shadows and lights* ◆ 1930, gelatin silver print, 20 x 16 cm ◆
MART, Archivio del '900, Rovereto ◆ see p. 81

Ottavio Berard *Futurist photograph: punch in the eye* ◆ 1932, gelatin silver print,
9.5 x 14.5 cm ◆ MART, Archivio del '900, Rovereto ◆ see p. 104

Umberto Boccioni *I-We* ◆ 1905–07, gelatin silver print, 9 x 13.5 cm ◆
Calmarini Collection, Milan ◆ see p. 18

Gustavo Bonaventura *Photodynamic portrait of Anton Giulio Bragaglia* ◆
1912/13, gelatin silver print, 22.8 x 16.5 cm ◆ Calmarini Collection, Milan
◆ see p. 29

Anton Giulio Bragaglia *Change of position* ◆ 1911, gelatin silver print,
12.8 x 17.9 cm ◆ Gilman Paper Company, New York ◆ see p. 31

Anton Giulio Bragaglia *Il Fotodinamismo futurista*, 1st edn, Nalato Editore,
Rome ◆ 1913 ◆ Library, Museo Nazionale del Cinema, Turin ◆ not illustrated

Anton Giulio Bragaglia *Self-Portrait* ◆ c. 1914, postcard, 15 x 10 cm ◆
Malandrini Collection, Florence ◆ see p. 22

Anton Giulio and Arturo Bragaglia *Polyphysiognomical portrait of Boccioni* ◆
1913, gelatin silver print, 12.3 x 17 cm ◆ Calmarini Collection, Milan
◆ see p. 30

Anton Giulio and Arturo Bragaglia *Typist* ◆ 1913, postcard, 9 x 14 cm ◆
Malandrini Collection, Florence ◆ see p. 23

Arturo Bragaglia *The writer Giannetto Bisi* ◆ 1919, gelatin silver print,
21.5 x 17 cm ◆ Calmarini Collection, Milan ◆ see p. 17

Arturo Bragaglia *Child* ◆ c. 1920, sepia-toned gelatin silver print, 16 x 12 cm
◆ Malandrini Collection, Florence ◆ see p. 59

Arturo Bragaglia *The Futurist Gerardo Dottori*, pentagonal photographic
construction ◆ c. 1920, gelatin silver print, 19 x 15 cm ◆ Archivio G. Dottori,
M. Duranti, Perugia ◆ see p. 52

Arturo Bragaglia *Prampolini and Archipenko* ◆ 1921, gelatin silver print,
26.5 x 19.5 cm ◆ private collection, Rome ◆ see p. 52

Arturo Bragaglia *Inauguration with Marinetti and the Futurists at the Casa d'Arte
Bragaglia, Rome* ◆ 1922, gelatin silver print, 12 x 17 cm ◆ MART, Archivio del
'900, Rovereto ◆ see p. 50

Arturo Bragaglia *Photodynamic portrait of a woman* ◆ c. 1924, gelatin silver
print, 11.5 x 16.2 cm ◆ The J. Paul Getty Museum, Los Angeles ◆ see p. 58

Arturo Bragaglia *Portrait of Anton Giulio Bragaglia* ◆ c. 1924, gelatin silver print,
13 x 9 cm ◆ MART, Archivio del '900, Rovereto ◆ see p. 51

Arturo Bragaglia *Portrait of Alberto Viviani* ◆ 1929, sepia-toned gelatin silver print, 16.6 x 11.7 cm ◆ Archivio storico del futurismo e primo '900 europeo Alberto Viviani, Arezzo, Florence, Milan ◆ see p. 51

Arturo Bragaglia *Polyphysiognomic portrait* ◆ 1930, gelatin silver print, 10 x 12 cm ◆ The J. Paul Getty Museum, Los Angeles ◆ see p. 95

Emilio Buccafusca *Women in space* ◆ 1933, gelatin silver print, 16.5 x 11.5 cm ◆ Archivio D'Ambrosio, Naples ◆ see p. 105

Giorgio Riccardo Carmelich *Photographic composition* ◆ c. 1928, gelatin silver print, 11 x 8.5 cm ◆ private collection, Trieste ◆ see p. 68

Giorgio Riccardo Carmelich *Photographic composition* ◆ c. 1928, gelatin silver print, 11 x 8.5 cm ◆ private collection, Trieste ◆ see p. 69

Giorgio Riccardo Carmelich *Photographic composition* ◆ c. 1928, gelatin silver print, 11 x 8.5 cm ◆ private collection, Trieste ◆ see p. 69

Giorgio Riccardo Carmelich *Photographic composition* ◆ c. 1928, gelatin silver print, 11 x 8.5 cm ◆ private collection, Trieste ◆ see p. 80

Giorgio Riccardo Carmelich *Photographic composition* ◆ c. 1928, gelatin silver print, 11 x 8.5 cm ◆ private collection, Trieste ◆ see p. 84

Giorgio Riccardo Carmelich *Photographic composition* ◆ c. 1928, gelatin silver print, 11 x 8.5 cm ◆ private collection, Trieste ◆ see p. 105

Mario Castagneri *Portrait of Emilio Settimelli*, dedicated to Vincenzo Ruggero ◆ 1925, bromide print, 13.5 x 8.4 cm ◆ Malandrini Collection, Florence ◆ see p. 57

Mario Castagneri *Female nudes* ◆ 1927, gelatin silver print, 29.5 x 23.5 cm ◆ Museo di Storia della Fotografia Fratelli Alinari – Castagneri Archive, Florence ◆ see p. 59

Mario Castagneri *Depero's hands: clarity and will* ◆ 1930, gelatin silver print, 18 x 26 cm ◆ MART, Archivio del '900, Rovereto ◆ see p. 94

Mario Castagneri *Fortunato Depero in New York*, photomontage for Depero's book *New York film vissuto* ◆ 1931, 30 x 24 cm ◆ MART, Archivio del '900, Rovereto ◆ see p. 102

Mario Castagneri *Fortunato Depero among the skyscrapers* ◆ 1933, photomontage, 30 x 24 cm ◆ MART, Archivio del '900, Rovereto ◆ see p. 103

Cesare Cerati *Propellers: free-photo aerocomposition* ◆ 1931, photocollage, 14.5 x 19 cm ◆ MART, Archivio del '900, Rovereto ◆ see p. 129

Gianni Croce *Composition of objects* ◆ 1932, gelatin silver print, 9 x 13 cm ◆ MART, Archivio del '900, Rovereto ◆ see p. 82

Gianni Croce *Composition of objects* ◆ 1932, gelatin silver print, 12 x 9 cm ◆ MART, Archivio del '900, Rovereto ◆ see p. 82

Gianni Croce *Futurist still life* ◆ 1932, gelatin silver print, 14 x 9 cm ◆ MART, Archivio del '900, Rovereto ◆ see p. 83

Gianni Croce *Harmony of lines* ◆ 1932, gelatin silver print, 9 x 13 cm ◆ MART, Archivio del '900, Rovereto ◆ see p. 83

Fortunato Depero *Self-portrait* ◆ 1915, gelatin silver print, mounted on card with signature, 15 x 11 cm ◆ MART, Archivio del '900, Rovereto ◆ see p. 38

Fortunato Depero *Self-portrait in a bar* ◆ 1915, gelatin silver print, 9 x 9 cm ◆ MART, Archivio del '900, Rovereto ◆ see p. 42

Fortunato Depero *Double self-portrait, 24 March 1915, Rome* ◆ 1915, gelatin silver print, 8 x 12.5 cm ◆ MART, Archivio del '900, Rovereto ◆ see p. 39

Fortunato Depero *Self-portrait with clenched fist, 24 March 1915, Rome* ◆ 1915, *gelatin silver print, 7.5 x 7 cm* ◆ MART, Archivio del '900, Rovereto ◆ see p. 38

Fortunato Depero *Self-portrait: cynical laugh, 16 April 1915, Rome* ◆ 1915, gelatin silver print, 8 x 8 cm ◆ MART, Archivio del '900, Rovereto ◆ see p. 40

Fortunato Depero *Self-portrait in a tree at Acqua Acetosa, 6 November 1915, Rome* ◆ 1915, gelatin silver print, 6.5 x 4.9 cm ◆ MART, Archivio del '900, Rovereto ◆ see p. 43

Fortunato Depero *Self-portrait with grimace, 11 November 1915, Rome* ◆ 1915, gelatin silver print, 9.5 x 9 cm ◆ MART, Archivio del '900, Rovereto ◆ see p. 41

Fortunato Depero *Depero and Clavel: Pantomime!* ◆ 1916, gelatin silver print, 8 x 8 cm ◆ MART, Archivio del '900, Rovereto ◆ see p. 44

Fortunato Depero *The first solo Futurist exhibition: Rome 1916* ◆ 1916, five gelatin silver prints, 9 x 9 cm each ◆ MART, Archivio del '900, Rovereto ◆ see p. 34

Fortunato Depero *Self-portrait: Depero plays hide and seek, Rome, 1916* ◆ 1916, gelatin silver print, 8.5 x 8 cm ◆ MART, Archivio del '900, Rovereto ◆ see p. 45

Fortunato Depero *Headquarters* ◆ 1928, photocollage, 20 x 31 cm ◆ MART, Archivio del '900, Rovereto ◆ not illustrated

Fortunato Depero *Returning from New York: the decks of the motor-ship 'Roma', October 1930* ◆ gelatin silver print, 16.5 x 23 cm ◆ MART, Archivio del '900, Rovereto ◆ see p. 53

Fortunato Depero *Crossing the Hudson on the ferry-boat* ◆ 1930–31, photocollage, 32.3 x 21 cm ◆ MART, Archivio del '900, Rovereto ◆ see p. 115

Fortunato Depero *Discovering New York* ◆ 1931, photocollage, 34.5 x 23 cm ◆ MART, Archivio del '900, Rovereto ◆ see p. 77

Rosetta Amadori Depero *Fortunato Depero on a visit to Lake Garda* ◆ 1926, gelatin silver print, 8.5 x 6 cm ◆ MART, Archivio del '900, Rovereto ◆ see p. 36

Rosetta Amadori Depero *Fortunato Depero on a visit to Lake Garda* ◆ 1926, gelatin silver print, 8.5 x 6 cm ◆ MART, Archivio del '900, Rovereto ◆ see p. 36

Rosetta Amadori Depero *Fortunato Depero on a visit to Lake Garda* ◆ 1926, gelatin silver print, 7 x 6 cm ◆ MART, Archivio del '900, Rovereto ◆ see p. 37

Rosetta Amadori Depero *On the Atlantic: Depero on board the motor-ship 'Roma'* ◆ 1930, gelatin silver print, 17 x 41 cm ◆ MART, Archivio del '900, Rovereto ◆ see p. 53

Emidio Filippini *Depero during the creation of 'Artful glory to Marinetti'* ◆ 1923, gelatin silver print, 42 x 30 cm ◆ MART, Archivio del '900, Rovereto ◆ see p. 54

Emidio Filippini *Depero, Melli, Melotti, Pollini, Rosetta Depero and friends in the 'Salon of the Paper Horsemen', Futurist decoration by Depero for the ball of 1923 in Casa Kappel in Santa Maria, Rovereto* ◆ 1923, gelatin silver print, 11.5 x 16 cm ◆ MART, Archivio del '900, Rovereto ◆ see p. 46

Emidio Filippini *Fortunato Depero* ◆ 1923, gelatin silver print, 23 x 17.5 cm ◆ MART, Archivio del '900, Rovereto ◆ see p. 63

Emidio Filippini *Pica, Depero, Marussig and Brenno del Giudice in Depero's studio decorated for the Futurist party on 10 January 1923 in Rovereto* ◆ 1923, gelatin silver print, 11 x 16 cm ◆ MART, Archivio del '900, Rovereto ◆ see p. 34

Maggiorino Gramaglia *Woman with serpent* ◆ 1930, gelatin silver print, 28.5 x 38.5 cm ◆ Museo Nazionale del Cinema, Turin ◆ see p. 96

Maggiorino Gramaglia *Spectralization of the Ego* ◆ 1931, photomontage, 37.5 x 28 cm ◆ Museo Nazionale del Cinema, Turin ◆ see p. 112

Maggiorino Gramaglia *Modernism* ◆ 1932, photomontage, 38.5 x 29.5 cm ◆ Museo Nazionale del Cinema, Turin ◆ see p. 87

André. Kertész *Portrait of Mondrian, Prampolini, Seuphor* ◆ 1926, gelatin silver print, 8.3 x 12.5 cm ◆ private collection, Rome ◆ see p. 61

André Kertész *Portrait of Enrico Prampolini* ◆ 1927, gelatin silver print, 8 x 12 cm ◆ private collection, Rome ◆ see p. 61

André Kertész *Portrait of Enrico Prampolini* ◆ 1927, gelatin silver print, 9 x 14 cm ◆ private collection, Rome ◆ not illustrated

André Kertész *Rue de la Grande Chaumière* ◆ 1928, gelatin silver print, 8.3 x 12.5 cm ◆ private collection, Rome ◆ see p. 61

Edmund Kesting *Image of a female dancer* ◆ c. 1933, photomontage, 17.5 x 17.5 cm ◆ MART, Archivio del '900, Rovereto ◆ see p. 132

Edmund Kesting *Image of a female dancer* ◆ c. 1933, photomontage, 23.5 x 17 cm ◆ MART, Archivio del '900, Rovereto ◆ see p. 135

Edmund Kesting *Image of a male dancer* ◆ c. 1933, photomontage, 22 x 18 cm ◆ MART, Archivio del '900, Rovereto ◆ see p. 133

Edmund Kesting *Image of a male dancer* ◆ c. 1933, photomontage, 24 x 18 cm ◆ MART, Archivio del '900, Rovereto ◆ see p. 133

Edmund Kesting *Image of a male dancer* ◆ c. 1933, photomontage, 21 x 17 cm ◆ MART, Archivio del '900, Rovereto ◆ see p. 134

Edmund Kesting *Image of a male dancer* ◆ c. 1933, photomontage, 24 x 17 cm ◆ MART, Archivio del '900, Rovereto ◆ see p. 134

Emanuele Lomiry *Marinetti and the Futurists Baroni, Azari, Rizzo, Ravelli, Casavola, Gerbino, Catrizzi* ◆ 1925, gelatin silver print, 31 x 20 cm ◆ private collection, Milan ◆ see p. 64

Emanuele Lomiry *States of mind* ◆ c. 1932, gelatin silver print, 16 x 11 cm ◆ private collection ◆ see p. 95

Fosco Maraini *Fillia in front of his paintings and between the sculptures of Luigi Pepe Diaz and Mino Rosso, in the Futurist room at the XVII Venice Biennale* ◆ 1930, gelatin silver print, 18 x 29 cm ◆ MART, Archivio del '900, Rovereto ◆ see p. 74

Filippo Masoero *Dynamised view of the Roman Forum* ◆ 1934, gelatin silver print, 20 x 30 cm ◆ TCI/Gestione Archivi Alinari, Milan ◆ see p. 92

Alberto Montacchini *Musical alchemy: the soloist* ◆ 1930, gelatin silver print, 11.5 x 16 cm ◆ MART, Archivio del '900, Rovereto ◆ see p. 93

Bruno Munari *And thus we would set about seeking an aeroplane woman* ◆ 1939, photocollage, 27.5 x 18 cm ◆ Museo Aeronautico Gianni Caproni, Trento ◆ see p. 116

Bruno Munari *Nothing is absurd to those who fly* ◆ 1939, photocollage and ink, 26.5 x 20 cm ◆ Museo Aeronautico Gianni Caproni, Trento ◆ see p. 114

Bruno Munari *They've even invented this. The world's gone mad* ◆ 1939, photocollage, 24 x 18 cm ◆ Museo Aeronautico Gianni Caproni, Trento ◆ see p. 117

Iwata Nakayama *Maria Ricotti in a mimed interpretation of 'Poème érotique' set to the music of Edvard Grieg* ◆ 1927, gelatin silver print, 24 x 19 cm ◆ private collection, Rome ◆ see p. 56

Iwata Nakayama *Photograph of scenery for 'Mercante di cuori'* ◆ 1927, gelatin silver print, 23.5 x 29.5 cm ◆ private collection, Rome ◆ see p. 56

Iwata Nakayama *Photograph of scenery for 'Mercante di cuori'* ◆ 1927, gelatin silver print, 24 x 30 cm ◆ private collection, Rome ◆ see p. 56

Mario Nunes Vais *The Futurist group: Palazzaeschi, Papini, Marinetti, Carrà, Boccioni* ◆ 1913, gelatin silver print from original glass plate, 24 x 18 cm ◆ Fondo Nunes Vais, Museo/Archivio di Fotografia Storica, Rome ◆ see p. 19

Mario Nunes Vais *Portrait of Carlo D. Carrà* ◆ 1913, gelatin silver print from original glass plate, 24 x 18 cm ◆ Fondo Nunes Vais, Museo/Archivio di Fotografia Storica, Rome ◆ see p. 14

Mario Nunes Vais *The editorial board of 'L'Italia futurista': Chiti, Neri Nannetti, Corra, Settimelli, Ginna, Maria Ginanni, Vieri Nannetti, Marinetti* ◆ 1916, gelatin silver print, 20 x 25 cm ◆ Fondazione Primo Conti: centro di documentazione e ricerche sulle avanguardie storiche, Fiesole ◆ see p. 34

Mario Nunes Vais *Marinetti as a soldier* ◆ 1916, 17.2 x 11.7 cm ◆ Museo di Storia della Fotografia Fratelli Alinari, Nunes Vais Archive, Florence ◆ see p. 15

Mario Nunes Vais *Marinetti indicates the future to the editors of 'L'Italia futurista'* ◆ 1916, gelatin silver print from original glass plate, 18 x 24 cm ◆ Fondo Nunes Vais, Museo/Archivio di Fotografia Storica, Rome

Ivos Pacetti *Futurist self-portrait* ◆ 1933, photomontage, 17 x 11 cm ◆ MART, Archivio del '900, Rovereto ◆ see p. 125

Vinicio Paladini *Scene from Molnar's 'The Legend of Liliom'* ◆ 1932, photocollage, 51 x 66 cm ◆ private collection ◆ see p. 118

Vinicio Paladini *Olympic Games* ◆ 1934, photocollage, 28.5 x 18.5 cm ◆ Museo di Storia della Fotografia Fratelli Alinari, Florence ◆ see p. 119

Vinicio Paladini *Olympic Games* ◆ 1934, photocollage, 28.5 x 18.5 cm ◆ Museo di Storia della Fotografia Fratelli Alinari, Florence ◆ see p. 120

Vinicio Paladini *Olympic Games* ◆ 1934, photocollage, 28.5 x 18.5 cm ◆ Museo di Storia della Fotografia Fratelli Alinari, Florence ◆ see p. 121

Vinicio Paladini *Olympic Games* ◆ 1934, photocollage, 28.5 x 18.5 cm ◆ Museo di Storia della Fotografia Fratelli Alinari, Florence ◆ see p. 122

Vinicio Paladini *Olympic Games* ◆ 1934, photocollage, 28.5 x 18.5 cm ◆ Museo di Storia della Fotografia Fratelli Alinari, Florence ◆ see p. 123

Giulio Parisio *Vesuvius,* photographic composition ◆ 1930, carbon print mounted on wood, 30 x 24.5 cm ◆ Archivio Parisio, Naples ◆ see p. 86

Giulio Parisio *Photodynamic portrait of the Futurist painter Carlo Cocchia* ◆ 1930, photomontage, 16.5 x 22.5 cm ◆ MART, Archivio del '900, Rovereto ◆ see p. 107

Enrico Pedrotti *Skier* ◆ 1927, gelatin silver print, 38 x 26 cm ◆ Foto Studio Pedrotti, Bolzano ◆ see p. 66

Enrico Pedrotti *Tracks* ◆ 1929, gelatin silver print, 29 x 26 cm ◆ Foto Studio Pedrotti, Bolzano ◆ see p. 67

Enrico Pedrotti *Acrobatic skiing* ◆ c. 1930, photomontage, 18 x 22 cm ◆ MART, Archivio del '900, Rovereto ◆ see p. 100

Enrico Pedrotti *Foundry* ◆ 1935, gelatin silver print, 21 x 29 cm ◆ Foto Studio Pedrotti, Bolzano ◆ see p. 101

Enrico Pedrotti *Advertising still for GIL* ◆ c. 1938, gelatin silver print, 52 x 37 cm ◆ Foto Studio Pedrotti, Bolzano ◆ see p. 79

Enrico Pedrotti *Advertising still for GIL* ◆ c. 1938, gelatin silver print, 64 x 45 cm ◆ Foto Studio Pedrotti, Bolzano ◆ see p. 79

Enrico Pedrotti *Shadows* ◆ c. 1938, gelatin silver print, 30 x 46 cm ◆ Foto Studio Pedrotti, Bolzano ◆ see p. 98

Enrico Pedrotti *Skaters* ◆ c. 1939, gelatin silver print, 26 x 38 cm ◆ Foto Studio Pedrotti, Bolzano ◆ see p. 99

Umberto Perticarari *Mino Somenzi with Marinetti in Rome as the latter declaims live into the microphone his "poetical Futurist exaltation" of the second Atlantic crossing during the return of Italo Balbo's squadron of seaplanes* ◆ 1933, gelatin silver print, 15.5 x 21 cm ◆ MART, Archivio del '900, Rovereto ◆ see p. 36

Enrico Prampolini *Self-portrait* ◆ 1927, gelatin silver print, 22.5 x 18 cm ◆ private collection, Rome ◆ see p. 65

Enrico Prampolini *'Aerodance' by Wy Magito, Galerie de la Renaissance, Paris* ◆ 1932, gelatin silver print, 17 x 12 cm ◆ private collection, Rome ◆ see p. 90

Scharankoff *Portrait of Silvio Mix at the piano* ◆ c. 1925, gelatin silver print, 17 x 11.5 cm ◆ private collection, Rome ◆ see p. 57

Scipio Sighele ◆ (left to right) *Marinetti, the journalist Ezio Gray, the French journalist Carrère, the politician and writer Enrico Enrico Corradini and the journalist Castellini at Bu-Meliana, in Libya* ◆ 1911, bromide print, 17 x 23 cm ◆ Malandrini Collection, Florence ◆ see p. 15

Studio Abeni *Depero in a dressing-room* ◆ 1927, gelatin silver print, 22 x 17 cm ◆ MART, Archivio del '900, Rovereto ◆ see p. 70

Studio Abeni *Depero, painter and poet* ◆ 1927, gelatin silver print, 22 x 17 cm ◆ MART, Archivio del '900, Rovereto ◆ see p. 71

Studio Bassani *Final installation of 'Artful glory to Marinetti' in the Depero room at the Esposizione Internazionale, Monza* ◆ 1923, gelatin silver print, 18 x 24 cm ◆ MART, Archivio del '900, Rovereto ◆ see p. 54

Studio Caminada *Portrait of F.T. Marinetti* ◆ 1909, printed postcard, 13 x 8.2 cm ◆ private collection ◆ see p. 14

Studio Caminada *Portrait of Fedele Azari* ◆ 1920, gelatin silver print, 23.5 x 17 cm ◆ MART, Archivio del '900, Rovereto ◆ see p. 62

Studio Coletti *Portrait of the aeropoet Mino Somenzi* ◆ 1932, gelatin silver print, 22.5 x 16 cm ◆ MART, Archivio del '900, Rovereto ◆ see p. 106

Studio Ottolenghi *Depero and Marinetti wearing Depero's Futurist waistcoats, with Marchesi, Fillia and Cangiullo in Turin* ◆ 1925, gelatin silver print, 22 x 17.5 cm ◆ MART, Archivio del '900, Rovereto ◆ see p. 47

Studio Santacroce *Giannina Censi: Aerofuturist dance* ◆ 1931, gelatin silver print, 17.5 x 12.5 cm ◆ MART, Archivio del '900, Rovereto ◆ see p. 130

Studio Santacroce *Giannina Censi: Aerofuturist dance* ◆ 1931, gelatin silver print, 17.5 x 12.5 cm ◆ MART, Archivio del '900, Rovereto ◆ see p. 130

Studio Santacroce *Giannina Censi: Aerofuturist dance* ◆ 1931, gelatin silver print, 17.5 x 12.5 cm ◆ MART, Archivio del '900, Rovereto ◆ see p. 131

Studio Santacroce *Giannina Censi: Aerofuturist dance* ◆ 1931, gelatin silver print, 17.5 x 12.5 cm ◆ MART, Archivio del '900, Rovereto ◆ see p. 131

Studio Schuch *Meeting between Marinetti and the German abstract painter Rudolf Bauer in Berlin* ◆ 1934, gelatin silver print, 18 x 24 cm ◆ MART, Archivio del '900, Rovereto ◆ see p. 77

Studio Stucchi Recchia *Fortunato Depero in Milan* ◆ 1926, gelatin sliver print, 23 x 17 cm ◆ MART, Archivio del '900, Rovereto ◆ see p. 60

Tato *Aero self-portrait* ◆ 1930, photomontage, 24 x 18 cm ◆ MART, Archivio del '900, Rovereto ◆ see p. 110

Tato *Perfect bourgeois* ◆ 1930, gelatin silver print, 18 x 24 cm ◆ MART, Archivio del '900, Rovereto ◆ see p. 126

Tato *Shepherd with little donkey* ◆ 1930, gelatin silver print, 18 x 24 cm ◆ MART, Archivio del '900, Rovereto ◆ see p. 85

Tato *Synthetic ballet by the dancer Stearina Candelotti* ◆ 1930, gelatin silver print, 18 x 24 cm ◆ MART, Archivio del '900, Rovereto ◆ see p. 84

Tato *War-like literary portrait of Mario Carli* ◆ 1930, photomontage, 25 x 18 cm ◆ MART, Archivio del '900, Rovereto ◆ see p. 108

Tato *Central weights and measures* ◆ 1932, gelatin silver print, 24 x 18 cm ◆ MART, Archivio del '900, Rovereto ◆ see p. 127

Tato *Drama of shadows and objects* ◆ 1932, gelatin silver print, 24 x 18 cm ◆ MART, Archivio del '900, Rovereto ◆ see p. 128

Tato *Amorous or violent penetrations: dynamic nude* ◆ 1933, gelatin silver print, 21 x 15 cm ◆ MART, Archivio del '900, Rovereto ◆ see p. 97

Tato *The last patrol: Futurist scenography* ◆ 1933, gelatin silver print, 18 x 12 cm ◆ MART, Archivio del '900, Rovereto ◆ see p. 128

Tato *Marinetti and Mino Somenzi among the members of the Savona-Albisola Futurist group, at the inauguration of the Prima Mostra Italiana d'Arte Futurista, Rome* ◆ 1933, gelatin silver print, 12.5 x 17.5 cm ◆ MART, Archivio del '900, Rovereto ◆ see p. 74

Tato *A room of the Prima Mostra Italiana d'Arte Futurista, Rome* ◆ 1933, gelatin silver print, 17.5 x 12.5 cm ◆ MART, Archivio del '900, Rovereto ◆ see p. 74

Tato *A room of the Prima Mostra Italiana d'Arte Futurista, Rome* ◆ 1933, gelatin silver print, 17.5 x 12.5 cm ◆ MART, Archivio del '900, Rovereto ◆ see p. 75

Tato *Fantastical aeroportrait of Mino Somenzi* ◆ 1934, photomontage, 24 x 18 cm ◆ MART, Archivio del '900, Rovereto ◆ see p. 124

Enrico Unterveger *Filippo Tommaso Marinetti* ◆ 1932, gum bichromate print, 28.5 x 25 cm ◆ Museo di Storia della Fotografia Fratelli Alinari – Unterveger Archive, Florence ◆ see p. 124

Wanda Wulz *Jazz Band* ◆ 1930, gelatin silver print, 29.5 x 22.5 cm ◆ Museo di Storia della Fotografia Fratelli Alinari – Wulz Archive, Florence ◆ see p. 111

Wanda Wulz *Cat+I* ◆ 1932, gelatin (chlorobromide) silver print, 29.5 x 23.5 cm ◆ Museo di Storia della Fotografia Fratelli Alinari – Wulz Archive, Florence ◆ see p. 113

Wanda Wulz *Futurist breakfast* ◆ 1932, solarized print, 19 x 29 cm ◆ Museo di Storia della Fotografia Fratelli Alinari, Florence ◆ see p. 81

Wanda Wulz *Gymnastic exercise* ◆ 1932, reproduction on glossy paper, 29.5 x 22.5 cm ◆ Museo di Storia della Fotografia Fratelli Alinari – Wulz Archive, Florence ◆ see p. 76

Wanda Wulz *Wunder Bar* ◆ 1932, reproduction on glossy paper, 27 x 21 cm ◆ Museo di Storia della Fotografia Fratelli Alinari – Wulz Archive, Florence ◆ see p. 76

BIBLIOGRAPHY

Ernst Mach, *Fixation photographique des phénomènes auxquels donne lieu le projectile dans l'air*, Berger-Levrault, Paris, 1888

Luigi Gioppi, *La Cronofotografia e il nuovo tachiscopio Anschütz*, in *Il Dilettante di fotografia*, III, no. 21, January 1892, Milan

Étienne-Jules Marey, *La Cronofotografia*, in *Il Dilettante di fotografia*, III, from no. 23, March 1892, to no. 32, December 1892, Milan

Giovanni Barco, *La Fotografia dei proiettili durante la loro traiettoria*, in *Il Dilettante di fotografia*, III, no. 24, April 1892, Milan

Étienne-Jules Marey, *Le Mouvement*, Masson Éditeur, Paris, 1894

Rodolfo Namias, *La Fotografia multipla*, in *Il Progresso fotografico*, II, no. 12, December 1895, Milan

Jean Finot, *La Photographie transcendentale*, Éditions Mendel, Paris, 1898

Ugo Ojetti, *Le Caricature di Cappiello*, in *Lettura*, I, no. 2, February 1901, Milan

Charles Chaplot, *La Photographie récréative et fantaisiste. Recueil de divertissements, trucs, passe-temps photographiques*, Éditions Mendel, Paris, 1904

Enrico Prezzolini, 'La Filosofia di Enrico Bergson', in *La Rassegna contemporanea*, I, no. 9, November 1908, Rome

Ducasse-Harispe, *La Photographie du monde invisible*, Éditions Mandélieu, Paris, 1909

Photographie du monde invisible, Librairie Analyse et Synthèse, Cannes, 1909

Enrico Bergson, *La Filosofia dell'intuizione*, ed. Giovanni Papini, Carabba Editore, Lanciano, 1909 (2nd edition 1911)

Auguste Rodin-Paul Gsell, *Le Mouvement dans l'art*, in *La Revue*, 15 March 1910, Paris

Auguste Rodin-Paul Gsell, *Pensieri di Rodin [Il Movimento nell'arte]*, in *La Nuova Antologia*, series V, vol. CXLVII, 1 May 1910, Rome

Albert Lafay, *La Photographie du vent. Étude photographique du champ aérodynamique*, Gauthiers-Villars, Paris, 1911

La Photographie transcendentale, Éditions Librairie Nationale, Paris, 1911

Cinematografia: Muybridge, in *La Fotografia artistica*, VII, no. 1, January 1911, Turin

André Chaumeix, *Les Entretiens de Rodin sur l'art*, in *La Revue hebdomadaire*, 5 August 1911, Paris.

Michele Biancale, *Rodin e l'arte*, in *Cronache letterarie*, II, no. 70, 20 August 1911, Rome

"Anton Giulio Bragaglia", in *L'Artista*, I, no. 5, December 1911, Rome (Advertisement for the lectures on photodynamism given by Bragaglia in Rome and Civitavecchia. Repeated in *Il Tirso*, no. 22, 11 February 1912, Rome. According to the advertisement, the text of the lecture should have been published, without illustrations, at this time. No confirmation of this has ever been found.)

Guillaume De Fontenay, *La Photographie et l'étude des phénomènes psychiques*, Gauthiers-Villars, Paris, 1912

Enrico Imoda, *Fotografie di fantasmi*, Edizioni Fratelli Bocca, Turin, 1912

Anton Giulio Bragaglia, *L'Arte nella fotografia (interviews with Biondi, Sartorio, Venturi e Bonaventura)*, in *La Fotografia artistica*, VIII, no. 2, February 1912, Turin (Reprinted in *Il Tirso*, no. 22, 11 February 1912, Rome)

Anton Giulio Bragaglia, *L'Innamorato del sole*, in *Patria*, 28 February 1912, Rome (Reprinted in *Le Cronache d'Attualità*, 30 July 1916, Rome)

Anton Giulio Bragaglia, *L'Arte nella fotografia*, in *La Fotografia artistica*, VIII, no. 4, April 1912, Turin

Anton Giulio Bragaglia, *L'Arte fotografica*, in *La Fotografia artistica*, IX, no. 5, May 1912, Turin

Giovanni Di Jorio, *L'Arte fotografica dei fratelli Bragaglia*, in *La Fotografia artistica*, IX, no. 6, July 1912, Turin

Anton Giulio Bragaglia, *La XX° Esposizione al Gabinetto Nazionale delle Stampe*, in *La Fotografia artistica*, IX, no. 10, October 1912, Turin

Ernst Baum, *Un Catalogo artistico-scientifico della Casa Goerz di Berlino*, in *La Fotografia artistica*, IX, no. 11, November 1912, Turin

Anton Giulio Bragaglia, *La Fotografia dei colori e le grandi invenzioni moderne*, in *La Fotografia artistica*, IX, no. 12, December 1912, Turin

Anton Giulio Bragaglia, *Fotodinamismo* (Typewritten text, with numerous corrections and instructions for the typographer, conserved at the Centro Studi Bragaglia, Rome. This is the second or third draft of the lecture, in which Bragaglia cites the kinematic paintings of Balla for the first time. This text was also not published.)

Anton Giulio Bragaglia, *Nell'anno 2000*, in *Patria*, 26 January 1913, Rome

Giovanni Ranzi, *La Fotodinamica futurista*, in *Il Corriere toscano*, 28 January 1913, Pisa

Giacomo Favale D'Aprile, *La Fotodinamica*, in *Corriere delle Puglie*, 2 February 1913, Bari

Nicola Pascazio, *La Sensazione del moto in fotografia: il fotodinamismo futurista*, in *Il Giornale del Mattino*, 11 February 1913, Bologna

Giovanni Cappelli, *La Fotodinamica futurista*, in *Patria*, 19 February 1913, Rome

Nicola Pascazio, *Una scoperta che sarà lanciata dal futurismo*, in *Don Marzio*, 13 March 1913, Naples

Francesco Freccero, *La Fotografia multipla a mezzo di dispositivi a specchio*, in *Il Progresso fotografico*, XX, no. 3, 25 March 1913, Milan

Il Fotodinamismo, la fotografia avvenirista del movimento, in *La Vita*, 26 March 1913, Rome

Anton Giulio Bragaglia, *La Fotografia del movimento (La Fotodinamica futurista)*, in *Noi e il mondo*, 1 April 1913, Rome (Reprinted in English in the journal *The Roman Herald*, 19 April 1913, Rome)

Anton Giulio Bragaglia, *Fotodinamica, cronofotografia e cinematografia*, in *Il Piccolo del Giornale d'Italia*, 2–3 April 1913, Rome

G.L.L., 'Fotodinamismo', in *La Cinematografia italiana ed estera*, no. 149, 15 April 1913, Turin

Anton Giulio Bragaglia, *Del dinamismo futurista*, in *Il Corriere toscano*, 5 May 1913, Pisa

Nicola Pascazio, *Che cosa è il fotodinamismo*, in *Humanitas*, no. 21, 18 May 1913, Bari

Edoardo Di Sambuy, *La Fotodinamica futurista di Anton Giulio e Arturo Bragaglia*, in *La Fotografia artistica*, X, no. 5, May 1913, Turin

Anton Giulio Bragaglia, *I Precursori del movimentismo: Dante e Velàsquez futuristi*, in *Il Piccolo del Giornale d'Italia*, 13–14 June 1913, Rome

Anton Giulio Bragaglia, *Fotodinamismo futurista*, Nalato Editore, 1st edition, n.d. [June 1913], Rome. (The book, illustrated with sixteen plates, was republished twice: the 2nd and 3rd editions, both undated, were printed in September and December 1913, respectively.)

Nicola De Aldisio, *La "Fotodinamica": fotografie di Anton Giulio e Arturo Bragaglia*, in *Italia!*, II, vol. 2, no. 7, July 1913, Turin

L'Obiettivo, 'La Fotografia del movimento: la fotodinamica', in *Primavera*, III, no. 9, September 1913, Rome

Boccioni-Carrà-Russolo-Balla-Severini-Soffici, *Avviso*, in *Lacerba*, I, no. 19, 1 October 1913, Florence

Anton Giulio Bragaglia, *I Fantasmi dei vivi e dei morti*, in *La Cultura moderna. Natura e arte*, XXII, no. 23, 1 November 1913, Milan (Reprinted in *Humanitas*, no. 16, 19 April 1914, Bari)

Rodolfo Namias, *Fotodinamismo futurista*, in *Il Progresso fotografico*, XX, no. 11, 25 November 1913, Milan

Filippo Tommaso Marinetti, *La nostra inchiesta sul cinematografo: il duce dei futuristi*, in *Il Nuovo Giornale*, no. 328, 28 November 1913, Florence

Anton Giulio Bragaglia, *La Fotografia dell'invisibile*, in *Humanitas*, no. 51, 21 December 1913, Bari (Reprinted in *La Fotografia artistica*, IX, no. 12, December 1913, to X, no. 1, January 1914, Turin)

Vincenzo Bonafede, *Fotodinamica e futurismo*, in *L'Ora*, 5–6 January 1914, Palermo

Giorgio Balabani, *Fotografia dinamica: l'arte dei futuristi*, in *La Fotografia artistica*, XI, no. 4, April 1914, Turin

Anton Giulio Bragaglia, *Moderne invenzioni antiche*, in *Humanitas*, no. 15, 12 April 1914, Bari (Reprinted in *La Cultura moderna. Natura e Arte*, XXVII, no. 5, March 1918, Milan)

Armando Giambrocono, *La Dinamofotografia*, in *Il Progresso fotografico*, XXVII, no. 5, May 1915, Milan Tidianeuq, *Il Controllo dei fantasmi per mezzo della fotografia*, in *Scena illustrata*, no. 11, 1 June 1915, Milan

Carlo D. Carrà, *Guerrapittura*, Edizioni futuriste di "Poesia", Milan, 1915

Guido Calderini, *Una nuova espressione d'arte*, in *Il Fronte interno*, IV, no. 349, 20 December 1918, Rome

Anton Giulio Bragaglia, *L'Arcoscenico del mio cinematografo*, in *Penombra*, January 1919, Milan (Reprinted in *L'Impero*, 11 May 1927, Rome)

Anton Giulio Bragaglia, *Fotografie d'arte*, in *Cronache d'Attualità*, II, no. 1, 5 February 1919, Rome

Anton Giulio Bragaglia, *Arte e fotografia*, in *Il Mondo*, V, no. 21, 25 May 1919, Milan

Sebastiano Arturo Luciani, *Il Futurismo al cinematografo*, in *Il Primato*, I, no. 2, November 1919, Milan

Carlo Fischer, *Il Futurismo in fotografia e la fotografia futurista*, in *La Cine-fono*, XIV, no. 438, 15–30 October 1921, Naples

Piero Illari, *Riflessi Kodak*, in *Rovente*, I, no. 1, January 1923, Rome

Emilio Mario Dolfi, Giorgio Riccardo Carmelich, *Il Secondo Convegno di Epeo*, 3 April 1923, Trieste (Portfolio with typewritten text and four original photographs by Dolfi)

Anton Giulio Bragaglia, *Notre art appliqué*, in *Index*, no. 87, July–August 1924, Rome

Filippo Tommaso Marinetti-Mario Castagneri, *Onoranze Nazionali a F. T. Marinetti*

animatore d'italianità, Casa Editrice La Promotrice, Milan, 1924 (Portfolio with facsimile reproduction of the manuscript of Marinetti's poem *Aeroplani* and an original photograph of Marinetti taken by Mario Castagneri)

Anton Giulio Bragaglia, *La Fotografia dinamica*, in *Novella*, 3 May 1925, Milan

Anton Giulio Bragaglia, *Successi e successori americani del fotodinamismo*, in *Comoedia*, 15 September 1925, Milan (Reprinted in *Il Mezzogiorno fotografico*, 30 September 1926, Chieti; in *Italy American Review*, June 1927, New York; in *Lavoro d'Italia*, 10 September 1928, Rome; in *Il Mattino*, 17–18 October 1928, Naples; in *Rivista Illustrata del Popolo d'Italia*, December 1929, Milan)

Anton Giulio Bragaglia, *Che cosa era la fotografia del movimento*, in *La Stirpe*, November 1925, Rome

Una "composizione" fotografica di Tato, in *L'Impero*, 7–8 February 1926, Rome

Raymond Selig, *Luigi Pirrone*, in *La Revue du Vrai et du Beau*, no. 94, 10 December 1926, Paris

Anton Giulio Bragaglia, *Poetica della fotocinetica*, in *Comoedia*, 20 November 1927, Milan (Reprinted in *La Gazzetta del Mezzogiorno*, 9 March 1928, Bari)

Armando Cantarelli, *Mario Castagneri e la sua arte*, in *Terra d'Italia*, II, nos. 7–8, November–December 1927, Milan

H.K. Frenzel, *Ein Italienischer graphiker: Ivo Pannaggi*, in *Gebrauchsgraphik*, no. 5, May 1928, Berlin

Anton Giulio Bragaglia, *Fotodinamica, cronofotografia e cinema*, in *Pattuglia*, 1 June 1929, Cagliari (Reprinted in *Comoedia*, XII, no. 6, 15 June–15 July 1929, Milan; in *Lo Spettacolo italiano*, May 1930, Rome)

Vinicio Paladini, *Fotomontage*, in *La Fiera letteraria*, V, no. 45, 10 November 1929, Rome

Antonio Boggeri, *Prefazione*, in *Luci e Ombre*, Annuario del Corriere Fotografico, Turin, 1929

Anton Giulio Bragaglia, *Il Film sonoro*, Edizioni Corbaccio, Milan, 1929

Filippo Tommaso Marinetti, *La Fotografia delle radiazioni vitali*, in *La Gazzetta del Popolo*, 28 January 1930, Turin

Filippo Tommaso Marinetti-Tato, *Manifesto*, leaflet published in April 1930, on the occasion of the launch of the I° Congresso Fotografico Nazionale (The text of the leaflet, which is the first version of the manifesto *La Fotografia futurista*, was republished in *Oggi e Domani*, II, no. 3, 10 November 1930, Rome)

C.E. Anderson, *Severo Antonelli Artist Photographer*, in *Bulletin of Photography*, no. 1185, 23 April 1930, Philadelphia

Guido Cremonese, *I Raggi della vita fotografati*, in *Oggi e Domani*, 28 April 1930, Rome

I° Concorso Fotografico Nazionale, exhib. cat., Aranciera di Villa Umberto I°, 9–30 November 1930, Rome (The catalogue also contains the first version of the manifesto *La Fotografia futurista* by Marinetti and Tato)

Filippo Tommaso Marinetti, *La Fotografia dell'avvenire*, in *La Gazzetta del Popolo*, 9 November 1930, Turin (Reprinted with the title *Tradizione e futurismo al 1° Concorso Fotografico Nazionale*, in *Il Giornale d'Italia*, 13 November 1930, Rome; Marinetti also delivered the lecture *La Fotografia futurista e il suo avvenire*, on 1 April 1932, at the Circolo Artistico of Trieste)

La Sala futurista al I° Concorso Fotografico Nazionale di Villa Borghese, in *Oggi e Domani*, II, no. 3, 10 November 1930, Rome

La Fotografia futurista, in *La Gazzetta del Popolo*, 15 November 1930, Turin

Fotografia futurista, in *Il Giornale d'Italia*, 17 November 1930, Rome

Renato Metalli, *Arte e fotografia*, in *Oggi e Domani*, II, no. 6, 20 November 1930, Rome

Vittorio Orazi, *La Mostra d'arte fotografica*, in *L'Impero d'Italia*, 23 November 1930, Rome

Guido Cremonese, *Spiritualismo scientifico*, in *Oggi e Domani*, II, no. 5, 17 November 1930, Rome

Tato, *La Fotografia futurista nell'avvenire*, in *Oggi e Domani*, II, no. 11, 8 December 1930, Rome (Reprinted with the title *La Fotografia futurista e la trasparenza dei corpi opachi*, in *Il Giornale d'Italia*, 12 December 1930, Rome)

Stefano Pittaluga, *Fotodinamica di un ambiente intellettuale*, in *Oggi e Domani*, no. 15, 22 December 1930, Rome

Mario Serandrei, *Delle nuove immagini*, in *Il Secolo XX*, December 1930, Milan

Nello Quilici, *Tato pittore dall'estro sempre in moto*, in *Rivista di Ferrara*, December 1930, Ferrara

Giovan Battista Fiore, *L'Arte di Ernesto Thayaht*, Edizioni Nirvana, Florence, 1930

Exhibition of Photography by Severo Antonelli, exhib. cat., Section of Photography, National Museum, Washington, D.C., 1930

Anton Giulio Bragaglia, *Arte fotogenica*, in *Il Lavoro fascista*, 9 January 1931, Rome

Filippo Tommaso Marinetti-Tato, *La Fotografia futurista – Manifesto*, in *Il Futurismo*, no. 22, 11 January 1931, Rome, where it is dated "11 April 1930" (Reprinted in *Futurismo*, I, no. 16, 25 December 1932, Rome; in *Stile futurista*, II, nos. 15–16, December 1935, Turin)

Guido Pellegrini, *La Prima Mostra Fotografica Internazionale alla Fiera*, in *La Fiera di Milano*, February 1931, Milan

Mostra Sperimentale di Fotografia futurista, exhib. cat., Segreteria Provinciale della Federazione Autonoma delle Comunità Artigiane, 15 March–6 April 1931, Turin (Foreword by Giuseppe Enrie, *La Fotografia contro il suo assoluto*)

Inaugurazione della Mostra di Fotografia futurista, in *La Stampa*, 16 March 1931, Turin

La Mostra di fotografia futurista inaugurata dall'On. Buronzo, in *La Gazzetta del Popolo*, 16 March 1931, Turin

C.M., *Fotografie futuriste a Torino*, in *La Gazzetta del Popolo*, 17 March 1931, Turin

Una Mostra futurista, in *La Stampa*, 28 March 1931, Turin

La Fotografia futurista illustrata da Marinetti, in *La Stampa*, 11 April 1931, Turin

Guido Pellegrini, *La Mostra fotografica*, in *La Fiera di Milano*, June–July 1931, Milan

Ivo Pannaggi, *Fotografia e fotomontage*, in *L'Ambrosiano*, no. 214, 9 September 1931, Milan

Severo Antonelli, in *Revue des Arts*, no. 160, September 1931, New York

Guido Pellegrini, *La Seconda Mostra Internazionale Fotografica*, in *La Fiera di Milano*, November 1931, Milan

Anton Giulio Bragaglia, *La Fotografia delle scene*, in *Oggi e Domani*, 8 January 1932, Rome

Anton Giulio Bragaglia, *La Fotografia del movimento*, in *Illustrazione del Popolo*, 27 March 1932, Turin (Reprinted in *Rassegna dell'Istruzione Artistica*, July 1932, Urbino; in *Il Giornale della Domenica*, 22 January 1933, Rome; in *L'Italia letteraria*, 30 June 1934, Rome)

Mostra fotografica futurista, exhib. cat., Esposizione Permanente del Sindacato Belle Arti, 1–17 April 1932, Trieste (Foreword by Bruno Giordano Sanzin)

Una Mostra fotografica futurista inaugurata da S. E. Marinetti, in *L'Impero*, 3 April 1932, Rome

Mario Granbassi, *La Mostra fotografica*, in *Il Piccolo*, 2 April 1932, Trieste

La Mostra fotografica futurista, in *Il Piccolo*, 4 April 1932, Trieste

Fotografia futurista, in *Il Piccolo della Sera*, 12 April 1932, Trieste

Bruno G. Sanzin, *La Mostra Nazionale di fotografia futurista all'Esposizione Permanente*, in *Il Popolo*, 14 April 1932, Trieste

Bruno G. Sanzin, *La Mostra Nazionale di Fotografia futurista*, in *L'Impero*, 17 April 1932, Rome (Reprinted in *La Città Nuova*, I, no. 6, 15 May 1932, Turin)

Manuel Caracciolo, *La Mostra Nazionale di fotografia futurista a Trieste*, in *Duemila*, I, no. 1, 30 May 1932, Bari

Mostra d'Arte Fotografica Moderna: Severo Antonelli, exhib. cat., Palazzo Salviati, 1–10 October 1932, Rome

La Sezione futurista alla Mostra internazionale d'Arte fotografica, in *Futurismo*, I, no. 4, 2 October 1932, Rome

Tato fotografo futurista: Ritratto dinamico di Marinetti, in *Futurismo*, I, no. 6, 16 October 1932, Rome

Arturo Bragaglia, *La Fotografia futurista*, in *Futurismo*, I, no. 7, 23 October 1932, Rome

Filippo Tommaso Marinetti, *Anton Giulio Bragaglia*, in *Futurismo*, I, no. 9, 6 November 1932, Rome

Mostra d'Arte fotografica, in *Futurismo*, I, no. 15, 18 December 1932, Rome

La Prima Biennale d'Arte Fotografica, in *Il Giornale d'Italia*, 18 December 1932, Rome

Prima Biennale Internazionale d'Arte Fotografica, exhib. cat., Palazzo del C.N.I., 19 December 1932–20 January 1933, Edizione Enzo Pinci, Rome (Foreword by Alberto Neppi and Renato Metalli)

Vittorio Curti, *Miracoli d'arte su una lastra di gelatina*, in *La Tribuna*, 20 December 1932, Rome

Anacleto Tanda, *Camuffamento, praticità, dinamismo nelle fotografie futuriste*, in *Futurismo*, I, no. 16, 25 December 1932, Rome

Mino Serafini, *La Prima Biennale Internazionale d'Arte fotografica*, in *Orizzonti*, II, no. 10, 21 January 1933, Rome

Battista Pallavera, *Ritocco del fotomontaggio*, in *Campo Grafico*, I, no. 1, January 1933, Milan

Mino Serafini, *Fotografia: l'arte del tempo nostro deve aderire alla vita*, in *Orizzonti*, I, no. 12, 21 March 1933, Rome

Damiani, *Mostra Vinicio Paladini*, in *Futurismo*, II, no. 38, 28 May 1933, Rome

Manuel Caracciolo, *Arte fotografica e fotografia futurista*, in *Roma*, 20 September 1933, Naples (Reprinted in *Elettroni*, nos. 5–6, 5 October 1933, Naples)

Prima Grande Mostra Nazionale Futurista, exhib. cat., "Sezione Fotografia", Edificio per Esposizioni del Sindacato Ingegneri, Piazza Adriana, 28 October–15 December 1933, Rome

Mino Serafini, *Ernesto Thayaht*, in *Orizzonti*, II, no. 18, October 1933, Rome

Guglielmo Ceroni, *La 1° Mostra Nazionale d'Arte Futurista*, leaflet dated 1 November 1933, published as a supplement to the journal *Futurismo*, Rome

Anno 1934, calendar-album, published by the Studio Fotografico Bragaglia, December 1933, Rome (In the calendar the original photodynamic image *La Giovane Italiana* was published, executed by Arturo Bragaglia and posed for by Liliana Biancini)

Carlo Manzoni, *Munari, palombaro della fantasia*, in *Natura*, VII, no. 1, 31 January 1934, Milan

Kurt Liebmann, *L'Arte nella fotografia*, in *Sant'Elia*, I, no. 4, 15 February 1934, Rome

Nicola G. Caimi, *A Proposito di fotografia pubblicitaria*, in *Il Risorgimento grafico*, no. 6, June, 1934, Milan

Nicola Albano, *Futurismo fotografico*, in *Nuovo Futurismo*, I, nos. 4–5, July 1934, Milan

Pasquale De Biasi, *Adele Gloria*, in *Carroccio*, no. 5, October 1934, New York

New Art Craze Draws Students To View, Antonelli Production, in *Philadelphia Sunday News*, 14 October 1934, Philadelphia

Guido Modiano, *Fotografia 1931*, in *Campo Grafico*, VI, no. 12, December 1934, Milan

Luigi Veronesi-Battista Pallavera, *Del fotomontaggio*, in *Campo Grafico*, VI, no. 12, December 1934, Milan

Giuseppe Enrie, *Io vi insegno la fotografia*, Società Editrice Internazionale, Turin, 1934

La Mostra fotografica di Fosco Maraini al Lyceum a Firenze, in *Il Progresso fotografico*, no. 5, 30 May 1935, Milan

Alfa Del Centauro, *Adele Gloria*, in *Noi*, no. 5, May–June 1935, New York

Arturo Ciacelli, *Fotoplastica*, in *Stile futurista*, II, nos. 8–9, May 1935, Turin

Fosco Maraini, *La Fotografia è una forma d'arte*, in *La Gazzetta della fotografia*, XIII, no. 6, 20 June 1935, Palermo

Arnaldo Ginna, *Fotonatura*, in *La Forza*, I, no. 1, 15 July 1935, Turin

Enrico Grossi-Bellezanti, *Tecnica foto-naturista*, in *La Forza*, I, no. 1, 15 July 1935, Turin

Enrico Prampolini, *Conquiste e strategie della camera oscura*, in *Natura*, IX, no. 3, March 1936, Milan

Severo Antonelli and his Pictures, in *The Camera*, no. 1, July 1936, Philadelphia

Guglielmo Policastro, *La Mostra fotografica di Pirrone*, in *Il Popolo di Roma*, 28 October 1936, Rome

Manuel Caracciolo, *Valore della fotografia nel film*, in *Cinema*, no. 8, 25 October 1936, Rome.

Anton Giulio Bragaglia, *Fotodinamismo e aereodinamica*, in *Illustrazione Toscana e dell'Etruria*, November 1936, Florence (Reprinted in *Primi piani*, I, no.1, 20 December 1936, Rome)

Alidada-Tullio D'Albisola, *Graffi a l'anima*, portfolio with a typewritten poem by Alidada and five original *rayogrammes* by D'Albisola, Savona, 1936

Attilio Rossi, *Fotografia e tipografia*, in *Campo Grafico*, V, no. 3, March 1937, Milan

Carlo Foà, *L'Organismo vivente allo schermo*, in *Cinema*, no. 18, 25 March 1937, Rome

Carlo Dradt-Antonio Rossi-Luigi Veronesi, *Il Fotogramma pubblicitario*, in *Campo Grafico*, V, nos. 5–6, May–June 1937, Milan

Filippo Tommaso Marinetti, *Estetica della pubblicità*, in *La Pubblicità d'Italia*, I, nos. 2–3 August–September 1937, Milan

Antonio Boggeri, *La Fotografia nella pubblicità*, in *La Pubblicità d'Italia*, I, nos. 5–6, November–December 1937, Milan

Thayaht, *La Fotoscena*, leaflet printed on burgundy paper, Florence, 1937

Attilio Podestà, *Le Fotografie di Veronesi*, in *Natura*, XI, no. 12, December 1938, Milan

Jole Vieni, *Una Mostra femminile d'arte: Adele Gloria*, in *Lavoro fascista*, 3 February 1939, Rome

Bruno Munari, *Divagazioni sulla fotografia*, in *Panorama*, I, no. 1, 27 April 1939, Rome

La Mostra Fotografica Pirrone al Palazzo delle Esposizioni, in *Il Popolo di Roma*, 19 January 1940, Rome

Ferdinando Caioli, *La Cartopittura di Pirrone*, in *Giornale d'Italia*, I February 1941, Rome

Giuseppe Lo Duca, *Meraviglie dell'ultracinematografia*, in *Sapere*, no. 35, 15 June 1941, Milan

Luigi Veronesi, *Il Fotomontaggio*, in *Note fotografiche*, XVIII, no. 1, July 1941, Milan

Aldo Scarella, *La Chiusura della Mostra Fotografica (Ivos Pacetti)*, in *Il Giornale di Genova*, 13 July 1941, Genoa

Luciano Jacobelli, *13x18 e 18x24: Parisio*, in *Roma*, 2 August 1941, Naples

Tato, *Tato raccontato da Tato: 20 anni di futurismo*, Casa Editrice Oberdan Zucchi, Milan, 1941

A.C., *La Mostra dei fotoplastici di guerra*, in *Vinceremo*, special edition of the journal *L'Azione fascista*, VI, no. 9, 25 May 1942, Macerata

Laszlo Moholy-Nagy, *Space-Time and the Photographer*, in *American Annual of Photography 1943*, vol. LVII, Boston, 1942

Gianni Boni, *Fotorealismo e Fotosurrealismo*, Edizioni Libreria Fratelli Bocca, Rome, 1944

E.F. Scopinich, *Fotografia*, Gruppo Editoriale Domus, Milan, 1944

Léon Werth, *La Peinture et la mode*, Grasset, Paris, 1945

Giuseppe Galassi, *La Lezione dei futuristi*, in *Il Giornale*, 24 April 1948, Naples

Anton Giulio Bragaglia, *"Perfido incanto" batte Fischinger e Caligari: ricordi personali sul primo cinema d'avanguardia*, in *Cinema*, IV, no.1, November 1951, Rome

La Conferenza di Maggiorino Gramaglia, in *Progresso Grafico*, nos. 11–12, November–December 1951, Turin

Mario Levi, *Il nostro fotografo: Ernesto Fazioli*, in *Vecchia Cremona*, Edizioni La Provincia, Cremona, 1955

Carlo Ludovico Ragghianti, *Fotodinamica futurista*, in *Selearte*, VII, no. 39, January–February 1959, Florence

Carlo Belloli, *Totalità di Anton Giulio Bragaglia*, in *Fenarete*, XIII, no. 4, September–October 1960, Milan

L'Improvvisa morte di Arturo Bragaglia, in *Il Messaggero*, 23 January 1962, Rome

Ivo Pannaggi, *Il Collaggio postale*, in *Pannaggi*, Reclamo Trykkeri, Oslo, 1962

Piero Raccanicchi, *Fotodinamismo futurista*, in *Popular Photography*, Italian edition, no. 67, January 1963, Milan

Carlo Ludovico Ragghianti, *Le Acrobazie di Boldini*, in *L'Espresso*, 11 August 1963, Rome

Piero Raccanicchi, *Fotodinamismo futurista e rapporto tra Balla e Bragaglia*, in *Sipra*, no. 6, June 1965, Turin

Carlo Ludovico Ragghianti, *Balla e la fotodinamica di Bragaglia*, in *Critica d'Arte*, September 1965, Florence

Mario Verdone, *Anton Giulio Bragaglia*, Edizioni Bianco e Nero, Rome, 1965

Maurizio Calvesi, *Dinamismo e simultaneità nella poetica futurista*, Edizioni Fabbri, Milan, 1967

Mario Verdone, *Il Contributo italiano alla fotografia contemporanea: Anton Giulio Bragaglia*, in *Ulisse*, no. 61, May 1967, Florence

Aaron Scharf, *Art and Photography*, Penguin Books, London, 1968

Luigi Veronesi, exhib. cat., Galleria Martano, Turin, 1968

Germano Celant, *Marcello Nizzoli*, Edizioni di Comunità, Milan, 1968

Mario Verdone, *Cinema e letteratura del futurismo*, Edizioni di Bianco e Nero, Rome, 1968

Henri Chapier, *Un Chef-d'Oeuvre de Bragaglia*, in *Combat*, 10 July 1969, Paris

Omaggio ad Anton Giulio Bragaglia, Centro Internazionale delle Arti e del Costume, Palazzo Grassi, Venice, 1970

Antonella Vigliani Bragaglia, *Regesto-cronologia-bibliografia*, in Anton Giulio Bragaglia, *Fotodinamismo futurista*, reprint ed. Centro Studi Bragaglia, Edizioni Einaudi, Turin, 1970

Giulio Carlo Argan, *Introduzione*, in Anton Giulio Bragaglia, *Fotodinamismo futurista*, reprint ed. Centro Studi Bragaglia, Edizioni Einaudi, Turin, 1970

Maurizio Calvesi, *Le Fotodinamiche di Anton Giulio Bragaglia*, in Anton Giulio Bragaglia, *Fotodinamismo futurista*, reprint ed. Centro Studi Bragaglia, Edizioni Einaudi, Turin, 1970

Maurizio Fagiolo, *Moderna Magia*, in Anton Giulio Bragaglia, *Fotodinamismo futurista*, reprint ed. Centro Studi Bragaglia, Edizioni Einaudi, Turin, 1970

Filiberto Menna, *Il Fotodinamismo come tecnica trascendentale*, in Anton Giulio Bragaglia, *Fotodinamismo futurista*, reprint ed. Centro Studi Bragaglia, Edizioni Einaudi, Turin, 1970

C.A., *Arte: fotodinamismo futurista*, in *L'Espresso*, October 1970, Milan

Carlo Sacchetti, *In ricordo di Maggiorino Gramaglia*, in *Corriere Artigiano*, May 1971, Turin

Maggiorino Gramaglia maestro fotografo, in *Graphicus*, nos. 7–8, July–August 1971, Turin

Enrico Crispolti, *Il Mito della macchina e altri temi del futurismo*, Celebes Editore, Trapani, 1971

Bruno G. Sanzin, *Fotodinamismo futurista di Anton Giulio Bragaglia*, in *Il Cristallo*, XIV, no. 1, January 1972, Bolzano

Enrico Crispolti, *I Futuristi e la fotografia*, in *Qui Arte Contemporanea*, no. 8, June 1972, Rome

Luigi Tallarico, *Fotografia futurista*, in *Il Secolo d'Italia*, 12 September 1972, Rome

Piero Raccanicchi, *Match truccato tra foto e pittura*, in *Fuoricampo*, no. 1, May 1973, Turin

Giovanni Lista, *Pol Bury cineasta*, in *NAC*, no. 26, October 1973, Milan

Paolo Fossati, *Le Ragioni astratte di Veronesi*, Edizioni Martano, Turin, 1973

Yasushi Inoue, *Le Futurisme, la peinture métaphysique et le dadaisme*, Japan Art Center, Tokyo, 1973

Ando Gilardi, *La vera storia di Anton Giulio Bragaglia*, in *Photo 13*, VC, no. 4, April 1974, Milan

Carlo Dradi, *Nasce a Milano la grafica moderna*, in *La Città di Milano*, no. 9, May 1974, Milan (Paragraph: *Fotografia e tipografia*)

Livio Zadra, *In memoria di Ottavio Bérard*, in *Il Finanziere*, 30 April 1975, Rome

Italo Zannier, *La Fotografia al servizio dell'ideologia fascista*, Galleria d'Arte Sagittaria, 18 October–30 November 1975, Pordenone

Gianni Croce pittore e fotografo, exhib. cat., Salone Amici dell'Arte, 20 November–4 December, Piacenza, 1975

Paolo Fossati, *Luigi Veronesi: fotogrammi e fotografie (1932–1974)*, Edizioni Martano, Turin, 1975

Jean Brun, *Le Voyage dans le temps*, in *Temporalità e alienazione*, Edizioni Cedam, Padua, 1975

Caroline Tisdall-Angelo Bozzolla, *Bragaglia's Futurist Photodynamism*, in *Studio International*, vol. 90, no. 976, July 1975, London

Marcello Vannucci, *Mario Nunes Vais fotografo fiorentino*, Casa Editrice Bonechi, Florence, 1975

Carlo Bertelli, *Silografia e fotografia secondo Veronesi*, in *Grafica*, II, no. 1, January 1976, Rome

Aaron Scharf, *A Note on Photography and Futurism*, in *Artforum*, vol. xv, no. 1, January 1976, New York

Giuseppe Turroni, *Marinetti e la fotografia*, in *Il Corriere della Sera*, 15 September 1976, Milan

Anna Caterina Toni, *L'Attività artistica di Ivo Pannaggi*, La Nuova Foglio, Macerata, 1976

Paolo Baldacci, *Thayaht*, Galleria Philippe Daverio, Milan, 1976

Geno Pampaloni-Mario Verdone, *I Futuristi italiani*, Edizioni Le Lettere, Florence, 1977

Franco Passoni, *Identikit del futurismo*, in *Avanti!*, no. 141, 25 June 1977, Milan

Claudio Quarantotto, *Il futurista Boccioni non intuì il futuro della fotografia*, in *Vita Sera*, no. 165, 25 June 1977, Milan

Sylvain Lecombre, *Marey, l'homme en mouvement*, in *Canal*, no. 13, 1–15 February 1977, Paris

Jean Clair, *Duchamp et la photographie*, Éditions du Chêne, Paris, 1977

Michel Frizot, *Étienne-Jules Marey (1830–1904)*, Musée National d'Art Moderne, Paris, 1977

Giovanni Lista, *Marinetti et le futurisme*, L'Age d'Homme, coll. "Avant-gardes", Lausanne, 1977

Bruno Munari, *Fantasia*, Laterza Editore, Bari, 1977

Francesco Carlo Crispolti, *Letteratura e fotografia*, Edizioni R.A.I., Rome, 1977

Pierre Cabanne, *L'Oeil moderne de Marey*, in *Le Matin*, 1 January 1978, Paris

Ricerche di Veronesi, exhib. cat., Palazzo dei Diamanti, 23 April–10 June, Ferrara, 1978

Hervé Guibert, *L'Art des machines*, in *Le Monde*, 24 August 1978, Paris

Daniela Palazzoli, *Bragaglia and Futurist Photodynamism*, in *The Print Collector's Newsletters*, vol. 8, no. 6, January–February 1978, Zurich

Italo Zannier, *70 anni di fotografia in Italia*, Edizioni Punto e Virgola, Modena, 1978

Emilio Bertonati, *Das Experimentelle Photo in Deutschland (1918–1940)*, Galleria del Levante, Milan, 1978

Kelly Wise, *Lotte Johanna Jacobi*, Addison House, Danbury, New Hampshire, 1978

Oreste Ferrari-Maria Teresa Contini, *Gli italiani nelle fotografie di Mario Nunes Vais*, Loggia di Sansovino, 26 May–24 June 1979, Vittorio Veneto

Emilio Bertonati, *Mario Castagneri: Mani*, Galleria del Levante, Milan, 1979

Giovanni Lista, *L'Art postal futuriste*, Jean-Michel Place Éditeur, Paris, 1979

Carlo Bertelli and Giulio Bollati, *Storia d'Italia: l'immagine fotografica (1845–1945)*, Edizioni Einaudi, Turin, 1979

Giovanni Lista, *Futurismo e fotografia*, Edizioni Multhipla, Milan, 1979

Franco Vaccari, *Fotografia e inconscio tecnologico*, Edizioni Punto e Virgola, Modena, 1979

Mario Verdone, *Fotografia e avanguardie*, in *Fotocultura*, no. 1, January 1980, Rome

Italo Zannier, *Una dinastia di fotografi: tre generazioni di Wulz*, in *Il Fotografo*, February 1980, Milan

Agnoldomenico Pica, *Fotografie di Antonio Boggeri*, Galleria del Levante, February 1980, Milan

Gustavo Bonaventura fotografo a Roma dal 1908 al 1930, exhib. cat., Galleria dell'Emporio Floreale, March 1980, Rome

Antonio Porta, *Le Immagini: futurismo inedito*, in *Alfabeta*, II, no. 12, April 1980, Milan

Italo Zannier, *La Fotografia in Italia negli Anni Venti*, in *La Metafisica, gli Anni Venti*, Galleria d'Arte Moderna, May–August 1980, Bologna

Enrico Crispolti, *Tato fotografo futurista*, in *Ricostruzione futurista dell'universo*, exhib. cat., Mole Antonelliana, June–October 1980, Turin

Carlo Ludovico Ragghianti, *Fotodinamica e fotospiritica*, in *Critica d'Arte*, nos. 172–174, July–December 1980, Florence

Giuliana Scimé, *La Fotografia del movimento*, in *Il Diaframma*, no. 252, October–November 1980, Milan

Carlo Bertelli, *Album di famiglia*, in *Panorama*, no. 710, 26 November 1980, Milan

Lise Brunel, *Futurisme et Photographie*, in *Art-Press*, no. 43, December 1980, Paris

Sebastiano Porretta, *La Fotografia all'Esposizione Universale di Roma nel 1911*, in *Roma 1911*, exhib. cat., Galleria Nazionale d'Arte Moderna, Rome, 1980

Glauco Viazzi, *Luigi Veronesi*, Editori Riuniti, Rome, 1980

Italo Zannier, *Illusion et réalité dans la photographie italienne entre les deux guerres*, in *Les Réalismes, 1919–1939*, exhib. cat., Centre Georges Pompidou, 17 December 1980–20 April 1981, Paris

Germano Celant, *Futurism and the Occult*, in *Artforum*, no. 5, January 1981, New York

Ando Gilardi, *Creatività e informazione fotografica*, in *Storia dell'Arte Italiana*, Edizioni Einaudi, Turin, 1981

Marzio Pinottini, *Peruzzi futurista*, All'Insegna del Pesce d'oro, Milan, 1981

Édouard Jaguer, *Les Mystères de la chambre noire: le surréalisme et la photographie*, Flammarion, Paris, 1981

Lo Studio Boggeri, Electa Editrice, Milan, 1981

Giovanni Lista, *Futurist Photography*, in *Art Journal*, vol. 41, no. 3, October–December 1981, New York

Giovanni Lista, *Photographie futuriste italienne (1911–1939)*, Musée de la Ville de Paris,

29 October 1981–3 January 1982, Paris (Catalogue published in Spanish for the presentation of the exhibition at the Museo de Bellas Artes, August–September 1984, Bilbao; in Japanese for the presentation of the exhibition at the National Museum of Modern Art, 30 May–28 June 1987, Tokyo)

Gaetano Pantaleoni, *La Scomparsa di Gianni Croce*, in *Libertà*, 3 May 1981, Piacenza

Italo Zannier, *Fratelli Pedrotti, immagini*, Provincia Autonoma di Trento, May 1981, Trento

France Huser, *La Photographie futuriste italienne*, in *Le Nouvel Observateur*, 31 October 1981, Paris

Michel Nuridsany, *Photo: actualité du futurisme*, in *Le Figaro*, 10 November 1981, Paris

Dominique Carré, *Futurisme photographique*, in *Les Nouvelles Littéraires*, 13 November 1981, Paris

Maria Grazia Tajé, *C'è un futurista nella camera oscura*, in *Il Secolo XIX*, 16 November 1981, Milan

André Parinaud, *Triomphe de la photographie*, in *Le Nouveau Journal*, 21 November 1981, Paris

Le Futurisme italien de 1919 à 1939, in *Le Photographe*, November 1981, Paris

Fabrice Pernisco, *La Photo futuriste italienne*, in *Spot Informations*, November–December 1981, Paris

Evelyne Artaud, *Les Nouvelles mythologies de la photographie*, in *Arts*, no. 52, November 1981, Paris

Photographie futuriste italienne, in *Magazine*, November–December 1981, Paris

Licia Zennaro, *I Wulz: tre generazioni di fotografi a Trieste*, Palazzo Costanzi, 21 November–15 December 1981, Trieste

Luigi Tallarico, *La Fotografia futurista al Museo di Parigi*, in *Il Secolo d'Italia*, 19 December 1981, Rome

Jean-François Coulomb, *Le Futurisme au présent*, in *Le Moniteur*, 26 December 1981, Paris

Michel Pincaut, *La Photographie futuriste italienne*, in *Canal*, no. 43, December 1981, Paris

Ginette Bléry, *Futurisme: une exposition révèle des chefs-d'oeuvre des années 20–30 inconnus à ce jour*, in *Photorevue*, no. 12, December 1981, Paris

Un vaste panorama du futurisme italien au Musée d'Art Moderne, in *Photo*, no. 171, December 1981, Paris

Jean Leroy, *La Photographie futuriste italienne* in *France-Photographie*, December 1981, Paris

Susan Cook Summer, *Sergei Mikhailav Tretiakov: Autoanimals (Samozveri)*, in *Art Journal*, Winter 1981, New York

Ando Gilardi, *Creatività e informazione fotografica*, in *Storia dell'Arte Italiana*, Edizioni Einaudi, Turin, 1981

Ferdinando Scianna, *Les Futuristes étaient aussi des photographes*, in *La Quinzaine Littéraire*, no. 362, 1–15 January 1982, Paris

M.C. Hugonot, *La Photographie futuriste italienne*, in *Le Quotidien de Paris*, 22 January 1982, Paris

Michel Nuridsany, *Photographies futuristes au Musée d'Art Moderne*, in *Art-Press*, no. 55, January 1982, Paris

Daniela Palazzoli, *Fotodinamici futuristi*, in *Bolaffi-Arte*, no. 116, February 1982, Milan

Gaetano Pantaleone, *A Paris la mostra del fotofuturismo*, in *Libertà*, 8 February 1982, Piacenza

Giovanni Lista-Karl Steinorth, *Futurismus und Fotografie in Italien*, Photokina-Italienisches Kulturinstitut, 3 October–3 November 1982, Cologne (2 vols.)

Stephan Schmidt, *Italienische Avantgarde*, in *Kölner Kultur*, no. 231, 5 October 1982, Cologne

Doris Schreiber, *Fotografie und Futurismus*, in *Kolnische Kundschau*, no. 239, 14 October 1982, Cologne

Serena Marchetti, *Fotografare con i futuristi italiani*, in *Corriere d'Italia*, 17 October 1982, Cologne

Rita Reif, *Futurist Photographs*, in *New York Times*, 5 November 1982, New York

Jeffrey Hogrefe, *Talking about.*, in *Vogue Magazine*, November 1982, New York

Bruce Weber, *The Italian Futurist Photography*, in *Interview*, no. 12, November 1982, New York

Enrico Crispolti, *Svolgimenti del futurismo*, in *Annitrenta*, Edizioni Mazzotta, Milan, 1982

Jean-Luc Daval, *La Photographie, histoire d'un art*, Éditions Skira, Geneva, 1982

Sibylle Maus, *Das Leben als Bewegung festhalten: Futuristische Fotografie*, in *Frankfurter Allgemeine Magazin*, no. 188, 7 October 1983, Frankfurt

Denis François, *L'Art entre les deux guerres*, Éditions Nathan, Paris, 1983

Floris M. Neususs, *Fotogramme, die lichtreichen Scatten*, Fotoforum Verlag, Kassel, 1983

Pietro Privitera, *Una ricerca sulla fotografia futurista in Italia*, in *Progresso fotografico*, no. 1, January 1984, Milan

Carlo Gentili-Nino Migliori, *Per Bragaglia*, Centro Diaframma, January 1984, Frosinone

Giovanni Lista-Yolanda Trincere, *Futurism and Photography*, Hillwood Art Gallery, Long Island University, 10 February–7 March 1984, New York

Ada Willich-Der Traum, *Dialog mù der Seele*, in *Deutsch Vogue*, no. 3, March 1984, Munich

Florence de Méredieu, *Photo et mouvement, de Marey au polaroïd*, in *Art-Press*, no. 79, March 1984, Paris

Rosa Maria Malet, *Fotografia futurista italiana*, Fundacio Joan Mirò, 22 March–6 May 1984, Barcelona

Jean-François Chevrier, *L'Autoportrait comme mise-en-scène*, in *Photographies*, no. 4, April 1984, Paris

Giovanni Lista, *Futurizam i Konstruktivizam*, in *Moment*, no. 1, May 1984, Belgrade

Giovanni Lista, *Architettura futurista dimenticata (Vucetich e De Giorgio)*, in *Lotta Poetica*, nos. 23–24, July–August 1984, Verona

Mario Fusco, *Marinetti le provocateur*, in *Le Monde*, 19 October 1984, Paris

Pierre Borhan, *La Photographie en mouvement*, in *Clichés*, no. 8, November 1984, Brussels

Luigi Tallarico, *La "rivoluzione futurista" proiettata nell'avvenire*, in *Il Secolo d'Italia*, 19 December 1984, Rome

Gérard-Georges Lemaire, *Bomba francese, miccia italiana ed è futurismo*, in *Il Sole 24 Ore*, 23 December 1984, Milan

Giovanni Lista, *Charakterystyka futuryzmu francuskiego*, in *Co Robic po Kubizmie*, Wydawnictwo Literackie, Cracow, 1984

Giovanni Lista, *Giacomo Balla futuriste*, L'Age d'Homme, Lausanne, 1984

Enrico Crispolti-Édouard Jaguer, *53 tableaux futuristes italiens*, Galerie Verrière, 4–18 October 1984, Lyon

Christine Carodot, *Le Second futurisme italien redécouvert*, in *Beaux-Arts Magazine*, no. 17, October 1984, Paris

Le temps: regards sur la Quatrième dimension, Palais des Beaux-Arts, 15 November 1984–20 January 1985, Brussels

Renzo Paris, *Nuovo interesse per il futurismo*, in *Corriere della Sera*, 3 January 1985, Milan

Frontiere d'avanguardia: gli anni del Futurismo nel Venezia Giulia, Palazzo Attems, February–April 1985, Gorizia

Erika Billeter, *L'Autoportrait à l'âge de la photographie*, Musée Cantonal des Beaux-Arts, 2 April–9 June 1985, Lausanne

Mario Verdone, *Carlo Ludovico Bragaglia, fotografo e cineasta*, in *Strenna dei Romanisti*, 18 April 1985, Rome

Marzio Pinottini, *Futurismo a Torino*, Galleria Il Narciso, 30 April–15 June 1985, Turin

Giovanni Lista, *De la Reconstruction futuriste de l'univers à l'art mécanique*, in *Opus International*, no. 98, Summer 1985, Paris

Hervé Guibert, *La photographe Germaine Krull*, in *Le Monde*, 17 August 1985, Paris

Tokuhiro Nakajima, *Modernism as a Mask Iwata Nakayama*, Hyogo Prefectural Museum of Modern Art, 5–31 December 1985, Kobe

Giovanni Lista, *La componente futurista in L'Herbier*, in *Marcel L'Herbier*, Pratiche Editrice, Parma, 1985

Giovanni Lista, *Le Futurisme*, Éditions Hazan, Paris, 1985 (American edition published by Universe Book, New York, 1986; English edition by Art Data, London, 1986; Italian edition by Jaca Book, Milan, 1986)

Futurismo e fotografia, in *Il Giornale*, 22 November 1985, Milan

I Futuristi e la fotografia, in *La Gazzetta di Parma*, 29 November 1985, Parma

Giovanni Lista, *I Futuristi e la fotografia: creazione fotografica e immagine quotidiana*, Museo Civico d'Arte Contemporanea, 7 December 1985–26 January 1986, Modena/Museo Depero, 14 February–16 March 1986, Rovereto

Enzo Di Martino, *La Fotografia dei futuristi*, in *Il Gazzettino*, 17 December 1985, Venice

Fiorella Jacono, *I Fotografi futuristi: pose liberatorie davanti al clic*, in *Il Manifesto*, 18 December 1985, Rome

S.L., *Quando Marinetti e Depero si mettevano in posa*, in *La Nuova Gazzetta*, 22 December 1985, Modena

Giuseppe Turroni, *I Seguaci di Marinetti e la fotografia*, in *Il Corriere della Sera*, 2 January 1986, Milan

Vittorio Boraini, *Rispunta Marinetti in formato polaroid*, in *La Repubblica*, 3 January 1986, Rome

Marina Tagle, *Futuristi nel mondo delle foto*, in *Il Resto del Carlino*, 9 January 1986, Bologna

W.G., *Depero, il futuro*, in *Alto Adige*, 10 January 1986, Trento

Lorenzo Pellizzari, *Dai futuristi a David Hockney*, in *Il Sole 24 Ore*, 13 January 1986, Milan

Elena Pontiggia, *Ritorno al "futuro"*, in *Il Giornale*, 19 January 1986, Milan

Dede Auregli, *A futurista memoria*, in *L'Unità*, 14 February 1986, Rome

Giovanni Lista, *L'Avant-garde futuriste*, in *Photo Avant-Garde: Italy and Japan*, The Contemporary Art Gallery, October 1986, Hyogo

Van Deren Coke-Diana C. Du Pont, *Photography: A Facet of Modernism*, Hudson Hills Press, New York, 1986

Giovanni Lista, *Les Trois étapes de la cinématographie futuriste: la ciné-peinture, le théâtre filmé, le cinéma*, in *La Coexistence des Avant-Gardes – Colloque International de la Société d'Esthétique*, Drustvo Za Estetiko, Ljubljana, 1986

Italo Zannier, *Storia della fotografia italiana*, Laterza, Bari, 1986

Il Laboratorio dei Bragaglia, Edizioni Essegi, Ravenna, 1986

Futurismo & Futurismi, Bompiani Editore, Milan, 1986

Giovanni Lista, *L'Ombre du geste*, in *Le Temps d'un mouvement: aventures et mésaventures de l'instant photographique*, Centre National de la Photographie, 2–15 June 1987, Paris

Erwin Koppen, *Literatur und Photographie*, J.B. Metzlersche Verlagsbuchhandlung, Stuttgart, 1987 (Chapter: *Photographie und Ästhetik des Italienischen Futurismus*)

Giovanni Lista, *Ginna e il cinema futurista*, in *Arte e civiltà delle macchine: il futurismo*, Longo Editore, Ravenna, 1987

Michel Frizot, *Photomontages*, C.N.P., Paris, 1987

Giovanni Lista, *De la chronophotographie de Marey au photodynamisme futuriste*, in *Vitalité et contradictions de l'avant-garde*, Éditions José Corti, Paris, 1988

Italo Zannier, *L'Occhio della fotografia*, Edizioni N.I.S., Milan, 1988

Giovanni Lista, *Dal futurismo all'immaginismo: Vinicio Paladini*, Edizioni del Cavaliere Azzurro, coll. "Onirolita", Bologna, 1988

Giovanni Lista, *Les Futuristes*, Éditions Henri Veyrier, coll. "Les Plumes du Temps", Paris, 1988

Jean-Claude Gautrand, *Visions du sport, photographies 1929–1960*, F.N.P., Paris, 1988

Werner Schmidt, *Edmund Kesting, Gemälde, Zeichnungen und farbige Blätter Graphik Photographien*, 1 November 1988–3 January 1989, Staatliche Kunstammlungen, Dresden

Giovanni Lista, *Futurisme et cinéma*, in *Peinture-cinéma-peinture*, Musée de Marseille-Centre de la Vieille Charité, October 1989, Éditions Hazan, Paris

Giovanni Lista, *La Scène futuriste*, Éditions du Centre National de la Recherche Scientifique, coll. "Spectacles, Histoire, Société", Paris, 1989

Alain Sayag, *La Photographie dans l'art du XXe siècle*, C.N.D.P., Paris, 1990

Giovanni Lista, *La Ricerca cinematografica futurista*, in *Cinema, avanguardie e immaginario urbano*, Manfrini Editori, Trento, 1990

Floris M. Neusüss, *Das Fotogram in der Kunst des 20 Jahrhunderts*, Dumont Buchverlag, Cologne, 1990

Matteo D'Ambrosio, *Emilio Buccafusca e il futurismo a Napoli negli anni trenta*, Liguori Editore, Naples, 1991

Carlo Belloli, *Anton Giulio Bragaglia e l'inverazione dello spettacolo totale*, in *Cenobio*, XL, no.3, July 1991, Lugano

Piero Raccanicchi, *Avanguardie e fotografia in Italia: Mollino e Bragaglia*, in Italo Zannier ed., *Segni di luce, la fotografia italiana contemporanea*, Longo Editore, Ravenna, 1993

Claude Eveno, *Carnet des villes*, Les éditions de l'imprimeur, Paris, 1994

Giovanni Lista, *Loïe Fuller, danseuse de la Belle Epoque*, Éditions Stock-Somogy, Paris, 1994

Omaggio a Carlo Ludovico Bragaglia, Edizioni Joyce & Co., Rome, 1994

Mario Verdone, *I Bragaglia e la "fotodinamica"*, in *Immagine*, no. 30, Spring 1995, Rome

Marey pionnier de la synthèse du mouvement, Musée Marey, 20 May–10 September 1995, Beaune

Giovanni Lista, *Futurismus und Okkultismus*, in *Okkultismus und Avantgarde von Munch bis Mondrian (1900–1915)*, Schirn Kunsthalle, 3 June–20 August 1995, Frankfurt

Pannaggi e l'arte meccanica futurista, Edizioni Mazzotta, Milan, 1995

L'Io e il suo doppio: un secolo di ritratto fotografico in Italia (1895–1995), Alinari, Florence, 1995

Giovanni Lista, *Les Futuristes: la dynamique d'une avant-garde*, in *Camera Photo international*, January–March 1996, Paris

Angela Madesani, *Fotografia tra le due guerre: documentazione, sperimentazione, avanguardia*, Galleria Milano, May 1996, Milan

Giovanni Lista, *Un inedito marinettiano: "Velocità", film futurista*, in *Fotogenia*, no. 2, December 1996–January 1997, Bologna

Futurismo, in *Saber*, no. 32, January–February 1997, Mexico City

Ettore Frangipane, *Enrico Pedrotti: una vita*, Galleria Goethe, September 1997, Bolzano

Danièle Meaux, *La Photographie et le temps: le déroulement temporel dans l'image photographique*, P.U.P., Aix-en-Provence, 1997

Irene Bignardi, *Carlo Ludovico Bragaglia*, in *La Repubblica*, 5 January 1998, Rome

Giovanni Lista, *Futurismo cinematografico: "Velocità" di Cordero, Martina e Oriani*, in *Fotogenia*, no. 8, September 1999, Bologna

Gioranni Lista, *'Cinema futurista'*, in *A nuova luce: cinema muto italiano*, Edizioni Clueb, Bologna, 2000